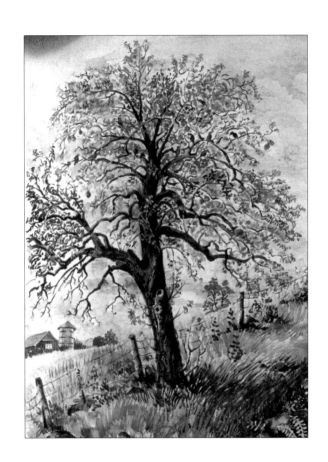

THE *Gág* FAMILY

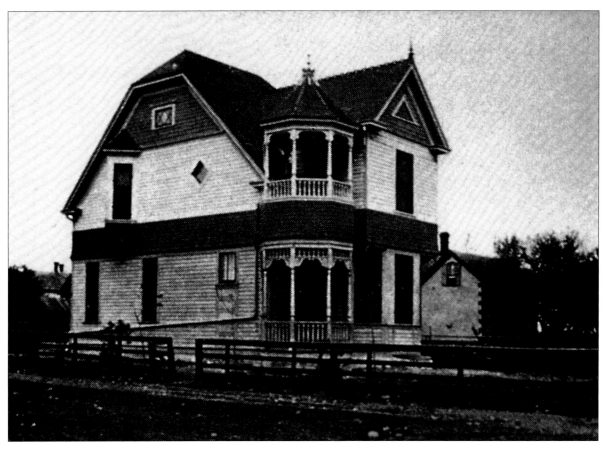

Gag house, New Ulm, Minnesota, c. 1897–98. Photograph by Anton Gag.

THE *Gág* FAMILY

GERMAN-BOHEMIAN ARTISTS
IN AMERICA

JULIE L'ENFANT

WITH RESEARCH ASSISTANCE BY

ROBERT J. PAULSON

AFTON HISTORICAL SOCIETY PRESS

Edited by Phil Freshman
Designed by Barbara J. Arney
Graphic layout by Mary Susan Oleson

Library of Congress Cataloging-in-Publication Data

L'Enfant, Julie.
 The Gag Family: German-Bohemian Artists in America / by Julie L'Enfant
L'Enfant ; edited by Phil Freshman. -- 1st ed.
 p. cm.
Includes bibliographical references.
 ISBN 1-890434-50-7 (hardcover : alk. paper)
 1. Gâag, Wanda, 1893-1946. 2. Gâag, Anton, 1858-1908. 3. Illustrators--
United States--Biography. 4. Artists--United States--Biography. I. Freshman, Phil. II. Title.
 NC975.5.G34 L46 2002
 700' .92'39186073 -dc21

 2002000902

Printed and bound in Canada

Publication of

The Gág Family: German-Bohemian Artists in America

was made possible with generous financial support from

Peter and Alexandra Daitch

*The Afton Historical Society Press publishes
exceptional books on regional subjects.*

W. Duncan MacMillan Patricia Condon Johnston
President Publisher

AFTON HISTORICAL SOCIETY PRESS
P.O. Box 100, Afton, MN 55001
1-800-436-8443
aftonpress@aftonpress.com
www.aftonpress.com

To Gary Harm,
who has kept
the legacy alive

Contents

Acknowledgments

My introduction to the Gag family came about through Richard W. Cox, my former professor of art history at Louisiana State University, who in 1995 invited me to collaborate on articles about Wanda Gág for *Minnesota History* magazine and the Tamarind Press. I will always be grateful for his faith in me and for his generous encouragement of this project. That initial research took me to the Brown County Historical Society (BCHS) in New Ulm, Minnesota, where I met Darla Gebhard, the society's remarkably knowledgeable research librarian, James Boeck, curator of the Wanda Gág House, and other custodians of the Gag legacy. My interest in Wanda's father, Anton, was piqued when, on my first visit to New Ulm, I saw a number of his paintings and photographs at the BCHS museum as well as a beautifully done video, directed by Lynn Lacy, that was originally shown on PBS. As I subsequently learned, although scholars such as Rena Neumann Coen, Lyndel King, and Peter Merrill had written about Anton Gag, he was still largely regarded as a minor provincial history painter, notable only for a few paintings of the Dakota Conflict of 1862 and as the father of Wanda Gág.

In April 1996 I met Gary Harm, son of Stella Gag Harm (the second of Anton and Elizabeth's seven children), who responded warmly to my inquiries about further research into his grandfather's life and work. Gary and his wife, Dolly, provided information, numerous materials, and support. But my project was galvanized when, in the fall of 1997, I met Robert J. Paulson, founder of the German-Bohemian Society in St. Paul and an accomplished genealogical researcher. Bob had uncovered information about Anton Gag's birth, which took place in Walk

(Valcha) in the county of Tachau (Tachov), Bohemia, on June 12, 1858, rather than in Neustadtl bei Haid (Bor) in 1859, as had been thought. Bob was also well on his way to discovering that Anton spent several years in St. Paul, Minnesota, after arriving in America in 1873, rather than going directly to New Ulm. His research in census records and city directories at the Minnesota Historical Society (MHS) to learn about Anton's years in St. Paul put a very different light on the artist's development in the crucial years between ages fifteen and twenty. Bob's documents and photographs as well as his continued research in the MHS archives were crucial contributions to "Anton Gag, Bohemian," published in the fall 1999 issue of MHS's *Minnesota History*.

The new emphasis on Anton Gag's German-Bohemian heritage in that article fostered thoughts about writing a family history. It was Gary Harm's suggestion that I write a triple biography of Anton, Wanda, and Flavia, for which he gave me access to Flavia's unpublished diaries and other family papers. With the help of Bob Paulson, who continued to research the Gags in Germany, the Czech Republic, and Austria as well as in St. Paul, I embarked on the monumental task of gathering and assimilating materials relating to these three very different figures whose lives spanned more than a century. Like all students of Wanda Gág, I owe a tremendous debt to Audur H. Winnan for her elegant 1993 catalogue raisonée of the prints. Winnan's book also includes liberal extracts from Wanda's numerous diaries, housed in the Department of Special Collections, Van Pelt-Dietrich Library Center, University of Pennsylvania, which had been closed to the public before March 1993. My own further research into the

diaries was greatly aided by Maggie Kruesi and other members of the Special Collections staff. I am also very grateful to Karen Nelson Hoyle, curator of the Children's Literature Research Collections (CLRC) at the University of Minnesota, Minneapolis, and author of *Wanda Gág* (1994), a study of her books for children that was another invaluable resource. Dr. Hoyle and her exemplary staff, particularly Jenny Hanson, guided me through the CLRC's treasures with patience and enthusiasm. At the Minnesota Historical Society I particularly thank Thomas O'Sullivan, former curator of art, and Anne R. Kaplan and Marilyn Ziebarth, editors of *Minnesota History*, for their help and guidance. Mary Beth Frasczak and Kathy Heuer, librarians at the College of Visual Arts, St. Paul, also have my gratitude for their enterprise in providing information.

Many of the images in this book come from the collections of Gary Harm, Barbara Jean Treat, the BCHS, the CLRC, and the MHS, and I am grateful to them all for their generosity. A number of prints by Wanda Gág are reproduced here by permission of the Minneapolis Institute of Arts; I thank DeAnn Dankowski and Lisa Michaux for their assistance. I am also grateful to the Art Institute of Chicago, the Memphis Brooks Museum of Art, Memphis, Tennessee, and the Philadelphia Museum of Art for additional images.

Above all, I thank my associates in this task:

Darla Gebhard, who spent numerous days with me in New Ulm, answering questions and running down information with tireless enthusiasm; Allan R. Gebhard, who laid the foundations for research on Anton Gag with his historical recall of articles in Brown County newspapers and who took many superb photographs for this book; and Bob Paulson, whose contributions to this volume include not only documents, photographs, and enterprising research but also an insider's knowledge of a national tradition about which, in the beginning, I knew little. As always, I am indebted to Gabriel P. Weisberg, Professor of Art History, University of Minnesota, my advisor for doctoral studies and mentor in archival research. I appreciate his sagacious counsel on this manuscript. Darla Gebhard and Bob Paulson also read the manuscript at various stages and offered valuable corrections and advice, although any errors that remain are, of course, mine.

The College of Visual Arts generously provided financial support for this project through faculty development funds. I also want to thank my husband, Norm, and his son, Andrew, for their patience and forbearance during my long months of work. The book would not have been possible without the splendid cooperation and support of Gary and Dolly Harm. Finally, I wish to thank Patricia Johnston of the Afton Historical Society Press and her staff as well as Phil Freshman, my conscientious editor, for bringing this book to fruition.

J. L.

Gag Family Chronology

Note to the Reader:

The family name, spelled Gaag in Bohemia, was changed to Gag after the family arrived in America in 1873. After she moved to New York City in 1917, Wanda began spelling her surname with various diacritical marks (Gäg, G'ag, and Gág) to encourage pronunciation with a broad "a" rather than a short one; she settled on Gág around 1925. Flavia followed suit, as did several of the other siblings. In this book, the Gág spelling is used for all the siblings as adults but is not applied retrospectively to their parents, Anton and Lissi.

1858 Birth of Anton Gag, Walk, Bohemia, June 13.

1872 Anton's elder sister Anna immigrates to America.

1873 Anton and his family—parents Georg and Theresia, sister Margaretha and husband Vincenz Klaus, and brother Joseph—immigrate to America, disembarking in Baltimore May 30 and settling first in St. Paul.

1874 Joseph and Anton Gag live at Eagle and Franklin Streets, St. Paul.

1876 Georg and Theresia Gag buy a house on the Immelberg, a hill on the outskirts of New Ulm, Minnesota, July 31.

1877 Georg Gag killed while digging a well on the Immelberg property, November 24.

1879 Anton Gag moves to New Ulm. Does decorative work for August Schell.

1880 Anton attends art schools in Chicago and Milwaukee.

1883 Anton opens photography studio with J. B. Vellikanje, May.

1885 Gag and Amme photography studio opens, April.

1886 Anton Gag marries Ida Berndt (b. 1864, New Ulm), May 4.

1887 Anton begins *Attack on New Ulm during the Sioux Outbreak, August 19–23rd, 1862*, January (completed 1904).
Anton becomes sole proprietor of photography studio, May.
Death of Ida Berndt Gag, June 21.
Death of infant daughter, Antonia, July 27.

1888 Elizabeth (Lissi) Biebl (b. 1869, Harrisburg, Pennsylvania) becomes Anton Gag's photography studio assistant (date approximate).

1890 Anton designs bas relief for Defenders' Monument, New Ulm, January.
Anton opens an art school with Christian Heller and Alexander Schwendinger (date approximate).

1891 Anton travels to Battle Creek, Michigan, for treatment of neurasthenia.
Anton begins work on Dakota Conflict panorama with Heller and Schwendinger (completed 1893).

1892 Anton Gag marries Lissi Biebl, May 16.

1893 Birth of Anton and Lissi's first child, Wanda Hazel, March 11.

1894 Birth of Stella Lona Gag, October 24.

CHRONOLOGY

1895 Anton enters business of decorating houses and churches.

1896 Anton reenters photography business in partnership with Albert Meyer, November.

1897 Birth of Thusnelda Blondine Gag (called Nelda or Tussie), April 4.

1898 Gag, Heller, and Schwendinger complete mural cycle, St. Patrick's Church, West Albany, Minn.
Death of Anton's mother, Theresia Heller Gag, October 9.

1899 Birth of Asta Theopolis Gag, July 22.

1900 Birth of Dehli Maryland Gag (called Dale or Dell), December 4.

1901 Gag, Heller, and Schwendinger create drop curtain for new Turner Hall theater and
begin an extensive decorative program (completed 1906).
Gag and Heller restore and add to murals in Turner Hall rathskeller, June.

1902 Birth of Howard Anthony Jerome Gag, December 13.

1903 Gag, Heller, and Schwendinger complete interior decoration of Cathedral of the Holy Trinity, New Ulm.

1906 Both Gag and Heller diagnosed with "occupational tuberculosis."
Anton travels briefly to Oregon in search of a cure.

1907 Birth of Flavia Betti Salome Gag (called Flopsy or Flops), May 24.

1908 Anton seeks medical treatment in St. Paul, April and early May.
Death of Anton Gag, New Ulm, May 22.
Death of Christian Heller, Youngstown, Ohio, September.
Wanda Gag begins record of family finances that develops into a diary, October.

1909 Drawings by Wanda, Stella, and Nelda published in *Journal Junior*, a *Minneapolis Journal* supplement.

1910 Minnesota State Art Society exhibition, New Ulm, includes works by both Anton and
Wanda Gag, April.
Wanda wins bronze medal in St. Paul Institute of Art drawing contest, July.

1912 Wanda graduates from New Ulm High School, June.
Wanda teaches at a rural school in Bashaw Township, near Springfield, Minnesota, November–May.
Death of grandfather Joseph Biebl, April 3.

1913 During University Week in New Ulm, Wanda meets Edgar Hermann of Minneapolis, June.
Wanda attends St. Paul School of Art, September–June.

1914 Wanda takes a job in a St. Paul design firm, Buckbee Mears, autumn.
Wanda enters Minneapolis School of Art, December 7.

1915 Wanda begins friendship with Adolf Dehn (b. 1895, Waterville, Minnesota).

1916 Death of grandmother Magdalena Biebl, August 3.

1917 Death of Lissi Gag, January 31.

Wanda Gag and Adolf Dehn win scholarships to Art Students League, New York. Wanda graduates from Minneapolis School of Art, June.

Wanda illustrates Jean Sherwood Rankin's *A Child's Book of Folklore: Mechanics of Written English*.

Wanda arrives in New York City, late September. Enrolls at Art Students League.

1918 Wanda makes her first prints at Art Students League. Returns to New Ulm for summer.

Adolf Dehn inducted into U.S. Army, July. At boot camp in Spartanburg, South Carolina, meets Earle Humphreys (b. 1892, Philadelphia).

Stella, Nelda, Asta, Dehli, Howard, and Flavia move to Minneapolis.

Wanda returns to New York to concentrate on commercial art, November. Begins painting lampshades and living in the workroom on West 58th Street that month. Rooms with Lucile Lundquist, beginning December.

1919 Wanda begins having success in commercial art field with advertisements for Majic Dye Flakes, November.

1920 Wanda, Lucile Lundquist, and Violet Karland move to 527 East 78th Street, New York, January.

Adolf Dehn introduces Wanda to George Miller, Boardman Robinson, and Carl Zigrosser.

1921 Wanda does fashion drawings for Gimbel Brothers and other department stores.

Wanda forms Happiwork Company with Janet and Ralph Aiken, working with them at their country home in Ridgefield, Connecticut, and staying at their guest house, Tophole.

Wanda contributes drawings to *The Broom* and *The Liberator*.

Wanda begins affair with Earle Humphreys, November.

1922 Wanda spends time at Tophole working on Happiwork and reconnecting with nature, summer.

Nelda Gag moves to New York City, December.

1923 Wanda exhibits with William Gropper at East 96th Street branch of New York Public Library, February 15–April 1.

Wanda stays at Tophole, April–October.

Asta Gag marries Herbert Treat, June 16.

Stella Gag marries William Harm, Minneapolis, August 18.

Happiwork Company fails.

1924 Wanda rents house in Chidlow, Connecticut, with Earle Humphreys, summer and fall.

Asta moves to New York City.

1925 Wanda rents house near Glen Gardner, New Jersey, called Tumble Timbers. Begins most productive printmaking period.

Carl Zigrosser buys Wanda's drawings on consignment; several exhibited and sold, summer.

Wanda adopts diacritical mark for her last name (Gág) (date approximate).

1926 Dehli and Flavia Gág move to New York City, spring. Howard Gág follows in fall.

Nelda, Asta, Dehli, and Flavia move into Wanda's apartment at 527 East 78th Street. Wanda moves to a new apartment at 1061 Madison Avenue.

Wanda has her first solo exhibition, Weyhe Gallery, New York, November 1–20.

1927 Wanda's lithograph *Elevated Station* (1926) selected as one of Fifty Prints of the Year by American Institute of Graphic Arts.

Wanda's essay "A Hotbed of Feminists" published in *The Nation*, June 22.

1928 Wanda's second one-person exhibition at Weyhe Gallery, March 19–31.

Ernestine Evans, editor at Coward-McCann, solicits a children's book manuscript from Wanda; the result is *Millions of Cats*.

Flavia begins a detailed diary, August.

1929 Wanda hires Flavia to type her diaries from 1908 to 1917.

A song written by Flavia is played at Roseland dance hall, New York, September 11.

Flavia goes to Minneapolis in late September to help Stella Gág Harm after birth of her child (Gary, b. November 19).

Wanda's *The Funny Thing* published, fall.

Wanda tours Midwest to promote *The Funny Thing*. Visits Minneapolis and New Ulm, late November.

1930 Wanda's third one-person exhibition at Weyhe Gallery, January 13–February 1.

Flavia suffers a serious breakdown in Minneapolis and stays in New Ulm for six weeks, February–March.

Flavia, Dehli, and Alma Schmidt share Wanda's apartment at 1061 Madison Avenue.

1931 Wanda and Earle buy a farm near New Milford, New Jersey, May; it comes to be called All Creation.

Wanda begins spending summers at All Creation and winters at a small apartment-studio in New York.

Flavia, Dehli, and Asta publish *Sue Sew-and-Sew*.

1932 Wanda begins affair with Hugh Darby that lasts about five years.

1933 Wanda's *The ABC Bunny* published.

1934 Wanda spends winter doing nature studies and other "abstract research work."

1935 Wanda's *Gone Is Gone* published.

Wanda begins work on "Childhood Reminiscences," focusing on the years before 1908.

1936 Flavia publishes a children's songbook, *Sing a Song of Seasons*.

Nelda Gág Stewart nearly dies from septicemia but is saved by an experimental sulfa drug, May.

Wanda's *Tales from Grimm* published.

Tyler McWhorter organizes a touring Gág family exhibition that includes works by Anton and his seven children.

1937 Flavia briefly attends Art Students League, New York, March–April.

Wanda continues experiments in oil painting.

1938 Wanda's *Snow White and the Seven Dwarfs* published.

Wanda serves on juries for Philadelphia Art Alliance and American Artists Congress.

1939 Wanda serves on New York World's Fair juries; two of her works shown in the exhibition *American Art Today* at the fair.

Wanda's work is included in the exhibition *Art in Our Time*, Museum of Modern Art, New York.

Wanda's essay "I Like Fairy Tales" published in *Horn Book* magazine, March–April.

Asta Gág Treat gives birth to a girl, Barbara Jean, October 31.

1940 Wanda's *Growing Pains: Diaries and Drawings for the Years 1908–1917* published.

Wanda goes on a book tour to Boston and the Midwest, ending in Minneapolis, November.

Retrospective exhibition of Wanda's work at Weyhe Gallery, October 21–31.

Wanda's *Nothing at All* published.

1942 Wanda represented in the exhibition *Artists for Victory*, Metropolitan Museum of Art, New York, December.

Howard Gág takes a job with Sinclair Oil Company to secure a draft deferment.

1943 Wanda's *Three Gay Tales from Grimm* published.

Wanda and Earle Humphreys married, New York, August 27.

1944 American Association of University Women sponsors the exhibition *Wanda Gág: Prints and Books*, which travels to twenty-three American cities.

1945 Wanda has exploratory surgery that reveals lung cancer, March.

Alma Schmidt Scott visits All Creation to gather material for a biography of Wanda, summer.

Wanda and Earle depart for Florida, December 24.

1946 Wanda and Earle travel through Florida by car, returning to All Creation in May.

Death of Wanda Gág, New York, June 27.

Memorial exhibitions for Wanda held at Minneapolis Institute of Arts, Philadelphia Museum of Art, and New York Public Library.

Flavia begins working as a children's book illustrator.

1947 Wanda's *More Tales from Grimm*, completed by Flavia Gág, published.

1949 Alma Scott's *Wanda Gág: The Story of an Artist* published.

1950 Death of Earle Humphreys, New Jersey, April 18.

Howard Gág marries Ida Rubin.

1952 Flavia's first children's book, *Four Legs and a Tail*, published.

1954 Stella and William Harm move from Minneapolis to Lake Como, Florida.

1958 Flavia moves to Lake Como, Florida, January.

Flavia's autobiographical story, *A Wish for Mimi*, published.

Death of Dehli Gág Janssen, New York, May 5.

1960s Flavia continues producing books and illustrations for the juvenile market and does water color landscapes and flower paintings. She also composes, including rock and roll songs.

1961 Death of Howard Gág, November 11.

1962 Death of Stella Gág Harm, Lake Como, Florida, March 26.

1973 Death of Nelda Gág Stewart, Congers, New York, November 16.

1977 Flavia accepts Kerlan Award, given posthumously to Wanda Gág, University of Minnesota, Minneapolis, June.

1978 Death of Flavia Gág, Crescent City, Florida, October 12.

1987 Death of Asta Gág Treat, Teaneck, New Jersey, July 13.

Introduction

During the nineteenth century, the term *Bohemian* became synonymous with the word *artist*. First popularized by Henri Murger's novel *Scènes de la vie bohème* (1847–49), it came to suggest a way of life characterized by irresponsibility, poverty, and devil-may-care behavior on the edge of respectable society.[1] In some ways, Anton Gag (1858–1908) might have been a character in Murger's book or even in the opera based on it, Giacomo Puccini's enduringly popular *La Bohème* (1896). Anton had a fine tenor voice and played several instruments. He was handsome and sensitive-looking and attractive to women, had two beautiful wives, and was involved in at least one scandalous love affair. Also, he was chronically poor. But Gag was Bohemian in the original sense of the word, having been born in the village of Walk, Bohemia. It may be that he lived the irresponsible "Bohemian" life for a few years after immigrating to America in 1873, but he undertook and honored serious responsibilities in his adult years. Anton Gag was Bohemian in a more profound sense than the popular stereotype. He was steeped in the German-Bohemian tradition, in which art is rooted in love of nature, devotion to family, and the integration of art and life.

Anton Gag took up life in New Ulm, Minnesota, about 1879. Founded in 1854 and largely a frontier town when Anton moved there, New Ulm even today retains a strong German and German-Bohemian character. By choosing to settle there rather than in St. Paul, he remained in a deeply German culture. Although he no doubt learned enough English to get along in business, he spoke German to friends and family until the end of his life. Along with other immigrants, he tried to build a life like the one he had known in the Old Country rather than assimilate to new ways. The house he built on North Washington Street and the life he led there with his family also reveal much about the values of German-Bohemian people.

Two of his children became professional artists (although all seven had notable artistic and musical talent). The eldest, Wanda Hazel Gág (1893–1946), is the best known. She was designated her father's heir by means of his stirring deathbed injunction—to finish what he had begun—that shaped her subsequent career. She left Minnesota at twenty-three and made her reputation in New York as a printmaker and children's book illustrator. Her work, however, drew its substance and style from the German-

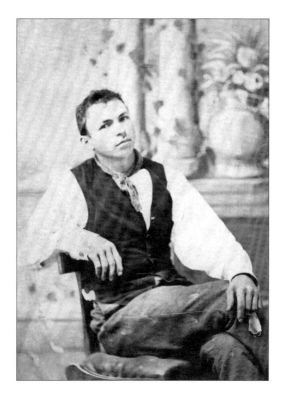

1. ANTON GAG, C. 1885.

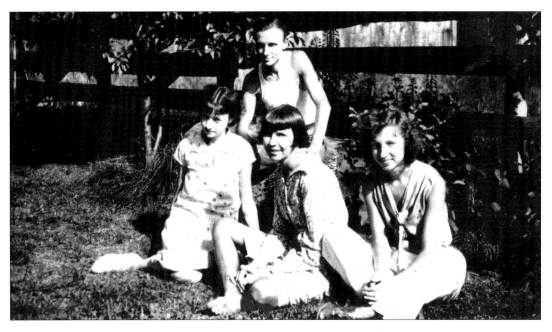

2. LEFT TO RIGHT: DEHLI, WANDA, FLAVIA, AND HOWARD GÁG AT CREAM HILL,
WEST CORNWALL, CONNECTICUT, SUMMER 1930.

Bohemian tradition more overtly than her father's had done. The life she forged on a farm near New Milford, New Jersey (called All Creation), bore a strong resemblance to the one she had led in New Ulm and, in turn, to Bohemia. The ménage at All Creation included her younger siblings Howard and Flavia.

Flavia Gág (1907–1978), the youngest of the seven siblings orphaned when their mother died in 1917, grew up in a poverty that was sometimes dire yet maintained an intense desire to develop her artistic and musical gifts. This book draws upon her extensive unpublished diaries, which picture life for a "young modern" in the New York of the late 1920s and during the Great Depression and also give a new point of view on Wanda's private life. Steered firmly by Wanda into the writing of children's books as a dependable source of income, Flavia continued composing music and painting watercolor landscapes. Her prolific work as a writer, illustrator, and painter deserves attention as part of this story of a remarkable family.

As suggested, an important theme of this study is the German-Bohemian tradition. Treatments of Anton Gag as an artist have tended to stress his lack of formal training and isolation in New Ulm, and to categorize him as a provincial Impressionist forced by family responsibilities to work as an artistic jack-of-all-trades. Yet an understanding of his background and formative influences allows us to see Anton in another light, as a German-Bohemian artist who responded to nature in a variety of mediums—easel painting, photography, decorative work, and music—while retaining the solid practicality of the Old World peasant, working hard and finding his riches in family life.

More broadly, Anton Gag fits into the venerable European tradition of the "jobbing painter," the versatile craftsman who works to create beautiful, harmonious environments. Gag's French contemporary Pierre-Auguste Renoir was another such artist, executing decorative commissions for friends and patrons even after making his mark as an Impressionist painter, always taking great pride in his roots in the

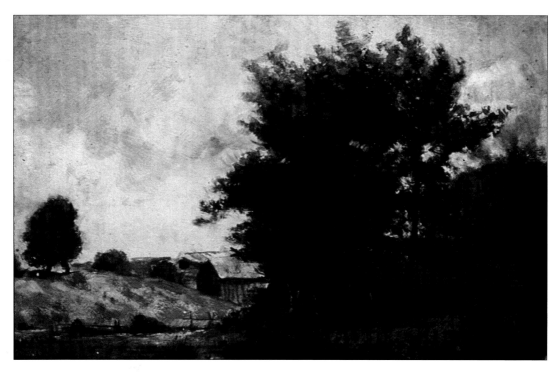

3. ANTON GAG, *REDSTONE* (NEW ULM LANDSCAPE), C. 1890, 3 7/8 X 6 3/4 IN.
MINNESOTA HISTORICAL SOCIETY.

workmanlike traditions of his birthplace, Limoges.[2] This same decorative tradition (often linked to the eighteenth-century Rococo) was a key element in art nouveau, the eclectic style typified by sinuous lines and foliate forms that became fashionable in the 1890s. Yet Gag was less concerned with innovation or fashion than with truth and poetic feeling for nature, which link him to nineteenth-century Romanticism. This romantic tradition and its conservative academic methods were still central to German-Bohemian art in the late nineteenth century and even into the twentieth, as can be seen in the work of Gag's contemporary in Bohemia, the landscapist Jan Prousek (1857–1914). Bohemian artists such as Prousek saw art as a means of exploring and expressing cultural ideals; unlike their counterparts in Paris at the time, they had little interest in the exploration of form.[3]

Anton's daughter Wanda maintained this romantic Bohemian creed. In her case it meant cultivating her individuality and freedom from the academic mold, as well as from the slick artificialities of commercial art. Nature, for Wanda, was often approached by way of sex, which offered a deep rhythmic intensity that characterized her mature style. Also a gifted writer, she could articulate the frisson before nature that Anton undoubtedly felt but seems rarely to have put into words. Like Anton, Wanda showed little interest in new styles per se, as seen in her derisive reaction to Cubist experiments by Nathaniel Pousette-Dart, a former teacher at the St. Paul School of Art: as "the most well-known superficial, obvious modern tendencies. . . . I hope my emancipation will take a different form than that. What is the use of doing those things without adding to the present store of emotions and formal discoveries?"[4]

In the first half of the twentieth century, art historians tended to look for "progress" in art based on innovations in style. Alfred H. Barr, Jr.,

founding director of the Museum of Modern Art in New York, literally diagrammed the development of modern art in such terms.[5] Later art historians have questioned this emphasis on innovation. Feminist art historians in particular have discarded "originality" as the criterion for great art and replaced it with broader values, much like those humanistic ones at the core of Wanda Gág's art. Selma Kraft, for example, declared that women tend to see art as "connection" and are thus not likely to make the abrupt breaks with tradition that innovation requires. Besides, Kraft adds, the pursuit of originality involves the loss of "the richness of meaning and social context found in women's art."[6] Revisionist art historians also question unspoken assumptions about what constitutes "great art" and the customary distinctions between "high" and "low" art.[7] In this light, such enterprises of Anton Gag as his decoration of houses and his portrait photography can be valued as creative work. Also, Wanda Gág's prints and children's books can be considered with the care formerly reserved for traditional "fine art."

There is a place for Flavia Gág in this wider scheme. Her children's books broke no new ground but partook of the same spirit of delight in nature and family as Wanda's. Her exacting craftsmanship mirrors that of both her sister and her father. Moreover, she achieved Wanda's wish for *her*: that she earn a living by making books. Flavia also explored the watercolor medium, producing numerous sensitive and beautiful images that are only now receiving critical attention. Whereas Wanda looked for passion, Flavia—whose gifts were in a lower key—looked for romance. She remained a true Bohemian, pursuing love and creative fulfillment rather than respectability or other conventional reward.

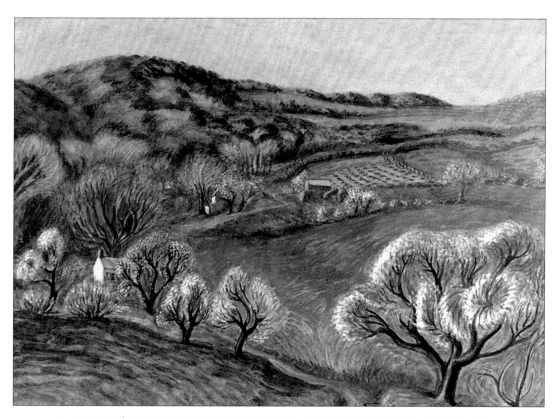

4. WANDA GÁG, *SPRING ON THE HILLSIDE*, N.D., PASTEL ON SANDPAPER, 13 1/2 x 18 IN. PRIVATE COLLECTION.

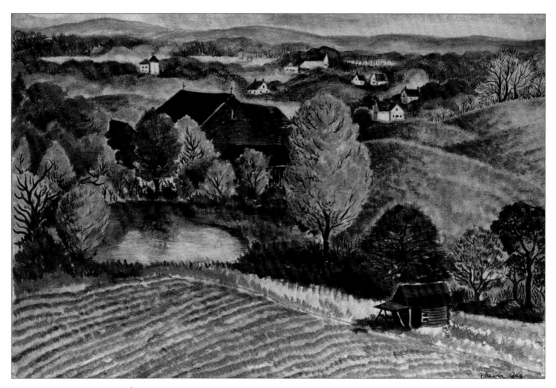

5. FLAVIA GÁG, *FALL FARM SCENE*, N.D., PASTEL, 14 x 16 IN. PRIVATE COLLECTION.

Another important theme of this book is the role of the family in art. So influential is the image of the artist as an individual driven by genius that we tend to forget that, before the seventeenth century, art was almost always a family business. Until the twentieth century, virtually all prominent women artists were the daughters or wives of artists.[8] A sound case can be made for the proposition that Wanda Gág became an artist because her father was an artist. A major goal of the present study is to show how the family—its economic circumstances, its emotional dynamics, and its traditions—fostered these artists' vocation and shaped their art.

The story of the Gag family involves a significant cultural journey from Bohemia to the American Midwest to New York and beyond. (That journey, by the way, is signified by the change in the spelling of the surname from Gaag in Bohemia to the anglicized Gag after the family arrived in America to the more

Slavic Gág, adopted by Wanda about 1925 to promote the proper pronunciation, which is with a broad "a.") A major challenge in writing about the several generations of Gags is the marked difference in the kinds of sources available for each. Research in Bohemia (now part of the Czech Republic) yields little more than contracts and deeds. Anton Gag left few papers, and the student is obliged to construct a portrait of him through the scattered, often fragmentary reminiscences of his children and through histories of the period. By contrast, Wanda and Flavia Gág were compulsive diarists and letter writers: here the student is deluged with day-to-day first-person accounts. Yet personalities do emerge and objective circumstances take shape. The rich visual record in photographs, paintings, and drawings also helps link the generations as they move through more than a century of American history, making art and music in a family tradition that has much to teach us about the sources of art.

1 IN THE BÖHMERWALD
1858 – 1873

The love of nature is a leitmotif running through the lives of Anton Gag and his children, who seemed to feel that they were most themselves when they were out among the hills and the trees. To understand this fundamental fact one must know that the family had its roots in Bohemia (then a province of the Austrian Empire and now part of the Czech Republic). As a peasant boy, Anton Gag looked after a herd of cows in the Böhmerwald, or Bohemian Forest, outside his home village of Walk (now Valcha). He carved wood to pass the time and recalled carving figures of the Madonna to place in hollowed-out shrines in trees.[1] Walking to the *Volksschule* (elementary school), he followed a path along the brook at the edge of the forest to the larger town of Pernartitz (now Bernartice) (figs. 1 and 2). In school he learned formal German, while at home and in the community he spoke a dialect of German called Böhmisch. The school also taught music, so that Anton, who had a fine tenor voice, had the opportunity to study voice

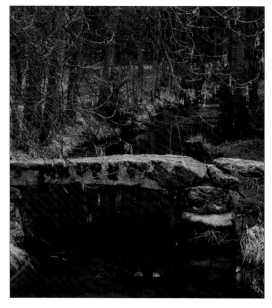

1. THE BROOK AND BRIDGE IN
WALK, BOHEMIA.

as well as violin and piano, instruments he later played with ease. Throughout his life he sang the "Böhmerwald lied," a romantic song that exalts these forests and hills.

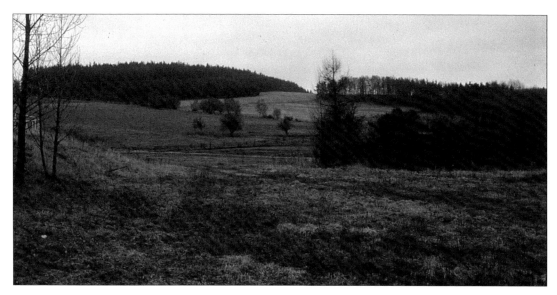

2. HILLS OF PERNARTITZ, BOHEMIA.

The *"Böhmerwald lied"*:
There deep in the Böhmerwald lies my homeland.
It is indeed very long ago that I went away from there.
But the memories that stay with me ensure
That I will never forget the Böhmerwald.

O lovely childhood, take me back once more,
Where I delighted in playing, that supreme happiness.
Where I stood in the green meadow by my father's house
And looked far out over my fatherland.

Just once more, O Lord, let me see the homeland,
The beautiful Böhmerwald, the valleys and the hills.
For I would gladly go back and call out joyfully,
"Bless you, Böhmerwald, I am staying home."

Refrain:
It was in the Böhmerwald, where my birthplace stood;
In the beautiful green Böhmerwald.
It was in the Böhmerwald, where my birthplace stood;
In the beautiful green Böhmerwald.

The Böhmerwald has more significance still. In a broad sense, it shaped the German-Bohemian mind and imagination, its dark mystery constituting the source of fairy tales, superstitions, and a sense of clannishness.[2] The Böhmerwald, which divides Bohemia from Bavaria, can even be said to be the central symbol of German-Bohemian romantic nationalism. This national identity has not always been clear.[3] The German-Bohemians were a border people with strong linguistic and cultural ties to the German states, kinship with Czech folk culture, and political ties to the Austrian Empire. Yet despite this mix of influences, they maintained a strong, if largely unarticulated identity that expressed itself through strong family ties, responsible citizenship, and a distinctive approach to the arts.

Anton Gag was born on June 13, 1858, in Walk, county of Tachau (now Tachov). The earliest photograph of him, taken when he was about twelve, shows a slender, serious-looking youth (fig. 3). He sits beside his father, Georg Gaag

(as the name was spelled in Bohemia), who was born in 1817 in the same county and was a *Zimmermeister* (master carpenter). Anton's mother, Theresia Heller Gaag, born in Walk in 1821, is seated on Georg's left. The daughter of a sheepherder, she has broad peasant features, is dressed plainly, and wears a kerchief. Standing is Anton's sister Margaretha, who was thirteen years older than he and who never manifested the sort of sensitivity that characterized him from his youth; it is unlikely that they were close. The Gaags had three other children: Anna, born in 1847; Joseph, born in 1852; and Kaspar, who was born in 1849 but died in 1856, before Anton's birth.

As far as we know, Anton never wrote about his life, but he did tell the occasional story. For instance, he told Wanda of how he once borrowed a knife from his father but somehow broke it. Afraid to confess the accident, he hid in the barn. But he cut his foot on a plow, and

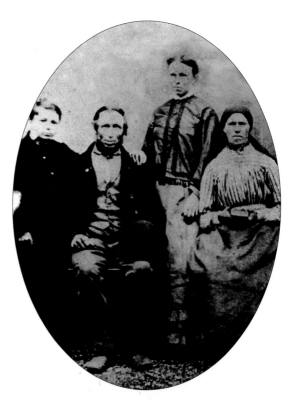

3. LEFT TO RIGHT: ANTON, GEORG, MARGARETHA, AND THERESIA GAAG IN BOHEMIA, C. 1870.

4. CHURCH OF SAINTS PETER AND PAUL, PERNARTITZ, BOHEMIA.

when it became infected, Georg Gaag was so frightened that he did not punish his son.[4] It would not be the last time Anton would get in trouble, but he was not a troublemaker. Rather, he would be known as he matured for his integrity and strong sense of honor.

Another incident that sheds light on Anton Gag's character relates to priests in Bohemia. He and his family attended the Catholic Church of Saints Peter and Paul in Pernartitz, an imposing structure with an ornate Rococo interior (figs. 4 and 5). It seems he was angered by certain questions the priests asked him—what the questions were he did not say—and from then on he rejected clerical authority, declaring that each person must answer the important questions for himself.[5] The ethical core of the Church's teachings would remain with Anton, but he would reject its theology.

Anton Gag was later described as an "artist to his fingertips," and it is evident that this

vocation manifested itself when he was a boy. He had a passion for drawing, although he had little in the way of pencils or paper and often used pieces of coal on wood. He did have a prized paintbox and chose to hoard his pfennigs for paints rather than squander them on fun with his friends. His parents did not think his abilities out of the ordinary—he developed

5. INTERIOR DETAIL, CHURCH OF SAINTS PETER AND PAUL, PERNARTITZ.

a poignant sense of not being understood—but there is no evidence that they opposed his desire to be an artist.

Walk was a picturesque hamlet of only about fifteen houses at the time of Anton's birth. Most of the dwellings were made of stone; in the Böhmerwald, which produced mostly softwoods such as evergreens, birch, and beech, wood was used for large roof overhangs and balconies, fences, and ornamental gates. It also was used for furniture and carriages. All these accoutrements were elaborately carved and painted. A custom that points up the importance of the wood-carving tradition in Bohemia is that of the *Totenbretter* (death board), on which corpses were laid in the household for three days before burial. Such boards were then placed at crossroads or in the fields, so that even in the midst of their daily lives the peasants might not forget their dead.[6]

The houses of Anton's village were clustered closely together around a mill.[7] Each family's land extended behind the house in a long, narrow strip (a holdover from medieval times, when land was plowed by teams of oxen, which were difficult to turn around). Like other families, the Gaags sought to raise as much of their own food as possible. Peasants such as the Gaags also often engaged in cottage industries to make extra money and further promote the self-sufficiency of the village. (It was rarely necessary to travel to another town simply to buy goods.) They thus plied supplementary trades as blacksmiths, harness makers, carpenters, weavers, or shoemakers. German-Bohemians also specialized in making linen and lace. Georg Gaag did ornamental wood carving in addition to his other pursuits.

Meanwhile, everyone, including children, had farming duties. Bohemians valued work and

took much pleasure in it—*Arbeit macht das Leben süss* (Work makes life sweet), according to one old German saying.[8] Nevertheless, farmwork was hard: tools were primitive, and much field and orchard labor was done by hand. The climate in this forested region is mild, yet the farmer's lot in every climate is uncertain, and the border region was subject to occasional extremes of weather, including droughts and floods.

Bohemian farmers knew something of the science of farming: they rotated the crops and fertilized them with manure, which was highly valued and kept in piles near the house. But they also sought to use religious faith—and various superstitions—to influence weather and promote fertility of the land. Seasonal festivities of the German Catholic Church—Epiphany, Lent, Easter, Pentecost, All Saints' Day, and the climax of the year, Christmas—retained strong pagan elements, as they did in many other folk cultures. For example, at Pentecost the Bohemians staged *Pfingstreiten*, a procession to bless the fields. The Feast of St. John on June 25 coincided with the summer solstice and was celebrated with bonfires and the ritual burning of a scarecrow to promote a good harvest. The central revelry of the year was the few weeks before Lent, called *Fasching*, which brought a series of dances accompanied by the village band and all sorts of organized foolishness in accord with the Bohemian love of merriment. On *Tolldonnerstag* (Crazy Thursday), for instance, young men wore straw costumes like grainstacks and young women parodied sowing and reaping and the otherwise all-too-serious business of farming.[9]

The house in Walk where Anton grew up represented a considerable comedown in the Gaags' worldly fortunes.[10] The family has

been traced back to the mid-eighteenth century, when they were peasant farmers in Heiligenkreuz, a German-speaking village in the foothills of the Bohemian Forest.[11] At that point, the Gaags were serfs and thus bound to the land, unable to move freely or even marry without permission from the regional lord. They owed this landlord not only rent but also labor service, which had to be performed before they could tend the crops for their own maintenance.[12] After reforms in 1781, however, peasants were allowed a good deal more personal freedom: they could move freely, marry, and even leave the land to study for another occupation without receiving permission. They could also actually buy land, although it still carried obligations for taxes and manorial labor.

The Gaag farm in Heiligenkreutz was a substantial one with about thirty-five acres of arable land. When Georg Gaag senior, Anton's

paternal grandfather, bought the farm in 1808, he incurred heavy obligations to make payments to his siblings as well as provide support for his parents (the so-called grandfather's pension, part of the strong Bohemian system of community support). But the house was big: peasant farmhouses in Bohemia were usually quite large, ranging up to 100 feet long, with three stories to accommodate the extended family, farm animals, and sometimes even the former owner of the farm (fig. 6).[13] The farm also came with accessories enumerated in the contract: a year-old calf, a plow, a harrow, a grain crusher, an axe, two saws, a manure form, a horseradish hoe, and other such specialized equipment to be used in the raising and harvesting of rye, wheat, barley, and potatoes.

Anton's father, the junior Georg Gaag, was born on this farm (fig. 7). By 1838 Georg Gaag senior had increased the size and value of the

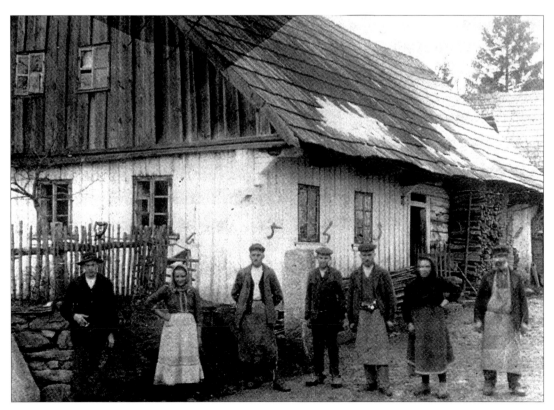

6. GERMAN-BOHEMIAN FARMSTEAD, C. 1905.

property; nevertheless, he sold it that year and moved to Dehenten, a much smaller village fifteen miles away.[14] The purchaser of the Dehenten property was not the father, though, but the son, then twenty-one years old and a soldier in the sapper corps of the imperial army. The Gaags seem to have traded down (a common method of getting out of debt), for the new farm was less than half the size of the one in Heiligenkreutz. But it had better equipment and accessories, and the grandfather's pension alloted to Georg senior and his wife, Maria, was better than the arrangement for his parents had been, suggesting that the move was a wise one, promising greater prosperity.

But the new farm also came with manorial duties. The younger Georg may have called himself a carpenter, but he had to provide his landlord with 182 days of manorial labor each

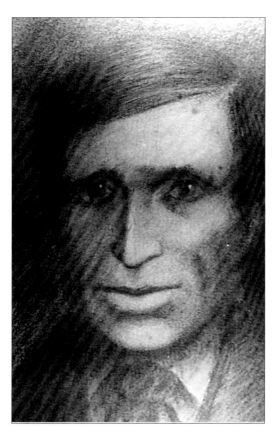

7. ANTON GAG, PORTRAIT OF GEORG GAAG, N.D., CHARCOAL, 20 x 16 IN. PRIVATE COLLECTION.

year. With taxes and additional obligations to support not only his parents but also Anton Fischer, who had sold him the farm, Georg could scarcely make a living for himself. Five years later he sold the farm and all its accessories at a considerable loss.

Georg, by then twenty-six, immediately paid half the proceeds to Theresia Heller, the daughter of Joseph Heller, a *Hausler* (cottager) in the nearby village of Walk, as part of their marriage contract (fig. 8). In return, she provided him with a cottage in Walk, which was even smaller than the one in Dehenten. The couple wed on June 17, 1843. Whether the union was a romantic one or simply a mutually beneficial contractual arrangement we do not know, but certainly it was beneficial to both: Georg Gaag was released from his onerous obligations for the farm in Dehenten and got a place to live; and Theresia got a husband.[15] It was customary in Bohemia until the twentieth century for husbands and wives to be brought together by a *Kuppler* (marriage broker). Certain customs emphasized the fact that marriage was a merger of property, such as when the bride's family loaded its contributions to the new household onto a horse-drawn wagon and proceeded ceremoniously through the village.

Bohemian peasant weddings were colorful and prolonged. A band played its way through the village to summon the entire community to the ceremony, which took place in the bride's home. Wedding clothes were traditional folk costumes with embroidery and lace. (Brides generally wore black.) There followed a dinner and dance with an array of special food and, of course, music. Two days later guests gathered again for *Nachhochzeit*, a second day of festivities to consume the leftovers. Like *Fasching*, weddings involved satirical skits, as when the "wild wife" (played by a musician) misbehaved with a straw "baby." Nuptials that united two

villages, such as that of Georg Gaag and Theresia Heller, were especially festive. The bride's band wound through the fields to summon the groom's family and friends and pipe them to the wedding (fig. 9).[16]

The marriage of Georg and Theresia seems to have been a happy one. On May 4, 1845, their first child, Margaretha, was born. In April 1846, they moved to a larger house in Walk where four more children—Anna, Kaspar, Joseph, and, finally, Anton—would be born. The family farmed the land and tried to fulfill its manorial duties. A gardener, Vincenz Klaus, helped with the manual work.

8. THERESIA GAAG, C. 1880.

This peasant life had much to offer young Anton Gag. Beauty surrounded him in the forests and mountains, the rich craft traditions of his village, and the music that formed an essential element of village life. The Gaags' decision to leave their homeland cannot have been an easy one and was almost certainly based on economics. With the purchase of each farm, they had become poorer. In Walk, Georg Gaag still had heavy obligations attached to his land. The contract for the house where Anton

9. A VILLAGE BAND IN ANDREASBERG, NEAR KRUMMAU IN THE BOHEMIAN FOREST, LEADS A WEDDING PARTY THROUGH THE COUNTRYSIDE, N.D.

was born required that Georg and Theresia pay rent, render fifty-two days per year of manorial service to the landlord, and pay taxes to the king, the Church, and the municipality. In time the obligation for manorial duty was reduced to twenty-six days—a bad sign, since those whose property was assessed at below twenty-six days were defined as the very poor and released from manorial obligations. Thus Georg Gaag was at the borderline of poverty: as early as 1848 he could neither fulfill his labor requirements nor pay his rent. Neither could many other Bohemians, who were bedeviled by a succession of droughts and harsh winters, and who suffered, moreover, from a general economic decline in the region.[17]

Such troubles were not new: the life of the Bohemian peasant had always been a struggle for survival. An underlying theme of Bohemian folktales is the acceptance of the harshness of fate and a reliance on faith (and superstition) to maintain hope for the future. Yet the tales take delight in nature and show, despite all, a sense of fun. The deepest value expressed by the tales may well be the belief in the importance of cooperation. In them, salvation usually comes through the actions of the community rather than the exploits of an individual hero.[18]

It was, in fact, as a family that the Gaags responded to an opportunity to change their fate. In 1872 Anton's elder sister Anna emigrated to America and soon made her way to Cottonwood Township, a German-Bohemian enclave near New Ulm, Minnesota, to work as a domestic servant for the John Seifert family. The opportunity probably arose through the Seiferts' neighbors, the Peter Gag family, who were collateral relatives of the Gaags.[19] The following year, Georg and Theresia, along with Margaretha, Joseph, Anton, and the gardener, Vincenz Klaus, who had recently married Margaretha, traveled on the USS *Ohio* from

Bremen to Baltimore. A few months later they arrived at the port of St. Paul. The Gaags were following the classic pattern of chain migration, by which one family member came to America, then sent for the others.[20] We know something of their expectations: Georg Gaag planned to join a friend in Minnesota in the carriage-decoration trade. Young Anton had read about the Indians in America and wanted to paint them.[21]

The Gaags were part of a growing wave of German-Bohemians coming to America in response to efforts by New Ulm and its surrounding rural settlements in Brown County to recruit German-speaking immigrants.[22] Yet in their hearts the German-Bohemians remained in the Böhmerwald. It represented the homeland and all the beauties of nature, and it gave rise to feelings that demanded expression in art and song.

10. VIEW AT SUNSET, CHURCH OF SAINTS PETER AND PAUL, PERNARTITZ, BOHEMIA.

2 THE NEW WORLD: ST. PAUL
1873 – 1879

The Gaags arrived in St. Paul sometime late in 1873, no doubt battered by the long journey and with very little money. They might be expected to have proceeded at once to Brown County to join daughter Anna, especially since she had made good, having married Joseph Sellner, another Bohemian immigrant, in January of that year. Sellner had a farm near the Seiferts in Albin Township and in time became the most prosperous farmer in the area. Georg Gaag did head in that direction to look for land and woodworking jobs. But the rest of the family took up residence at the corner of Eagle and Franklin streets in St. Paul's rough Upper Levee neighborhood, near the river. Theresia Gag stayed with them for a time, perhaps to look after Anton, who was only fifteen, although by 1875 she was living with the Sellners in Brown County.[1] After arriving in America, the Gaags began spelling their name "Gag." Anton even went by Anthony or Tony for the first few years.

The Gags were part of a great boom in immigration to St. Paul, then still a relatively young city. It had been founded in the early 1840s as a modest settlement of shanties, named Pig's Eye for Pierre ("Pig's Eye") Parrant, owner of the best-known local landmark, a saloon. Eventually it was given a more decorous name and designated the capital of Minnesota Territory, which was growing rapidly by means of treaties with the Dakota and Ojibwe tribes.[2] Situated at the navigational head of the Mississippi River, St. Paul had a thriving steamboat traffic. By the 1870s it was the headquarters of James J. Hill's growing railroad empire and a center of wholesale trade linking the eastern and western parts of the country.[3] Known as the "Gateway to the Northwest,"

the city would grow from twelve thousand residents to more than forty-one thousand between 1870 and 1880.

Many immigrants like the Gags settled on the Upper Levee. Germans, Poles, Italians, Czechs, and Bohemians congregated in enclaves, trying to preserve their old way of life. (Bohemians were often confused with either Czechs or Germans, giving rise to a mix-up of national identity that was sorted out only in the late twentieth century).[4] Housing was cheap and close to the riverfront industries, which employed both skilled and unskilled laborers. Beer brewing was one of the most important of these industries: St. Paul offered fresh water, readily available barley and hops, and a series of natural caves as well as a large colony of Germans with the requisite skills.[5] Vincenz Klaus, now part of the Gag family through his marriage to Margaretha, found employment in this profitable industry at the City Brewery on the Upper Landing. Joseph worked as a tailor, and Anton lived at Eagle and Franklin with them.[6] Records do not specify what he did during his first years in St. Paul. He probably did not obtain more formal schooling, having spent as much time at the *Volksschule* as most peasant youths, but he would have been exposed to the English language and started learning enough to get along in this multilingual culture. It is likely that he earned money as an errand boy or a day laborer.

There were plenty of opportunities for work. St. Paul had grown dramatically since the end of the Civil War, and it was becoming so prosperous that one local chronicler, J. Fletcher Williams, could assert in 1876 that "business

1. VIEW OF MOORE'S BLOCK, SEVEN CORNERS, ST. PAUL, 1874.

was never was more flourishing; real estate buoyant; immigration increasing; employment plenty for all classes; every branch of trade and manufacture brisk." His account rhapsodizes about the city's numerous institutions which are the outgrowth of civilization and refinement, aided by wealth.[7] Even allowing for the hyperbole of boosterism, it appears that St. Paul was a dynamic city on the rise with much to offer its citizens.

The Gags lived not far from some of these outgrowths of civilization and refinement. Two blocks away was Irvine Park, a small but elegant public space created in the early 1870s that was surrounded by handsome mansions. Up the hill was Seven Corners, at that time a major commercial hub of St. Paul (fig. 1). Also nearby was the splendid Romanesque-style Assumption Church, designed by a Bavarian architect and serving a large German-speaking parish.[8] Its dedication ceremonies on October 18, 1874, drew thousands of visitors. Vincenz

and Margaretha's first son, Joseph, born in the summer of 1875, was baptized there.

But the Upper Levee itself had little in the way of civilization, much less refinement. The house at Eagle and Franklin was a shanty (the official designation for one of the exceedingly modest houses owned by slum landlords) and the neighborhood was notorious as the red light

2. ANTON GAG, EAGLE STREET, ST. PAUL, MAY 12, 1878, PENCIL, 3 1/4 x 5 1/4 IN. BROWN COUNTY HISTORICAL SOCIETY, NEW ULM, MINNESOTA.

district (fig. 2).[9] In fact, census records designated the buildings on either side of the Gags' shanty as "ladies' boarding houses," a euphemism for houses of prostitution. The streets were lined with taverns such as the notorious Bucket of Blood Saloon. Such establishments have been romanticized as a part of St. Paul's colorful past, but they were rough, unhygienic, and sometimes dangerous (fig. 3).[10] There were frequent cries for reform, as in this 1881 description of the Gags' neighborhood:

Respectable people desiring to visit the park in the cool of the evening, in order to reach it by the most direct thoroughfares, are obliged to pass these abodes of vice, in and about which are gathered the vile of both sexes. The ladies and children of the respectable households in the vicinity of the park in going up town cannot traverse these streets in the daytime without meeting offensive sights, and risking the probability of vulgar salutation; and a walk through them after nightfall is attended with the certainty of open insult and the danger of personal assault from the gangs of loafers and drunkards who infest the corners and the steps leading to Third street.[11]

Such a milieu no doubt had some fascination for a teenage boy; nor was his family necessarily shocked by the Upper Levee goings on. Scenes of taverns and prostitutes were the stock-in-trade of artist-*flaneurs* in Paris at about this time. But a set of sketches by Anton in a small commercial autograph book of the period provides little evidence that he was interested in such raw subject matter. The sketchbook's twenty-eight pencil and watercolor drawings show the city's houses, businesses, and parks as well as landscapes

3. JUENEMANN'S HOTEL AND SALOON, 904 WEST SEVENTH STREET,
UPPER LEVEE, ST. PAUL, C. 1870.

4. ANTON GAG, DEAD TREE, MARCH 31, 1878,
PENCIL, 3 1/4 x 5 1/4 IN. BROWN COUNTY
HISTORICAL SOCIETY, NEW ULM, MINNESOTA.

and such bits of nature as a dead tree (fig. 4). The only specific events he recorded were fires that destroyed the Park Place Hotel and other businesses on May 19, 1878 (fig. 6).[12]

In Bohemia, Anton had been surrounded by the decorative arts of the Bohemian folk tradition. But his experience of more formal art was probably limited to the Rococo church in Pernartitz. St. Paul, for all its frontier qualities, offered more opportunities for seeing art in the grand tradition. Attitudes toward art in St. Paul were, as elsewhere in America in the 1870s, firmly conservative. In Europe art was on the cusp of great change. In 1874 the Impressionist exhibition in Paris was the first in a series of exhibitions independent of the Salon that overturned established academic procedures and outraged the public. But St. Paul was at a safe remove from such disturbances. Like other frontier communities, it typically expected artists to record the local scene as well as to provide portraits of the citizenry, both notable personages and "types."[13]

5. ANTON GAG, SLEEPING MAN IN PARK, ST. PAUL, JULY 4, 1878, WATERCOLOR, 3 1/4 x 5 1/4 IN.
BROWN COUNTY HISTORICAL SOCIETY, NEW ULM, MINNESOTA.

6. ANTON GAG, RUIN OF THE PARK PLACE HOTEL, ST. PAUL, MAY 19, 1878, PENCIL, 3 1/4 x 5 1/4 IN. BROWN COUNTY HISTORICAL SOCIETY, NEW ULM, MINNESOTA.

There was as yet no art academy or museum in St. Paul. Artistic activity centered on commercial establishments along Third Street (now Kellogg Boulevard), a few blocks from the Gags' shanty. Here Zimmerman's and other successful photography studios served as the city's main cultural institutions, often exhibiting paintings as well as photographs (fig. 7). Anton and his brother Joseph had their photograph taken at Whitney's about 1874 (fig. 8). Third Street had yet another kind of art emporium, the book or stationery store that also exhibited and sold paintings and other works of art. Metcalf and Dixon (later called Hough and Dixon, then Sherwood and Hough) and Taylor's Book Store were prominent examples. In addition, the public flocked to see panoramas, a form of entertainment consisting of series of paintings focused on a historical event or scenic wonder, accompanied by dramatic readings, music, and lights. The State Fair, held annually in St. Paul, was also a popular venue for the exhibition of art.[14]

The young Anton had the opportunity to see the work of artists with national reputations who visited the city periodically and were much celebrated in the press. Perhaps the most famous was Gilbert Munger (1837–1903), who had family in St. Paul and, beginning in 1867, came for lengthy stays.[15] A passionate landscapist, he

7. THIRD STREET ABOVE WABASHA, ST. PAUL, C. 1867.

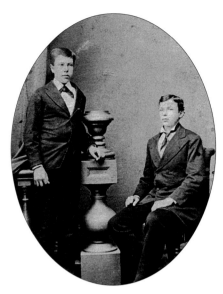

8. LEFT TO RIGHT: JOSEPH AND
ANTON GAG, C. 1874.

beginning to command respect.) Alvah Bradish (1806–1901) exhibited portraits and narrative paintings. Among the paintings he showed at the Park Place Hotel in October 1874 was a life-sized painting of James Fenimore Cooper's Leatherstocking, admired by the St. Paul reviewer for its accuracy of detail and for its nobility of spirit.[18]

Another visitor to St. Paul whose work is related to Anton Gag's subsequent development was Carl Gutherz (1844–1907). More than Munger, Meeker, or Bradish, Gutherz represents the formal academic style to which Anton would aspire. Born in Switzerland, Gutherz had studied at the Ecole des Beaux Arts in Paris, the Academy of Fine Arts in Brussels, and with Wilhelm von Kaulbach at the Royal Academy in Munich.[19] His 1872 allegorical painting *The Awakening of Spring* (1872, fig. 9), having been exhibited with great success in Rome and Munich, was displayed at Taylor's Book Store in August 1873 and given a good deal of attention in the local press. (Like Munger, Gutherz had family connections in St. Paul.) When shown at the 1876 Centennial Exposition in Philadelphia, *The Awakening of Spring* would establish his American reputation. Gutherz, who had spent several years in Paris, represents spring as a golden-limbed recumbent nude in the mode of Alexandre Cabanel's *Birth of Venus* (1863). Putti gambol about the nude, creating a scene that revels in nature and art in the manner of the romantic neoclassicism of fashionable academic art. Gutherz would soon settle permanently in St. Louis, where he established the department of fine arts at Washington University. But he would continue to make periodic visits to Minnesota and would contribute to the public discussion on the need for an art school in St. Paul.[20]

had by the mid-1870s thoroughly recorded Minnehaha Falls and the St. Croix Valley, the most picturesque subjects in the area. He had also produced large-scale exhibition pictures derived from sketching trips to California with Albert Bierstadt, whose sweeping yet finely detailed works his own efforts resemble. In November 1874 a painting by Munger entitled *Yosemite Valley* was displayed at Metcalf and Dixon.[16]

Anton's later work was also presaged by that of two other artists who exhibited in St. Paul in the later 1870s, Joseph Rusling Meeker and Alvah Bradish. Meeker (1827–1887), born in New Jersey and educated at the National Academy of Design in New York, was the leading artist in St. Louis.[17] He traveled to various parts of the country in search of picturesque scenes but was best known for his scenes of Louisiana swamps, notable for their silvery light. In September 1874, at Metcalf and Dixon, he showed *Evangeline*—derived, like many of his works, from Henry Wadsworth Longfellow's 1847 narrative poem—and the atmospheric *Cypress Swamp of Louisiana*. (The latter work was bought by James J. Hill, whose collection of both American and European works was

The comings and goings of these various professionals underscore the fact that few artists could make a living in St. Paul or in neighboring

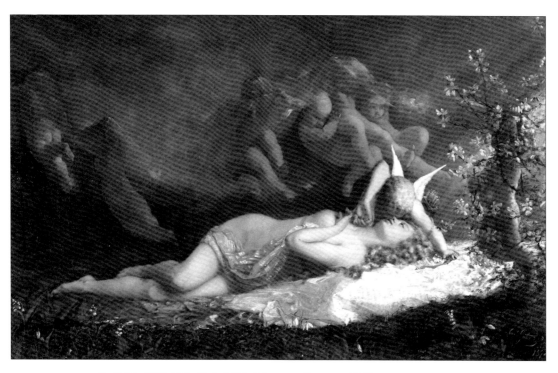

9. CARL GUTHERZ, *THE AWAKENING OF SPRING*, 1872, OIL ON CANVAS,
40 1/4 x 66 IN. MEMPHIS BROOKS MUSEUM OF ART, MEMPHIS, TENNESSEE.

Minneapolis. The career of one of the few who did, the Danish-born Peter Gui Clausen (1830–1924), reveals much about what an aspiring artist such as Anton could expect.[21] Clausen had an impressive background. Before immigrating to the United States in 1866 he had studied at the royal academies of Copenhagen and Stockholm and begun a promising artistic career. An opportunity to paint frescoes in a Minneapolis church brought him to Minnesota in 1869. He was primarily a landscapist, his special subject being the Mississippi River, especially its falls, which had fascinated him even before he arrived in America (fig. 10). But since landscapes and even portraits did not produce enough income to support his family, he accepted commissions to decorate churches. It is significant that this accomplished painter with European training felt it necessary to advertise his services as an artistic jack-of-all-trades.[22] Clausen also had pupils in Minneapolis for almost thirty years, making him one of the earliest artist-teachers in the area.

One of St. Paul's few art teachers was Henry J. Koempel, a little-known German-born portrait painter and decorator of churches who had a studio on West Third Street. Koempel was the teacher, and later the father-in-law, of Nicholas R. Brewer (1857–1949), an artist with many similarities to Anton.[23] Brewer was born on a farm near Rochester, Minnesota, the son of German immigrants. At age eighteen, having shown a marked talent for drawing, he went to St. Paul to become an artist. Brewer's autobiography, *Trails of a Paintbrush*, published in 1936 when he had achieved renown as a portrait and landscape painter, describes his struggles to earn a living in St. Paul (which from his point of view "possessed neither art nor artists") as a housepainter, a bill collector, and even as a market gardener.[24] Anton Gag's little sketchbook from 1878–79 establishes an interesting link between the two young men who shared artistic ambitions: one page contains the signature of Nicholas Brewer, surrounded by birds and flowers. A similar page by Anton (signed "Anthony J. Gag") is in

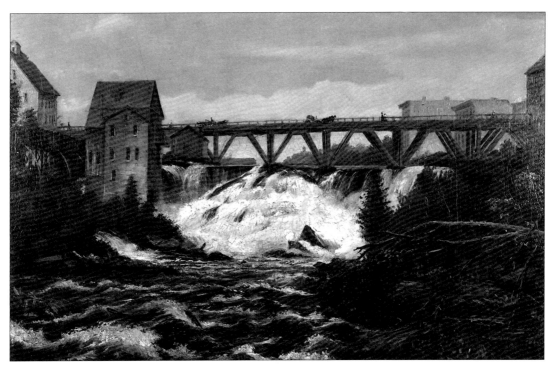

10. PETER GUI CLAUSEN, *ST. ANTHONY FALLS, HENNEPIN ISLAND BRIDGE,*
1869, OIL ON PAPER ON BOARD, 15 x 24 1/2 IN. MINNESOTA HISTORICAL SOCIETY.

a markedly different style, with strong lines and more painterly brushwork (figs. 11 and 12). During the spring of 1878 Brewer was hard up, according to his autobiography. He bargained with his landlady at 20 Marshall Street to paint the exterior of this boardinghouse in lieu of five months' rent, and that summer he assisted Henry Koempel in decorating a church in Hastings—though Koempel could hardly afford to pay him.

Anton is listed in the 1877–78 St. Paul city directory as "Tony Gag, artist," which shows remarkable courage, given this tough market. Clearly his ambitions were stimulated in the city, but his career (and Brewer's) would find scant support. St. Paul still had no formal organization to promote the arts, although 1876 had seen a promising proposal for an art society that would assemble casts and models with

11. NICHOLAS BREWER, SIGNATURE PAGE,
SKETCHBOOK, APRIL 30, 1878, WATERCOLOR,
3 1/4 x 5 1/4 IN. BROWN COUNTY HISTORICAL
SOCIETY, NEW ULM, MINNESOTA.

12. ANTON GAG, SIGNATURE PAGE, SKETCHBOOK,
APRIL 29, 1878, WATERCOLOR, 3 1/4 x
5 1/4 IN. BROWN COUNTY HISTORICAL SOCIETY,
NEW ULM, MINNESOTA.

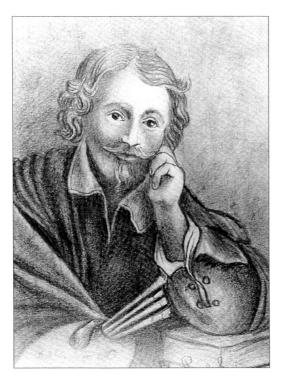

13. ANTON GAG, PORTRAIT OF PETER PAUL
RUBENS, 1879, PENCIL, 3 1/4 x 5 1/4 IN.
BROWN COUNTY HISTORICAL SOCIETY,
NEW ULM, MINNESOTA.

Tony Gag's career in this milieu was short-lived. The 1878–79 city directory—the last to list him—gives his occupation as "cigarmaker."[27] This interval cannot have been happy for Anton, who was now twenty. (Years later, when his sister-in-law Annie Biebl went to St. Paul to find work, Anton remarked to his daughter Wanda that he would rather see one of his children *dead* than working in a factory.[28]) Soon he moved on. It may be that a turning point in the career of Nicholas Brewer helped Anton Gag find his way. In the winter of 1879 Brewer became a "crayon artist," someone who made pencil or charcoal portraits from photographs.[29] Anton's sketchbook, which shows a gap of almost one year beginning in August 1878, resumes with eight final sketches dated 1879, five of which are pencil portraits. Two of these are of great artists, Peter Paul Rubens (fig. 13) and Raphael. They show Anton's skill as a copyist as well as his interest in the history of art. His earliest known oil portrait also dates from this time (fig. 14). Probably a self-portrait, it closely resembles the photograph taken at the Whitney studio several years earlier.[30]

the ultimate goal of founding a school of art and design, a library, and a museum. Unfortunately, it never materialized. Proposals in 1878 for an art academy and an art loan exhibition, the latter to draw from the growing private collections in the city, also came to naught.[25] In the 1880s, after Anton had moved on to New Ulm, St. Paul would establish the Art League Sketch Club and mount its first successful art loan exhibition. Yet even as late as 1887 the local newspaper decried the lack of patronage: "[W]ith all the wealth the city contains, artists cannot permanently locate here. They all say the same thing, they succeed for a time but can neither, in the long run, make money nor gain honor where art is unappreciated, and they grow homesick for an art-atmosphere and (the) sight of a good picture." Fifty professional artists were working in St. Paul in 1887. Most stayed afloat, like Clausen and Koempel, by taking pupils or doing decorative work.[26]

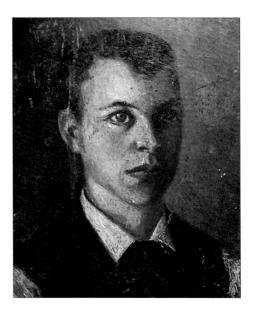

14. ANTON GAG, EARLY PORTRAIT (POSSIBLY
SELF-PORTRAIT), N.D., OIL ON CANVAS,
14 x 10 IN. BROWN COUNTY HISTORICAL
SOCIETY, NEW ULM, MINNESOTA.

15. ANTON GAG, PORTRAIT OF JACOB HOTTINGER,
1879, PENCIL, 3 1/4 x 5 1/4 IN. BROWN
COUNTY HISTORICAL SOCIETY,
NEW ULM, MINNESOTA.

In 1879 or 1880 Anton moved to New Ulm, ninety miles southwest of St. Paul. In July 1876 Georg Gag had bought a lot on the Immelberg, a wooded hill on the southeastern edge of New Ulm, and built a house. He died in November 1877, while digging a well on this property.[31] Theresia Gag stayed on in the house, joined by Vincenz and Margaretha Klaus and their growing family.[32] Vincenz now worked for the Schell Brewery in New Ulm, and perhaps Anton saw his way to gainful employment there as well as a new market for portraits in this growing town. His sketchbook includes a portrait of Jacob Hottinger, a New Ulm businessman, which suggests he may have been demonstrating his skill to a potential patron (fig. 15).

Family ties and the possibility of employment more salubrious than cigar-making were more than enough reason for Anton to move. But also he was very likely weary of the din and disorder of the Upper Levee. The horizon in Brown County is wide, the prairies bordered by long hills and woods. It is a rich green area that, especially in spring and summer, looks much like Bohemia.

New Ulm is an ordered and peaceful town set in a broad valley between the Cottonwood and Minnesota rivers. Its broad streets and avenues and unusually wide house lots are based on a clear, open plan that reflects its origins as a utopian community (fig. 1). As adults both Wanda and Flavia Gág tended to characterize New Ulm as philistine, even likening it to Gopher Prairie, the fictional Minnesota town of Sinclair Lewis's novel *Main Street*. Although it is true that, like most rural towns, New Ulm had limited use for the arts, it was nevertheless founded on certain ideas that made it more hospitable to the arts than the community that was the object of Lewis's satire.

The utopian spirit that could be found amid the day-to-day materialistic concerns of a midwestern farming-and-manufacturing community derived from the ideals of its first settlers. New Ulm was founded in 1854—only twenty-five years before Anton arrived—by the Chicago Land Association, a group of German immigrants looking to establish a new home in the West. In 1856 they were joined by the Cincinnati Turner Colonization Society, part of the Turnerbund of North America, an organization that had originated in Berlin in 1811.[1] *Turnvereins*, or Turner Societies, promoted physical culture in the form of gymnastics but also intellectual culture, particularly the German language and literature. The Chicago Land Association and the Cincinnati Turners, many of whose members were "Forty-eighters" who had come to the United States after the failure of the 1848 revolution, shared the desire to found a new community where they could live according to German customs and values. They were

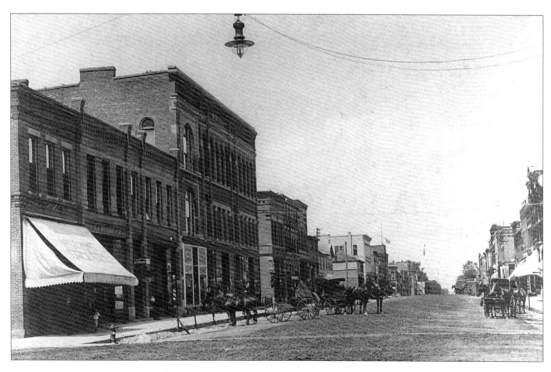

1. MINNESOTA STREET, NEW ULM, C. 1880.

passionate liberals and, in many cases, free-thinkers (who were nevertheless tolerant of succeeding groups of German immigrants to New Ulm who were predominantly Catholics and Lutherans). The two groups merged to form the German Land Association and in November 1856 created their own *Turnverein*, building the first of several halls that would serve as a general community center with a gymnasium, library, theater, rathskeller, and kindergarten. Members of the *Turnverein* in New Ulm, as in other such communities across the Midwest, were the town's economic and social elite.

The *Turnverein* would play a significant role in Anton Gag's career, beginning with the young man's friendship with an influential Turner and New Ulm pioneer, August Schell. Anton's children later put forward the story that Schell virtually adopted Anton—took him in, fed him, and gave him his first artistic recognition.[2] Such a scenario is unrealistic: we now know that Anton did not live in New Ulm until at least 1879, by which time he was a young man of twenty-one who already had experience as an artist in St. Paul. But certainly August Schell became Anton's patron and helped set his artistic career in motion. Perhaps he also assumed the role of father for the young man whose own father had so recently died.

Schell had a love of the beautiful. Born in 1828 in Durbach in Germany's Black Forest, he was the son of Carl Schell, a forester and property owner of substance, and Anna Viccellio, the daughter of an Italian count.[3] August Schell was trained as an engineer but left Germany for America after the 1848 revolution. He first settled in Cincinnati, where he married Theresia Hermann, a German woman. The Schells arrived in New Ulm in 1856 with a group of Cincinnati Turners. He entered the brewery business in 1860, and by the late 1870s he was the proprietor of a thriving concern. His estate—still intact today—is just south of New Ulm in

the Cottonwood River valley. In 1879 the Schells lived in a house connected to the brewery that had already been expanded several times, and Schell had begun creating a park and formal gardens there reminiscent of his family's estate in Germany. The Schells eventually had six children. The youngest, Otto, born in 1862, would become a close friend of Anton. In 1881 the nineteen-year-old Otto would go to Germany for a year to study brewing methods; in time he would head the family business (fig. 2).

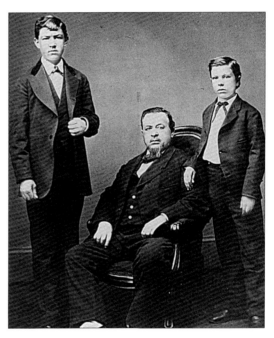

2. AUGUST SCHELL AND (LEFT TO RIGHT) SONS ADOLPH AND OTTO, N.D.

Anton Gag may have met the Schells through his brother-in-law Vincenz Klaus, who worked for August; he may also have worked at the brewery in his early days in New Ulm. Or perhaps Anton first became friends with Otto and was then introduced to August Schell.[4] In any case, Anton soon joined a circle of family and friends who gathered in the evenings at Schell's guest house to relax with music and conversation. Anton was thus lifted into an entirely different social sphere from the one a young German-Bohemian of peasant origins might expect to inhabit in New Ulm. Brown

County German-Bohemians tended to be farmers or, in town, laborers with jobs akin to those they had held back home—butcher, carpenter, brewery worker.[5] The Bohemians were known for their industry and perseverance. Some farmers, such as Joseph Sellner, attained wealth. Yet most Bohemians, who tended to adhere to the peasant ways of the Old Country, remained poor.[6] Many lived in an enclave down by the Minnesota River called Goosetown, where they wore traditional dress, raised vegetables, and tended domestic animals, especially geese, very much as they had in the Old Country (fig. 3). The socio-economic gap between Goosetown or the Gag house on the Immelberg and the house of a founding member of the New Ulm *Turnverein* such as August Schell was great, yet clearly Anton had the attractive personality—and compelling talent—to cross that divide.

Anton impressed the Schells and their friends. That he was affable and musical would not have been surprising: German-Bohemians were known for their musical ability and their way with folk songs, polkas, and band music. The "German" musical tradition in New Ulm—the many bands, polka groups, and choruses—is more accurately characterized as German-Bohemian.[7] One of the most prominent musicians in New Ulm in the late nineteenth century was George Gag, a distant cousin of Anton.[8] Even so, Anton's tenor voice and his instrumental talent were considered remarkable. One of August Schell's friends recounted, for example, how Anton learned to play the zither beautifully in just three weeks. But it was his artistic ability that really set Anton apart. From the beginning, he was a meticulous craftsman who seemed able to turn his hand to anything. By 1880 he was already a versatile artist: he performed journeyman tasks, such as painting beer signs for August Schell; painted murals in the Schells' guest house that evoked the forests of Germany and Bohemia; and created a diorama on one wall that depicted a mountain village. In fact, Anton was already accomplished enough to try his

3. GOOSETOWN, NEW ULM, C. 1880.

hand at teaching. On occasion he led the Schell family and their guests in evening painting sessions.

Schell was so impressed with Anton's ability that he undertook to send him to art school in Chicago. Records of this sojourn, which occurred in 1880, are scant, consisting of two brief notices in the *New Ulm Review*, the local newspaper that would take much notice of Anton's later career.[9] But Schell's choice of Chicago as the place for Anton to study indicates a desire to go about this patronage of the young artist in a first-class way. The Twin Cities of Minneapolis and St. Paul were becoming important urban centers, but Chicago was the capital of the Midwest, and it was there that bright, talented young men and women of the region went to make their mark. (New York had not yet established itself as the inevitable goal for the writer, singer, or artist.)[10] Just as, later in the century, Thea Kronborg in Willa Cather's novel *Song of the Lark* (1915) left the town of Moonstone, Colorado, to study music in Chicago, so Anton left New Ulm to gain access to the best available teachers and artistic experience.

In 1880 Chicago had an array of artists and art teachers and the beginning of a strong system of patronage.[11] The newly opened Chicago Academy of Fine Arts (forerunner of the modern School of the Art Institute) was modeled on European art academies and guided by Marshall Field and other leading midwestern businessmen and industrialists.[12] The school embodied the deeply conservative ideas of academies in other important centers such as New York and Philadelphia.[13] It promoted the hierarchy of painting traditional to European academies, with history painting (that is, heroic, classicizing paintings depicting noble scenes from Roman poetry, ancient history, or the Bible) at the top, followed by heroic landscapes, portraits, still lifes, and genre subjects.

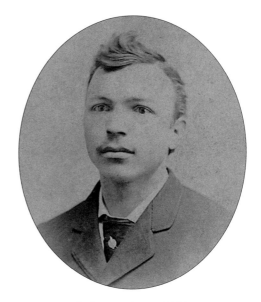

4. ANTON GAG, C.1880.

The curriculum began with drawing, particularly of the human figure—the *sine qua non* of academic training—and went on to include the related matters of chiaroscuro and perspective.

Anton Gag never enrolled at the Chicago Academy of Fine Arts: he either studied at a smaller school or simply in the atelier of a painter working in the city. But the instruction he received reflects the academic approach of the Chicago school. Its source was Europe, and it can be assumed that his teacher or teachers had received at least part of their training there. Artists attaining prominence during this time might, like William Morris Hunt, study academic art in Paris and also absorb the innovations of the Barbizon School, particularly its devotion to nondramatic rural subjects. Or they might, like William Merritt Chase, study in Munich, where students at the Bavarian Royal Academy (many of them Americans) adopted the dark palette, loose brushwork, and heavy impasto that were inspired by the seventeenth-century Dutch realists Frans Hals and Rembrandt and reinforced by the practice of the modern masters Gustave Courbet and Édouard Manet. Munich was the preferred destination for midwestern students.[14] A letter from an art student

there published in the *Chicago Times* and reprinted in the *St. Paul Pioneer Press* gives some of the reasons:

> It is the artist's paradise; and now even more than in summer, for the art school is in session with its 470 students, and the resident artists have returned from their trips to the mountains with fresh studies and sketches. And then, too, the quaint old city itself, its narrow streets, big houses, and wonderful roofs and chimneys, its courts and cloisters, churches and kellers, built in the centuries ago —oh, it's fine. We at home build more costly, comfortable, and healthy houses, but some way the spirit of beauty that hovered over the building of these thick-walled, stuccoed, brown-roofed houses has escaped us. The Munich art may not be so refined as the art of Paris, possibly not so simple and great, but to an American it seems all that can be wished for. It is a fact that Americans educated here have been more successful at home than those who have had the advantage of Paris.[15]

Anton wanted to return to Europe to study art, and it is likely that he would share this preference for the German school. Robert Koehler (1850–1917), a contemporary of Anton who would have a part to play in Wanda Gág's life, exemplifies the Munich approach. Born in Hamburg and brought to Milwaukee when he was four years old, Koehler studied lithography at the German-English Academy in Milwaukee and later at the National Academy of Design in New York. But he found a "different atmosphere" in Munich, not oriented toward the business of art but toward promoting "one desire: to study, to advance, learn to do and to be something."[16]

Certain conclusions about Anton's studies can be drawn from four works he sent back to New Ulm to be auctioned to raise money for his studies. They were paintings, not drawings, so we know that he was not on the traditional path to artistic mastery, which slowly leads the student from drawing from casts to drawing from life before being allowed to pick up a brush. Full-blown works such as *The Muses* (c. 1880, fig. 5) indicate either that Anton was

5. ANTON GAG, *THE MUSES*, C. 1880, OIL ON CANVAS, 11 1/2 X 23 IN. PRIVATE COLLECTION.

simply getting some quick instruction in painting techniques or that he was jumping ahead of his instructor—not unheard of among art students—to produce a work to sell. *The Muses* is a creditable exercise in academic history painting. It depicts five female figures, modestly draped and displaying the attributes of the muses of music (Euterpe, with pan flute and laurel crown), astronomy (Urania, with globe), love poetry (Erato, with a putto bearing a lyre), tragedy (Melpomene, with tragic mask and sword), and painting (this last not one of the traditional nine muses but fitting well enough into the company with her palette and brush). The painting gives no sense of having been drawn from live models and is probably a copy of an earlier artist's work. Figures are handled well, and the background foliage looks fresh and spontaneous. On the other hand, the handling of color is crude and not likely to have been commended by a teacher.

Another of the four works he sent back to New Ulm is *Seascape* (c. 1880, fig. 6), a moonlit view of a headland across a stretch of water. Two or three small structures on the land are echoed by what appear to be two ships on the horizon, but the exact nature of these shapes is mysterious. Even the headland is an ambiguous, whale-like presence. *Seascape* bears some affinity with the dreamlike imagery of Albert Pinkham Ryder, who was beginning to do his most characteristic work around 1880. But Anton Gag's approach is more naturalistic: the clouds and sea are well observed and not, despite the ambiguity of shape, simplified into abstractions. Anton's response to nature was strong, and this scene is invested with the experience of seeing moonlight, pointing the way to his future preoccupation with capturing natural effects.

Anton stayed in Chicago only about four months, perhaps because he could no longer

6. ANTON GAG, *SEASCAPE*, C. 1880, OIL ON CANVAS, 20 1/2 X 26 IN.
WANDA GÁG HOUSE ASSOCIATION, NEW ULM, MINNESOTA.

afford to stay, perhaps because he felt he had acquired sufficient skills to resume working on his own. Later that same year, however, he managed to go to Milwaukee for a few more weeks of study. Although not a regional capital like Chicago, this city was undergoing rapid development in the arts—fast outstripping St. Paul. In 1882 local businessmen would found the Milwaukee Museum of Fine Arts. Also in the near future were an art school (later named the Milwaukee Art School) and the Layton Art Gallery, another museum.[17] Milwaukee was known as the German-speaking "Athens of the Midwest," and most of the city's artists were from Germany. The leading spirit was Henry Vianden, who taught at the German and English Academy and painted strong, dramatic landscapes in a "cast-iron" style that reflected his training in Düsseldorf. His teaching emphasized academic drawing and modeling. Milwaukee abounded in portraitists and panorama painters, many of whom had been brought there from Germany to satisfy the public taste for this sometimes flashy kind of art. It was perhaps here that Anton developed the idea and skill for his later large paintings about Minnesota history.

Upon his return to New Ulm in 1880 or 1881, Anton Gag established himself as a professional artist. His most dependable source of income in the early years was portraits (the stock-in-trade of artists in America from Colonial times). A number of commissions came from prominent citizens of the town such as the Schells. Not surprisingly, however, Anton was unable to support himself exclusively as a painter. Thus in 1883 he and a partner, J. B. Vellikanje, opened a photography studio, a common tactic among painters in the mid- and late-nineteenth century. (Anton's photographic work is treated more fully in Chapter 4 but is introduced here because it was inextricably

combined with his painting.) The practice of the day was to provide either an oil portrait or a set of photographs, depending on what the client preferred or could afford.[18] Even the client who wanted an oil portrait would probably be photographed first to obviate tiresome multiple sittings. The artist could also hand-paint a photograph to provide a customized, one-of-a-kind likeness that had the verisimilitude of a photograph. That seems to have

7. ANTON GAG, PORTRAIT OF EMMA SCHELL MARTI, N.D., TINTED PHOTOGRAPH, 4 X 5 5/8 IN. BROWN COUNTY HISTORICAL SOCIETY, NEW ULM, MINNESOTA.

been the process for Anton's portrait of Emma Schell Marti, one of August Schell's daughters (fig. 7). In this small work (only four by five and five-eighths inches) Anton outlined the figure, colored in the clothing, and provided a shadowy background with loose brushwork; yet the face emerges from this painterly background with the truth to appearances so prized in rural America at the time. Gag also did a portrait of

James J. Hill, probably from a photograph (there is no evidence that Gag ever met Hill); presumably it hung in the New Ulm railroad station or some other public place. In 1901 he painted a portrait of Daniel Webster for a lawyer in town.[19] Such efforts show Anton's enterprise and determination to succeed in a market where only the elite could afford to buy fine art.

modest about his technical accomplishments in such works. In later years he confided his doubts to his daughter Wanda, lamenting his inability to get the transparency in flesh tones he desired and attributing his short-comings to lack of education—not fully real-izing, according to her, that his difficulty was actually that he had no experience with the well-known process of glazing.[21]

8. ANTON GAG, *DEATH OF MINNEHAHA*, N.D., OIL ON CANVAS, 25 3/4 X 33 1/8 IN. BROWN COUNTY HISTORICAL SOCIETY, NEW ULM, MINNESOTA.

Meanwhile, however, he persisted in painting pictures in the grand tradition, most of which did not sell. For example, his *Death of Minne-haha* (fig. 8) is a narrative painting (again, perhaps a copy) that, like the work of artists such as Alvah Bradish, draws on romantic lit-erature. Anton also produced picturesque "types" such as the *Old Man*, a view in profile reminiscent of Rembrandt and quite typical of the Munich school.[20] Anton was always

Yet other works by Anton exhibit a mastery of the effects of light. Still lifes such as *Plums* (fig. 9) are often so realistic as to fool the eye; they are also remarkably luminous and seem translucent when lit from below. It is signifi-cant that Anton's still lifes have an almost rit-ualistic simplicity.[22] Whereas in seventeenth-century Dutch painting this genre is character-ized by a profusion of objects, both animate and inanimate, offering not only a welter of

9. ANTON GAG, *PLUMS*, N.D., OIL ON CANVAS,
14 1/2 x 20 IN. PRIVATE COLLECTION.

Meanwhile, as his career developed, Anton maintained his close ties with the Schell family. In 1885 he presented Otto Schell with a ceramic plaque with putti, vine leaves, and other classical motifs. That same year, August

10. CADURCIS PLANTAGENET REAM, *PURPLE PLUMS*,
1895, OIL ON CANVAS, 16 x 22 IN. ART INSTITUTE
OF CHICAGO, BEQUEST OF CATHERINE M. WHITE,
1899.907. ALL RIGHTS RESERVED.

colors and textures but also symbolic messages, Anton typically concentrated on one kind of fruit or flower. He observes the fruit with passionate interest to capture the play of light on the surfaces. Such studies are almost certainly another result of his study in Chicago: they strongly resemble works by Cadurcis Plantagenet Ream (1838–1917), who settled in Chicago in 1878 and was that city's most famous still-life artist. Ream's *Purple Plums* (1895, fig. 10) was the first painting by a Chicago artist to enter the collection of the Art Institute of Chicago.[23]

and Theresia Schell built a magnificent new house near the brewery that was modeled on a German manor house. Called Schell's Thal, its grounds included a deer park and formal gardens with plantings that Otto had brought back from Germany (fig. 11). Anton

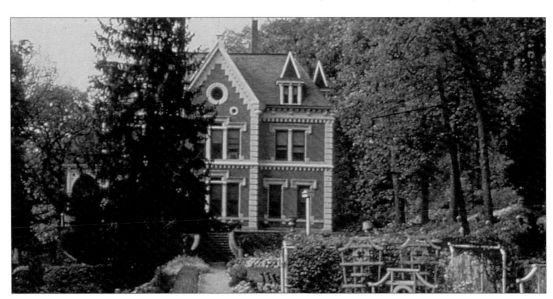

11. SCHELL'S THAL, C. 1890.

played a part in the decoration by designing a spectacular fountain, about fifteen feet tall, that was erected in the brewery garden in 1887. The gazebolike structure above the basin enclosed plants; decoration included an arcade of Corinthian columns and a set of four gargoyles. The effect was both grand and festive. A photograph of the fountain taken the

12. ANTON GAG'S FOUNTAIN, SCHELL'S
BREWERY GARDEN, NEW ULM, 1887.
LEFT TO RIGHT: AUGUST, THERESIA,
(POSSIBLY) ADOLPH, AND OTTO SCHELL.

year it was built shows August Schell, by then virtually crippled by arthritis, seated and holding a cane, alongside his wife and two sons (fig. 12).

It was at the Schell estate that Anton met Ida Berndt (fig. 13). Born in 1864, this gentle-looking girl was one of four daughters of Julius Berndt, another Turner and part of Schell's cultured circle. She thus would have been quite out of the young Bohemian artist's reach were

it not for his connection to the Schells.[24] Like Schell, Julius Berndt was a Forty-eighter, having come to New Ulm in 1857 by way of Chicago. Born in Silesia (which was part of Prussia but not far, either geographically or culturally, from Bohemia), he was trained in Breslau as an architect and civil engineer.[25] As surveyor of Brown County for almost thirty years, he played a noteworthy role in New Ulm's development. He designed the first two Turner halls: a simple frame structure in 1858 and, in 1866, a far more imposing Greek Revival-style edifice. In fact, he oversaw construction of most of the important buildings in Brown County during the last third of the century.[26] In the eyes of his fellow citizens, his main achievement was his campaign to erect the Hermann Monument, a statue originally designed as the symbol of his fraternal lodge, the Sons of Hermann, but enthusiastically adopted as the symbol of the town. Dedicated in 1897 in a park on the summit of the bluff overlooking New Ulm, the 102-foot-tall statue commemorates Hermann the Cherusker, a first-century A.D. Germanic warrior and symbol of nineteenth-century German nationalism. Anton celebrated the occasion by producing what might be his most imaginative venture into history painting: Hermann the Cherusker astride a galloping horse in a German forest.[27]

Anton Gag and Ida Berndt were married on May 4, 1886. Despite differences in social standing and Anton's modest circumstances, the marriage seems to have been an ideally happy one. The couple lived in a small brick house near the Schell brewery. Ida would walk across the fields with her husband each morning as he left for work, then walk to meet him each evening coming home.[28]

Marriage seems to have spurred Anton's artistic ambitions: in January 1887 he visited St. Paul to purchase supplies and do research at the Minnesota Historical Society for a proposed

series of paintings depicting the first battle of New Ulm, fought in August 1862.[29] Dakota Indians had attacked the town's white settlers in the first major fight of the brief but deeply traumatic war that was then called the Sioux Uprising but is now known as the Dakota Conflict.[30] Anton's interest in Indians—awakened when he was a boy in Bohemia and strengthened by their presence in Minnesota—led him to go to great lengths to create authentic work.[31] He interviewed battle survivors (known as the "Defenders") for eyewitness accounts. He also went to the Morton Indian Reservation to draw and paint the Indians and their artifacts, making two pictures of every sitter in order to give one in return for the favor of posing (the only payment the Dakota would accept); he probably also used photographs to record what he saw.[32]

Attack on New Ulm during the Sioux Outbreak, August 19–23, 1862 (1904, fig. 14) is Anton's best-known work. In the foreground some

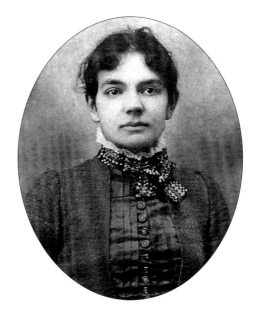

13. IDA BERNDT, C. 1885.

half-dozen Indians, including a chief on a white horse, advance on a pioneer settlement that is already ablaze. The sky beyond roils with flames, smoke, and clouds. It is noteworthy that the artist focuses on the Indians,

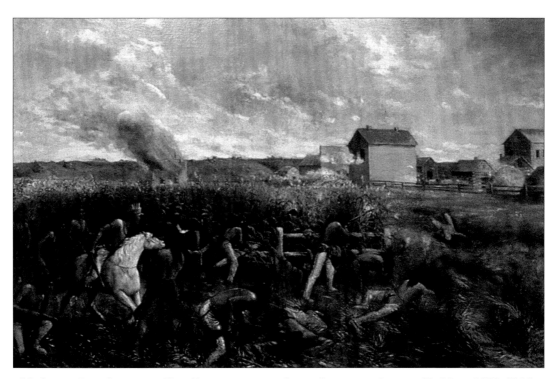

14. ANTON GAG, *ATTACK ON NEW ULM DURING THE SIOUX OUTBREAK, AUGUST 19–23RD, 1862*, 1904, OIL ON CANVAS, 70 X 94 1/8 IN. MINNESOTA HISTORICAL SOCIETY.

who look stalwart and determined. Wanda Gág would remark on her father's mixed feelings about the battle and his sympathy for the native point of view—a notably liberal stance at a time when most Minnesotans thought of the Dakota as savages interfering with Manifest Destiny. The painting hung for many years at the Minnesota State Capitol.[33]

During the summer of 1887 Anton's life took a tragic turn. In June, Ida Gag gave birth to a daughter, Antonia, but died of a fever a few days later. She was twenty-three years old. Four weeks later, Antonia also died. Inconsolable, Anton fell ill and spent several weeks in bed at the Berndts. He wrote tragic poetry, including a poem expressing his thoughts about leaving New Ulm.[34]

Anton also spent hours walking in the fields around the town. It may have been during this time that he began the series of undated paintings that register the local terrain, partic-

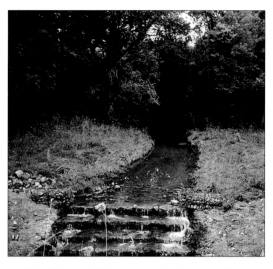

15. BROOK, COTTONWOOD RIVER, NEW ULM.

ularly the Cottonwood River and a brook that runs by the road to the Schell estate (figs. 15 and 16). The landscape, a broad river valley between two banks of hills, is remarkably similar to the setting Anton had known in Walk and Pernartitz, and it may have consoled him.[35] These paintings are small—about six by four or five inches—and most were never sold. Notable for their fresh color and spontaneous

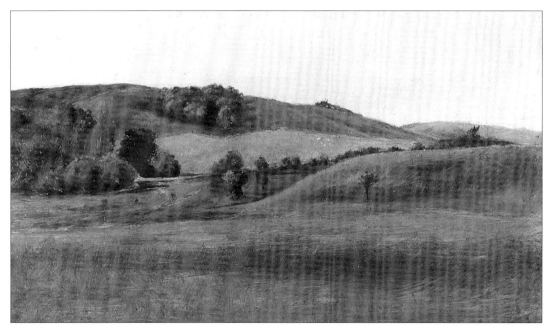

16. ANTON GAG, *NEW ULM SCENE: LANDSCAPE—HILLS*, C. 1890, OIL ON CARDBOARD,
4 X 6 IN. MINNESOTA HISTORICAL SOCIETY.

handling, they have been linked with Impressionism. It is true that a number of European-trained American artists returned to Europe in the 1880s—just as Gag was embarking on his career in New Ulm—to learn the new lessons of French Impressionism, a movement that, though it had begun amid a flurry of public and critical scorn, soon became popular with schools, from the seventeenth century onward. His preoccupation with one particular landscape—his home, and a locale similar to that of his boyhood—is actually closer to the practice of the early nineteenth-century English artist John Constable than to the work of the Impressionists.[37] Unlike Constable, however—and certainly unlike the Impressionists in

17. ANTON GAG, *MEYER'S CREEK*, N.D., OIL ON CANVAS, 18 1/2 X 23 1/4 IN.
WANDA GÁG HOUSE ASSOCIATION, NEW ULM, MINNESOTA.

artists eager for a new approach and viewers responsive to its everyday subject matter and sunlit effects. The eminent painters J. Alden Weir and John Twatchman (the latter the son of German immigrants to Cincinnati) were just two of the many American artists who converted to Impressionism in the 1880s.[36]

Yet it is more plausible, in view of Gag's limited exposure to contemporaneous art, to understand these landscapes as spontaneous oil sketches done before nature, similar to those made by many artists, of various periods and France in the 1870s or America two or three decades later—Gag did not appropriate new subject matter or develop new painting techniques. Also, these small landscapes, along with a few done on the West Coast two decades later, remain the only examples of such self-expression in his œuvre. In terms of technique, it is more profitable to compare Anton with artists such as Ludwig Richter (1803–1884), whose melancholy landscapes and diary on his wanderings are important documents of the German Romantic movement. *Meyer's Creek* (fig. 17), one of Anton's

18. LUDWIG RICHTER, *LANDSCAPE*, N.D., WOODCUT, IN D. PAUL MOHN,
LUDWIG RICHTER (LEIPZIG: BIELEFELD, 1896).

19. ANTON GAG, *COWS IN THE RIVER*, C. 1890, OIL ON CANVAS, 16 1/4 X 23 1/4 IN. PRIVATE COLLECTION.

more finished landscapes, has the strong linear quality of Richter's woodcuts (fig. 18).[38]

One of Anton's most accomplished landscapes—indeed, one of his most accomplished paintings—is *Cows in the River* (c. 1890, fig. 19). Far from resembling an Impressionist painting concerned with the play of light on form, this work, with its subdued tonality, echoes the naturalism of the Munich school. It also suggests the verisimilitude of mid-nineteenth-century French naturalists such as Jules Breton and P. A. J. Dagnan-Bouveret. Like their work, *Cows in the River* was based on a photograph (fig. 20).[39] Another factor distinguishing Gag's work from Impressionism is his use of imaginative elements. For example, the undated painting entitled *Goose Girl* (fig. 21) depicts a girl walking down a path toward a church in the distance. The title evokes Goosetown in New Ulm, yet no such view exists in New Ulm. On the other hand, the view is clearly reminiscent of the regular walk young Anton had taken along the brook to Pernartitz.[40]

20. ANTON GAG, CABINET CARD, C. 1890.

The importance to Anton of an imaginative response to nature is demonstrated by some written thoughts that Wanda Gág titled "Papa's Art Notes," found among her papers after her death.[41] The passage opens with the description of a landscape after sunset. A leaf-filled hollow and other ordinary details comprise the foreground. "How can such a plain, simple motif evoke such an overpowering impression in us?" the writer asks. "But it is just this that constitutes Art, and is the *poesie* or poetic spirit of

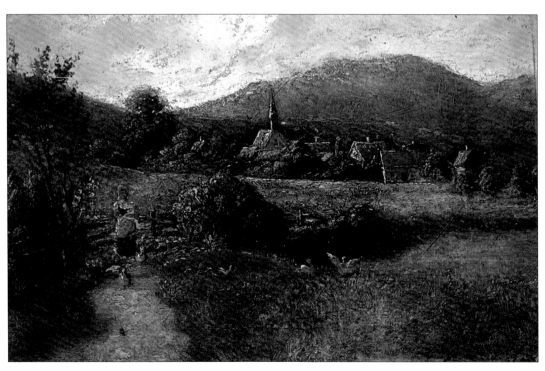

21. ANTON GAG, *GOOSE GIRL*, N.D., OIL ON CANVAS, 6 1/2 x 9 1/2 IN. PRIVATE COLLECTION.

22. LEFT TO RIGHT: ANTON GAG,
CHRISTIAN HELLER, AND ALEXANDER
SCHWENDINGER, C. 1889.

ler was born in Switzerland in 1863 and began his artistic training there with "famed craftsmen."[44] He arrived in America at age twenty. Schwendinger, born in Dornbirn, Austria, in 1862, was the son of Ignatz Schwendinger, a sculptor and stonecutter who came to New Ulm in 1879 and started a successful stonecutting business that specialized in funerary monuments. Alexander's brother Theodore joined Ignatz in this business, but Alexander, aspiring to be a fine artist, went in 1885 to study in Munich and stayed four years.[45] Presumably, Schwendinger was the prime mover of the art-school enterprise: having just returned from the Royal Academy in Munich, he doubtless felt well qualified to teach. New Ulm, these young artists could hope, was surely primed by its strong German culture for aesthetic cultivation.

23. ANTON GAG, *HERO AND LEANDER*, 1886,
OIL ON CANVAS, 48 3/8 X 39 IN.
BROWN COUNTY HISTORICAL SOCIETY,
NEW ULM, MINNESOTA.

the artist. How is that to be attained, you may cry, and the answer is by diligent observation, study, and practice." But art is difficult, the writer goes on: it requires cultivation and stimulation, which are to be found in nature. In vivid detail the writer then describes the same scene at different times: on a fresh spring day, at noon in summer, after a sudden rain. The point is that the artist must not only experience the poetic mood but also make a serious study of nature in order to know, for example, different types of trees.[42]

Anton's interest in the education of the artist manifested itself in his starting of a school about 1889, a venture with two friends and fellow European immigrants, Christian Heller and Alexander Schwendinger, who would play an increasingly important role in his life.[43] Hel-

24. GAG, HELLER, AND SCHWENDINGER, CHERUB PANEL, C. 1889, OIL ON PLASTER, 64 3/4 x 25 7/8 IN.
BROWN COUNTY HISTORICAL SOCIETY, NEW ULM, MINNESOTA.

The three young men played the artist role to the hilt. An array of photographs show them in the studio, decked out in velveteen jackets, soft ties, and berets like Parisian Bohemians or Dutch masters. One group portrait (fig. 22) shows Chris Heller in the center, gazing at a painting on the easel, Anton's *Hero and Leander* (1886, fig. 23), another classicizing study that is probably the copy of another artist's work. Alexander Schwendinger sits before the easel holding a brush, palette, and maulstick; Anton gazes directly at the viewer in the manner of artists who include their self-portraits in paintings. The portrait in the background is a sketch for a portrait of the New Ulm businessman Jacob Hottinger that Anton completed in 1882.

Little is known about the school except that it was located at 125 North Minnesota Street, New Ulm's main thoroughfare, and that it was not a success. The three artists painted two murals, each measuring a little over five by two feet, on the walls of the premises (fig. 24). Both represent putti gamboling in nature and are classical fantasies of nature. In one, two putti hold a net; others hold animals, some alive (a puppy and a deer), others dead (a bird and a lamb). A row of putti of this sort, seen in various positions and views, is an age-old classical motif; thus these wall paintings,

quite in the style of Carl Gutherz's much-admired *Awakening of Spring* (p. 37) proclaim the school's serious aims. Yet the idea that the three artists were less than effective teachers is suggested by a humorous sketch preserved from one of Anton's sketchbooks (fig. 25).

25. ANTON GAG, NEW ULM ART SCHOOL,
C. 1889, PEN AND INK.

Anton continued to collaborate with Heller and Schwendinger. From 1891 to 1893 they worked in a jointly held studio on the Dakota Conflict panorama. Consisting of eleven panels, each seven by ten feet and done on a single roll of fabric, the paintings chronicle the 1862 conflict, beginning with the attack on

Fort Ridgely on August 20 and climaxing with the mass execution of thirty-eight Dakota Indians in Mankato on December 26.[46] It is impossible to determine the exact role each artist played in the project, but it is likely that Gag and Schwendinger, who had the most training, took the lead and that Heller, whose background was largely in decorative painting, did much of the filler work necessary for a canvas amounting to 770 square feet.

Large-scale panoramas had been a popular form of entertainment since the late eighteenth century. Particularly popular in nineteenth-century America were works such as Benjamin Russell's *Whaling Voyage round the World* (1848, advertised, with some exaggeration, as "Three Miles of Canvass") and *The Battle of Atlanta* (1885–86), which still draws crowds today.[47] In the 1880s both Minneapolis and St. Paul had circular buildings built specifically for these shows, and several artists had already had big successes with them in Minnesota. John Stevens, a former sign painter from Utica, New York, executed no fewer than five versions of the 1862 Indian war, all of which were displayed in small communities throughout the Midwest. His drawing was primitive and his approach to composition naive, yet Stevens's presentations, which included melodramatic narration, were an immense hit.[48] Peter Gui Clausen, a more accomplished artist, also pleased the public with a panorama of the western United States from Minnesota to the coast that was eight hundred feet long. This mammoth work was introduced to the Minneapolis public at the Grand Opera House in 1888 and was exhibited later that year at the Third Minneapolis Industrial Exposition. Over the next two years it was shown in Chicago, Boston, and New York.[49]

Anton and his two colleagues were no doubt aware of these lucrative projects. Their particular subject had proven marketability and was still vividly remembered in Minnesota. In

August 1885 New Ulm had seen a reunion of the town's surviving defenders that included volunteer soldiers from surrounding towns who had come to their aid. The survivors' point of view was clearly expressed in the *New Ulm Review*: "No event in the history of Minnesota is nearly so important as the one proposed to be celebrated, and nowhere did the early settler, poorly armed and unskilled in military warfare, respond more promptly to his country's call or do battle with more undaunted courage." For that reporter and many of his readers, the attack on New Ulm was the "massacre of white settlers" by the Indians and the ultimate salvation of "defenseless inhabitants of other portions of the Minnesota valley from flight, pillage or massacre."[50]

In addition to its eleven chronologically arranged panels, the Dakota Conflict panorama includes a map of Minnesota emphasizing the Minnesota River, along which many events in the thirty years of warfare between Indians and settlers took place. Like all effective large-scale narrative paintings, this work presents generalized forms and bold, clear-cut action. Figures are deployed clearly, like actors on a stage, against broad vistas.

The historian John L. Marsh has seen the panorama as pure melodrama, with the "noble redmen" (who are also savage villains) pitted against the settlers, who are defenders of civilization.[51] But the panorama is not so one-sided as that. For while Gag, Heller, and Schwendinger could easily have relied upon the histrionic poses and dramatic lighting effects that were already part of the American history-painting tradition through such artists as Benjamin West and John Trumbull, they instead strove to present an almost documentary record of two cultures at war. A panel such as *Attack on Fort Ridgely, 20 August 1862* (fig. 26) does show the Dakota arising from the forest primeval, as it were, their natural vigor and

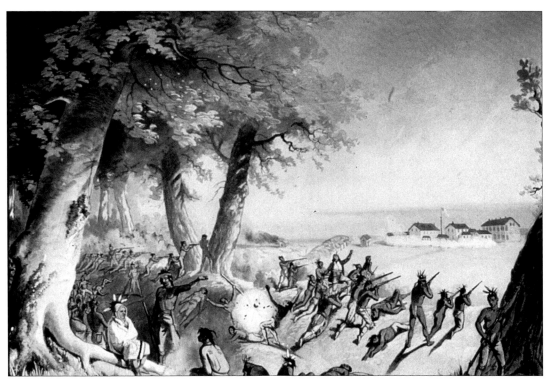

26. GAG, HELLER, AND SCHWENDINGER, DAKOTA CONFLICT PANORAMA, *PANEL NO. 3, ATTACK ON FORT RIDGELY, 20 AUGUST 1862*, OIL ON CANVAS, 84 x 120 IN. MINNESOTA HISTORICAL SOCIETY.

strength a stirring contrast to the vulnerable-looking fort in the distance. Yet overall, the Dakota are not demonized: the panels convey their dignity as well as their power, and the artists pay respectful attention to the particulars of their battle gear. (Anton achieved authenticity in these and other Indian paintings by using photographs of himself and friends taken on camping trips to Meyer's Creek and other riverside spots, where they staged battle scenes; fig. 27.) The panorama does not dramatize the brutality of war; it merely stages it, and the scenes have just enough suggestion of the struggle and glory of the conflict to awaken fine feelings in the breasts of survivors on either side.

The Dakota Conflict panorama went on view for the first time at the Heller, Schwendinger, and Gag studio in February 1893. It was, of course, warmly admired in New Ulm, primarily for its lifelike figures and dramatic evocations

of the past. Yet it met with wider success. One panel, representing the attack on New Ulm, was reportedly exhibited at the World's Columbian Exposition in Chicago in 1893. The

27. ANTON GAG, PHOTOGRAPH OF (LEFT TO RIGHT) LORENZ MERKLE, ADAM PETERS, AND JOHN RICKERS AT MEYER'S CREEK, 1907.

entire panorama was taken on tour through the Midwest and East, and it is probable that, like John Stevens, Gag, Heller, and Schwendinger sold the work to a touring company on the Chautauqua circuit.[52]

28. ANTON GAG, RIVER LANDSCAPE, 1898, OIL ON TIN, DIAM.: 24 1/2 IN. BROWN COUNTY HISTORICAL SOCIETY, NEW ULM, MINNESOTA.

Anton Gag's paintings—done after a day's work at more lucrative enterprises or on weekends—make up an impressive body of work. He produced a steady stream of history paintings, landscapes, portraits, and still lifes. Although he made no innovations in style, he always strove to represent beauty in nature in accord with the tradition that represented his deepest values. Exemplifying these ideas are two unusual landscapes he painted on tin in 1898 as wedding presents for his former brother-in-law August Berndt. One represents a river landscape (fig. 28); the other is a castle on a rocky bluff evoking the Rhineland (fig. 29). These are not images of specific places. Rather, they are idealized scenes with strong associations in the artistic tradition—the isolated castle touching on the notion of the sublime, the charming river scene evoking the picturesque. Light, beautifully depicted even on the un-promising support of tin, suffuses both works with strong feeling. One imagines that the harmony depicted in these landscapes was Anton's deepest wish for his friend.

29. ANTON GAG, LANDSCAPE WITH CASTLE, 1898, OIL ON TIN, DIAM.: 24 1/2 IN. BROWN COUNTY HISTORICAL SOCIETY, NEW ULM, MINNESOTA.

4 FAMILY BUSINESS: ANTON AS PHOTOGRAPHER
1883 – 1896

Anton Gag might have wished to dwell in realm of fine art, but, like many nineteenth-century painters, he was brought into the more practical world of photography by the need to earn a living. There was no photographic studio in New Ulm in the early 1880s—remarkable, considering the widespread popularity of photography in America since the introduction of the daguerreotype process in 1839—and it is characteristic of Anton that he acted on this good business opportunity.[1] But in photography he also found a medium that capitalized on his talents, both as artist and craftsman. And it had the unexpected dividend of bringing him an assistant—and collaborator—who became his second wife.

Anton's first photographic firm opened in 1883. His partner was J. B. Vellikanje, a teacher and sometime superintendent of schools in New Ulm. Like August Schell and Julius Berndt, Vellikanje was a Turner who would strengthen Anton's connections to New Ulm's social elite. Whether Vellikanje had any training in photography is not known. Neither is it known, for that matter, where Anton received his training, although it was probably in St. Paul.[2] In the 1880s photography was still generally perceived as a trade with some artistic elements; training had not yet been defined or formalized.

The firm announced its willingness to do portraits of all types, especially family groups and copies of old pictures. It also advertised photography of residences, farms, and landscapes. All photographs would be painted in oils or watercolors if the client so desired. But the main trade was in portraits, important in an immigrant community where many were separated from

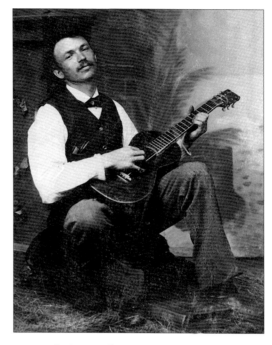

1. ANTON GAG, TINTYPE, C. 1885.

their loved ones.[3] The photographic process was becoming faster and easier, both for photographer and subject. Daguerreotype portraits had been grueling, requiring the subject to remain immobile in a metal head clamp for some twenty minutes. (Photography studios were commonly referred to, with some truth, as "torture chambers.") But the use of collodion as the light-sensitive substance on glass negatives—the wet-plate process—reduced the time to just a few minutes. The Gag-Vellikanje firm did tintypes, an inexpensive version of the wet-plate process. A delightful tintype portrait of Anton still exists (fig. 1). The firm also produced *cartes-de-visite*, small images approximately four by two-and-one-half inches each (fig. 2). Such images, popular in the 1860s, were made with special cameras that allowed up to eight poses on a single plate. A customer could have dozens of small *cartes* for the price of a painted portrait

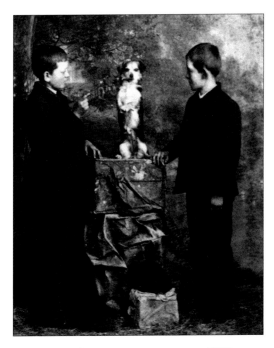

2. ANTON GAG, *CARTE-DE-VISITE*, C. 1883.

The room in which the photograph was taken was almost exactly like the props department of any theater. There was no logic as to how the balustrades and columns were arranged on oriental rugs or parquet floors, jumbled together alongside a variety of chairs and tables of every style. Heavy drapery swags opened onto painted backcloths showing snow-capped mountains, undergrowth or the view of a port. It was unusual for a portrait to be taken in an everyday setting. Outdoor shots were practically unheard of.[4]

Anton would pose the sitters, then disappear under a black focusing cloth to expose the plate. The glass negative would probably be retouched; the finished print might well be painted over to enhance its appearance and also raise it to the status of a unique, handcrafted work of art, if the customer so desired.

or even one large photograph. By 1880, however, most customers wanted cabinet cards, measuring about six by four inches and still quite inexpensive. People collected such cards, albums for which were sold at Gebser's and the City Drug Store in New Ulm. Examples of Anton's early cabinet cards show conventional formal poses and studio settings meant to suggest status and wealth.

As we saw in the preceding chapter, photography studios often served as exhibition galleries in late-nineteenth-century American towns. Anton probably used his new premises to display his own paintings. Certainly he would have made his studio as fashionable as the new firm's finances allowed. Photographic studios typically included an array of props—tables, draperies, rustic fences, artificial grass, and other accoutrements, as in the photograph here of two children on a settee (fig. 3). The pilaster and wall decorations were no doubt scenic decorations that Anton painted, and quite in keeping with the usual approach, as described by Jean Sagne:

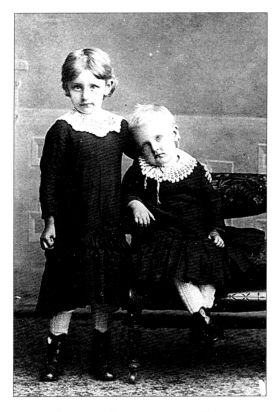

3. ANTON GAG, PORTRAIT OF TWO
UNIDENTIFIED CHILDREN, C. 1885.

Gag's partnership with Vellikanje lasted only four or five months, but in April 1885 he opened another firm, Gag and Amme. Amme was either W. M. Amme, owner of the grocery store at 301 North Broadway and a regular advertiser in both New Ulm newspapers, or his son Herman, who was only seventeen but who might have been a valuable assistant.[5] In any case, Anton now signed his work "A. Gag," as seen in an 1885 photocollage that shows notable persons and scenes of New Ulm (fig. 4). (The figure at center is Monsignor Alexander Berghold, rector of the Cathedral of the Holy Trinity. A native of Austria, Berghold was a good friend of Anton and was active in recruiting Germans and German-Bohemians to New Ulm. The house below Berghold is Schell's Thal.) Photographers of the day often advertised their work with such composite images.[6]

Gag and Amme soon encountered competition. Around the time their business began, a St. Paul photographer, C. J. Greenleaf, advertised in the *New Ulm Review* as a "Practical Photographer" who could copy old pictures. Also in 1885, E. E. Seiter opened a rival firm in New Ulm that would continue in business, on and off, for ten years. Seiter was noted for his many tintype portraits.[7]

It was in 1886, during his partnership with Amme, that Anton married Ida Berndt. Later that year Anton became sole proprietor of the firm. After Ida and their baby girl died in the summer of 1887, Anton temporarily placed the care of the studio in the hands of Ida's sister Julie. It was she who put a sign in the studio window advertising for a shop assistant. The requirement that applicants be "artistic" attracted the attention of Elizabeth Biebl, a young woman who, despite her lack of experience in photography, got the job.[8]

Elizabeth, called Lissi, was the daughter of well-educated immigrants from Kscheutz (now

Kŝice), Bohemia. The Biebls had settled in Harrisburg, Pennsylvania, in 1867, where Lissi was born two years later, and moved to New Ulm in 1874. They lived on a farm about two miles out of town, where Joseph Biebl desultorily farmed and each member of the family followed idiosyncratic artistic interests. There

4. ANTON GAG STUDIO, PHOTOCOLLAGE WITH MONSIGNOR ALEXANDER BERGHOLD (CENTER) AND SCHELL'S THAL (BELOW CENTER), 1885.

were eight Biebl children, the three oldest of whom, including Lissi, were by 1887 already out on their own.

Before being hired at the Gag studio, Lissi Biebl had worked at a hotel in town. Like a growing number of young women of the period, she saw photography as an interesting way of earning a living when employment options for young women were few. (Teaching was out of the question for Lissi, who had only six years of schooling.) Photographic studios regularly

hired women but usually for the behind-the-scenes work of exposing negatives, pasting up images, and handling accounts. Yet it was paid work at a time when women were increasingly

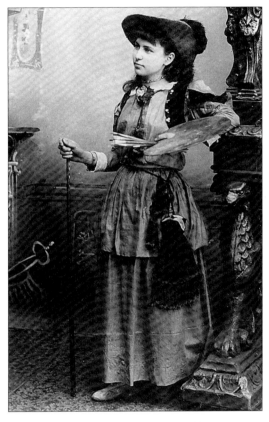

5. ANTON GAG STUDIO, LISSI BIEBL IN COSTUME AS ARTIST, C. 1892.

tographed her in costume for one of the masquerade balls at Turner Hall she was attired as an artist (fig. 5). Lissi encouraged sitters to wear natural-looking clothing rather than formal dress. Portraits of children especially benefited from this approach (fig. 6). The Gag studio's portraits were far more imaginative in terms of costumes and props than those of E. E. Seiter (fig. 7).

being urged to seek financial independence. Catherine Barnes and other influential figures in the strong feminist movement of the day promoted photography as a career for women because the training—available through apprenticeships or manuals—was relatively brief and the hours were flexible. Between 1890 and 1910, the number of professional women photographers rose from 271 to 4,900.[9]

Lissi Biebl soon assumed an important artistic role in the firm. She was an excellent seamstress and had a natural taste for costume and décor. She herself was picturesque—dark-eyed and petite—and when Anton pho-

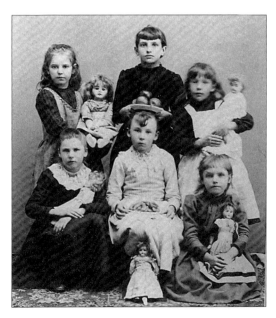

7. E. E. SEITER STUDIO, UNIDENTIFIED CHILDREN.

The sitters' poses also began to show more spontaneity. Photographers considered posing the most important element of the portrait-taking process: master photographers such as Mathew Brady and Gaspard-Felix Tournachon (known as Nadar) simply came in to pose their subjects, leaving the rest of the work, including the actual taking of the photograph, to assistants. "To produce an intimate likeness rather than a banal portrait, the result of mere chance, you must put yourself at once in communion with the sitter, size up his thoughts and his very character," Nadar said.[10] But in the case of the Gag studio, it is likely, given the change in portraits after Lissi was hired, that she took an active role creating the poses and that she was, in fact, more a partner than an assistant. Anton Gag was well liked and charming but could seem aloof. Lissi, on the other hand, was warm and motherly. The photographs of the 1890s capitalized on his artistic skills and meticulous craftsmanship, her taste for materials and ability to put people at ease.

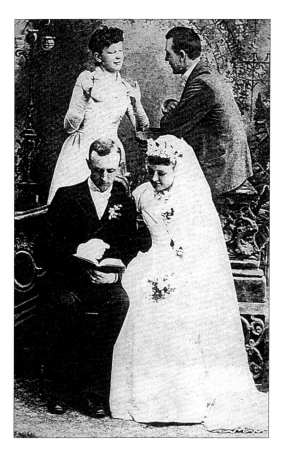

9. ANTON GAG STUDIO, ALMA AND LEWIS KROOK WEDDING PHOTOMONTAGE, 1890.

The kind of photographs produced by this team is exemplified by the 1890 wedding portraits of Alma and Lewis Krook (fig. 8). In one photograph, they stand in the conventional formal pose but exhibit a lively naturalness that is unusual in wedding photography of the day. The series also includes a witty montage of two views of the couple, one in wedding costume, looking at a book and the other in everyday dress, having a chat (fig. 9).

For a time the relationship between Anton Gag and Lissi Biebl was strictly professional. About 1890 Anton became romantically involved with a young seamstress in town, Anna Ledrach, who in January 1891 sued him for breach of promise. He made a spirited

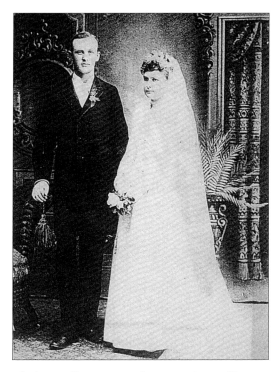

8. ANTON GAG STUDIO, ALMA AND LEWIS KROOK WEDDING PHOTOGRAPH, 1890.

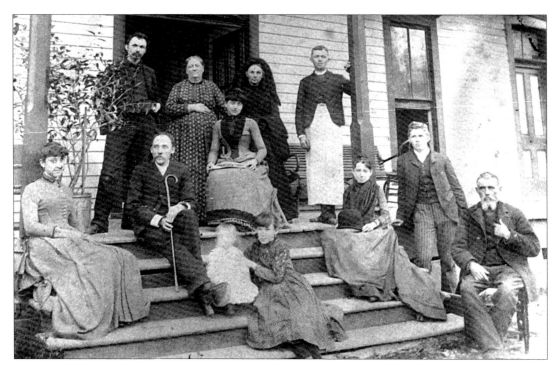

10. ANTON GAG (STANDING, SECOND FROM LEFT) AT THE MEDICAL AND SURGICAL SANITARIUM IN BATTLE CREEK, MICHIGAN, 1891.

answer to the charges. According to the lively account in the *New Ulm Review*, the case "for the first time in the history of legal proceedings set up the defense that the man had been seduced by the woman." Gag asserted that Ledrach had tried a similar ruse with another man, and that she was unchaste. But the jury's sympathy lay with the plaintiff, who characterized Anton as "a man of considerable property and good standing in the community." The artist denied that he had "any property outside of his photographic outfit, and on which he [is] still indebted to a considerable amount." The jury awarded Ledrach $500.[11]

Another compelling element of the trial was Anton's strong plea of ill health. A month after filing his answer to Ledrach's charges, he left town for a sanitarium in Battle Creek, Michigan (fig. 10). His New Ulm physician, L. A. Fritsche, declared in an affidavit to postpone the trial that for several months Anton had been suffering from "neurasthenia, a nervous disorder which, unless arrested, gradually undermines the system and is likely to and almost certain to result in nervous mental as well as physical wreck and its consequences." Although a skeptic might suspect that Gag was attempting to evade responsibility, it is plausible that Anna Ledrach's charges, with their threat to reputation and livelihood, provoked a genuine crisis in the sensitive young artist.[12]

On May 16, 1892, four months after the trial, Anton Gag and Lissi Biebl were married. Lissi's family, especially her three sisters, disapproved of the match. Accounts of their objections vary, some sources noting that the Biebls thought Anton unlikely to be able to support Lissi, others that they saw him as not physically strong enough. There is also the reasonable suggestion that the trial had damaged his reputation and that they viewed him as a womanizer. In any case, the Biebls dismissed him as "da Gach" ("the Gag") and refused to help Lissi with wedding preparations. Anton was offended by

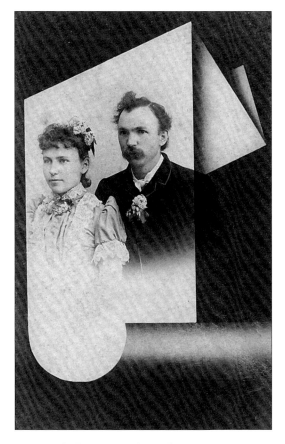

11. ANTON AND LISSI GAG WEDDING
PORTRAIT, 1892.

portrait is a photomontage demonstrating the growing sophistication of their work; notable are the contrasts in shape, texture, and value (fig. 11). Anton was also taking advantage of new technological developments, as indicated in an advertisement that first ran in the *New Ulm Review* on August 31, 1892: "I have now equipped my Gallery according to the latest method and am now able to furnish only the finest line of work. My new Apparatus lately bought is especially adapted for nervous people and children and enables me to overcome with ease a long felt trouble." One such new method was the "instantaneous process," permitting a reduction in exposure time. An advertising card he distributed at the Brown County Fair in 1893 presented a collage of his cabinet cards on the front and, on the back, a statement about his work (fig. 12).

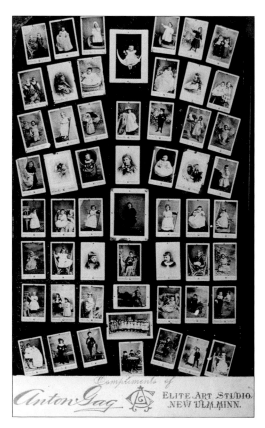

12. ANTON GAG STUDIO, ADVERTISING CARD,
BROWN COUNTY FAIR, 1893.

their attitude; he also disapproved of *them* for the way they ran their farm. He thought they did not work hard enough or exercise enough foresight.[13] Even so, the wedding took place at the Biebl farm, with a justice of the peace officiating. Alexander Schwendinger was Anton's best man. A brief notice in the *New Ulm Review* indicates that the wedding had been a secret to all but family and close friends, and it identifies both Anton and Lissi as photographers well known in New Ulm.[14]

The couple's first residence was an apartment above their North Third Street business, which was now called the Elite Art Studio. Anton, whose artistic signature had varied over the years, took to using the monogram AG, superimposed on images he produced in the manner of Albrecht Dürer.[15] The couple's wedding

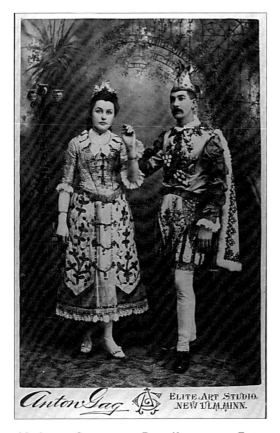

13. ANTON GAG STUDIO, ROSA KELLER AND EMIL WICHERSKI IN MASQUERADE COSTUMES FOR TURNER BALL, MID-1890S.

presenting prints to Turner Hall, the new court-house, the new courthouse, and the Catholic parsonage (fig. 15). The following year, he photographed the unveiling of the New Ulm Defenders' Monument, for which he had designed the bas-relief on the base (fig. 16).

Anton's interest in the technology of photography led him to work for years on various inventions. For example, he developed a camera that would take pictures at night, only to discover that the idea had already been patented.[16] In 1893 the *New Ulm Review* reported Anton's intention to build an addition to his studio and "show the people of New Ulm some surprises in photography."[17] Yet less than two months later Anton sold the operation to Albert Meyer and Joseph Sattler, announcing his intention to give up photography, take a rest, and devote more time to painting. The

The Elite Art Studio produced photographs not only for individual clients but for the general market as well. Just as photographers in New York and Paris produced keepsake photographs of famous beauties or actresses, the Gags made cabinet cards featuring local celebrities such as Rosa Keller, reputedly the most beautiful young woman in New Ulm (fig. 13), and the casts of plays performed at Turner Hall. They also produced collectible cabinet cards in the pictorialist tradition, that is, photographs that mimic paintings—landscapes, genre scenes, and still lifes. An undated photograph of a blooming cactus is a study of a single subject that reflects Anton's favorite approach to still life (fig. 14). A scene of cows in the river closely resembles his painting of the same title (see p. 54). Anton also documented important civic events in New Ulm. In 1890 he photographed nine surviving original settlers of New Ulm,

14. ANTON GAG STUDIO, BLOOMING CACTUS, C. 1890.

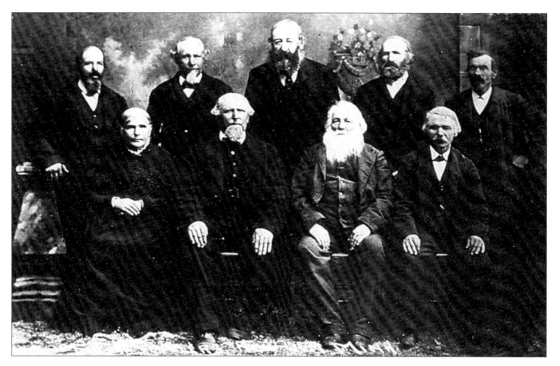

15. ANTON GAG, ORIGINAL SETTLERS OF NEW ULM, 1890.

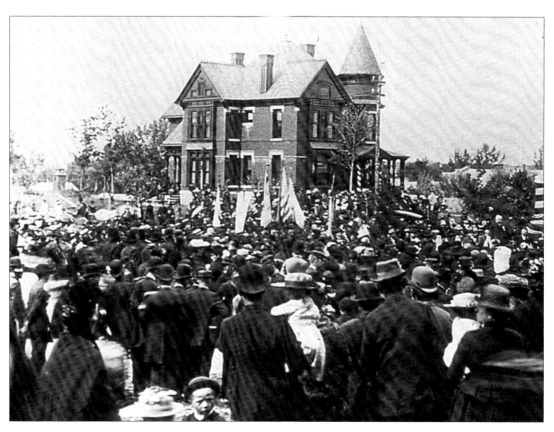

16. ANTON GAG, DEDICATION OF THE NEW ULM DEFENDERS' MONUMENT, 1891.

Review's reaction to this announcement attests to his reputation as a photographer whose work was particularly artistic.[18]

Anton would reenter the photography business in November 1896, however, joining Albert Meyer in his popular gallery on Broadway.[19] By that time he was doing decorative painting of houses and churches (see Chapter 5), but his income needed further bolstering largely because of the advent of several new Gags.

17. ANTON GAG STUDIO, WANDA GAG, 1894.

On March 11, 1893, Anton and Lissi's first child, Wanda Hazel, was born (fig. 17). Shortly thereafter, Anton built a Queen Anne-style house at 226 North Washington Street in New Ulm but had to sell it before moving in because he was unable to pay the property taxes.[20] The young family, expanded in October 1894 by the birth of a second daughter, Stella Lona, moved three times during the next four years to various apartments in New Ulm—each one infested by bedbugs—until the boost in income from the photography

business allowed them to buy the house back in 1897 (fig. 18).

Photography was integral to the life of the family that grew in this house. Anton maintained a photography studio there, and Lissi had a studio of her own in an alcove upstairs. Occasionally she produced photographs bearing the imprint "Mrs. L. Gag." Some of these were self-generated projects, as when she was prompted by the discovery of a newly hatched butterfly to round up three neighborhood boys to stage a genre scene. She also made numerous photographs of her children. A third daughter, Thusnelda Blondine (called Tussie or Nelda), was born in April 1897, shortly before the family moved into the house. Two more daughters, Asta Theopolis and Dehli Maryland, were born in July 1899 and December 1900, respectively. Anton was a devoted father who maintained that "the children are our greatest treasures. . . . I am rich in children."[21]

Wanda wrote of her parents' "warm, close knit love" and saw their union as the unusual kind in which "the thought of adultery does not occur, where there was never a rift, never a roving eye, never a yearning for pastures newer and greener."[22] In her eyes they were completely unselfish. Her father simply gave his life to his family, without regard for his innermost needs as an artist. Her mother never played the martyr but was simply selfless. No doubt this view was an idealization, but it became Wanda's model for marriage and parenthood, exerting a strong influence over her own adult choices.

Wanda also recorded her perceptions of community disapproval of the Gags. Artists were suspect in New Ulm, she believed. A photograph from about 1904 of Lissi Gag with Asta, Dehli, and Thusnelda indicates some of the ways the Gags might have seemed too free

and easy to some in New Ulm (fig. 19). They sit in the backyard of the North Washington Street house, which had a lawn rather than a sensible, money-saving vegetable garden. The children wear loose, comfortable clothing rather than the stiff, starched garments that were then commonplace. A more serious concern was the fact that the children were not baptized. (Anton believed in free thought and self-determination, even for children. Lissi apparently shared her husband's disaffection with organized religion: her own family had fallen away from the Catholic Church and only occasionally attended the Congregational Church.) Despite New Ulm's roots in freethinking principles, some citizens looked askance at this failure to have the children attend Sunday school and obey other conventions of small-town life.[23]

18. GAG HOUSE, 226 NORTH WASHINGTON STREET, NEW ULM.

But Wanda's retrospective ruminations notwithstanding, the Gag family was thoroughly respectable. Anton was admired for his integrity and dependability, and any fears by the Biebls that his devotion to Lissi would waver proved to be unfounded. Despite his agnosticism,

Anton had excellent relations with churches and churchmen in Minnesota: many of his commissions as a decorator came from churches in the area; and he counted several priests, including Father Alexander Berghold, among his

19. LISSI GAG WITH (LEFT TO RIGHT) ASTA, DEHLI, AND THUSNELDA, C. 1904.

friends. Moral instruction in the household was rarely explicit, however: Anton Gag set a strong example, and his values, derived from his German-Bohemian heritage, were clear: hard work, thrift, devotion to family, love of nature, and an exaltation of art and music.

Wanda would remember life with her mother and father on North Washington Street as a kind of children's paradise.[24] The architecture of the house itself has a fairy-tale-like quality: the tower was meant to evoke the *Turm* of castles on the Rhine, and its irregular outlines and varying materials and textures are highly picturesque. Diaries and memoirs by the Gags give the impression that the house was a hive of creative activity. The first-floor parlor served as a music room, where Anton played his zither and the family, all of whom were musical, learned the Bohemian songs of his youth. Upstairs were two bedrooms and Anton's *Malzimmer* (studio) with built-in bookshelves. The children became familiar with books belonging to Anton, who despite his limited education had acquired a love of learning and literature. Among his books were Dante's *Inferno*, Milton's *Paradise Lost* (both with illustrations by Gustave Doré), Cervantes's *Don Quixote*, a German Bible illustrated by Carl von Schnorensfeld, and the collected works of Goethe.

The third story, with three more rooms, had a trapdoor to shut out the world. In time Anton established a studio on this floor when the second-floor studio was needed as a bedroom for the children. It had a skylight, which neighbors considered impractical but that provided the northern light an artist needed. Elsewhere in the attic Anton stored the Indian regalia collected on his visits to the Morton Indian Reservation—headdresses, chamois pants, and other trappings that the children loved to wear. Here, too, were more bookshelves, with German art magazines and portfolios of engravings. The children absorbed these books and

pictures, which introduced them to Germanic culture—mountain and forest landscapes, picturesque costumes, and handcrafted interiors. "Sometimes I forget that I have never been in Europe," Wanda later said. "I always feel as though I might have lived there."[25]

Although Anton had close friends and associates, in many ways the family provided its own society. Anton and Lissi remained rather aloof from both sets of in-laws. Anton did not reconcile with the Biebls and in fact never visited their farm. Nor, on the other hand, was Lissi close to the Gags. Anton's mother, Theresia, died in 1898 (fig. 20). Wanda's unpublished "Childhood Reminiscences" record various little

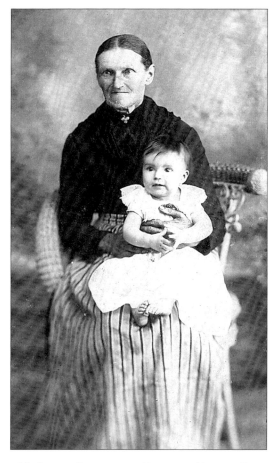

20. ANTON GAG STUDIO, THERESIA HELLER GAG WITH WANDA GAG, C. 1894.

21. BIEBL FARM, C. 1900.

slights that kept Lissi from developing intimacy with Anna and Joseph Sellner in Cottonwood Township or with Margaretha and Vincenz Klaus, who continued living in the Gag house on the Immelberg. Occasionally the children visited the Klauses, but Wanda found them unrefined and lacking in the sensibilities that governed her own home. The Immelberg had its interest—the woods there reminded Wanda of the settings of German fairy tales, but the cousins were not congenial company for the Gag children, and Wanda even found Tante Klaus somewhat alarming: because of a slight stroke she winked and wore a half-smile that suggested insincerity.[26]

The Biebls were another matter. Their farm, which the children called "Grandma's Place," was their own in a sense since the adults did not visit back and forth, and the long walk from the house on North Washington Street down to the river and along the railroad tracks took on a ritual cast. In the summer that walk could be painfully hot, especially the tracks themselves, yet to young Wanda

they represented "a bright parallel promise—a promise of good things to come."[27] The Biebl farm was outside town on a hillside above the Minnesota River, where the red-brick house, not large but pleasant and inviting, was surrounded by cottonwood trees and orchards (fig. 21).

The Biebls were from Kscheutz, Bohemia, about twenty-five miles from Anton's birthplace of Walk. They, too, were peasants but were better educated than the Gags ("refined peasants," in Wanda's view). Joseph Biebl, born in Bohemia in 1833, was the son of a farmer and innkeeper. He had finished high school and even studied for the priesthood (his brother was a priest) but married instead.[28] His wife, Magdalena, born in 1835, also came from an educated Bohemian family. Her brother was a professor in Prague, her niece an opera singer. Joseph and Magdalena had three children in Bohemia: Andreas, born in 1857; Maria Anna, called Mary, in 1860; and Franz (Frank), in 1864. In 1867 they left for America aboard an old sailing vessel, which almost sank after

colliding with another ship during one of several storms that imperiled their crossing.

The family settled in Harrisburg, Pennsylvania, where five more children were born: Eva (1867); Elisabeth, or Lissi (1869); Joseph, later called Josie (1871); and, in 1874, twins, Sebastian and Magdalena, called Lena. In 1874 the seven-year-old Eva contracted "galloping consumption" after a fall through the ice. The family decided to move to Minnesota, widely advertised as having a salubrious climate, but Eva died shortly after they arrived in West Newton. A ninth child, Anna, was born in 1877. The farm outside New Ulm that was the family's final destination was on the spot where the first settlers disembarked from the riverboat *Franklin Steele*.[29] Joseph and Magdalena did some farming but only just enough to get along (fig. 22). Joseph was more noted for his storytelling ability than for his industry as a farmer; he also served as scribe for many Goosetown residents, writing letters to the Old Country. Magdalena, who had more entrepreneurial spirit, drove a milk wagon.[30]

For Wanda, Grandma's place was characterized by "plenty":

> There was so much of everything, or everything had so much of something. The cows had calves and milk, the horse had a baby, the hens had eggs or chickies, Jack had puppies. The orchards were full of apple and plum trees, the bushes hung heavy with berries, the gardens were [unintelligible] (bursting with) flowers, the fields had hay. Plenty![31]

Wanda gives much attention in her unpublished reminiscences to the delights of Grandma's Place—the feel of the orchard, the glamour of the more prosperous farms across the river, the romance of the woods. The Gag children played intensely there in ways that contributed as much to their later artistic endeavors as did reading their father's books or watching him work. They played with dolls and learned to sew for them from the two aunts then living on the farm, Mary and Lena, who had trunks full of magical scraps and frills. One of Wanda's reminiscences, "Paper Dolls at Grandma's," recounts her joy in creating whole families (complete with "stern Papa") from the Sears, Roebuck catalog, where the flat cutout figures become part of three-dimensional worlds.[32]

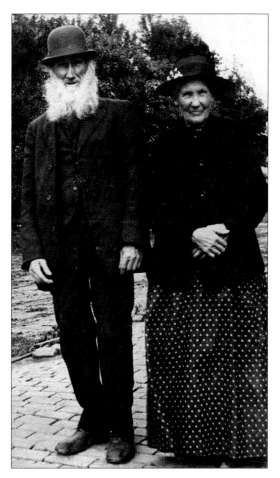

22. JOSEPH AND MAGDALENA BIEBL, C. 1910.

The children were intrigued by the Biebls, who were not so "cerebral" as their father—who were, in fact, relatively inarticulate. They haunted Wanda in later life, becoming points of reference for understanding herself and her

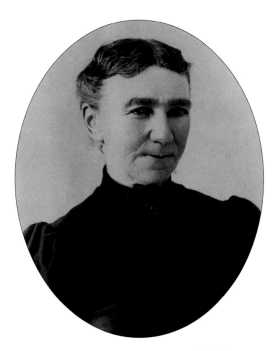

23. MAGDALENA BIEBL, C. 1895.

Mary was the oldest Biebl daughter living at home around 1900, the approximate time of Wanda's reminiscences; she was then about forty.[35] The most industrious member of the family, she is pictured as scuttling rapidly about in a half-run, half-walk. She was small-boned and wiry, with a peasant face and little vanity. The only Biebl female who had found work away from the farm, Mary had been a "hired girl" for various New Ulm families. She was the "stable, businesslike, responsible one," who worried about budgets, taxes, and running the house. Mary did her duty "consistently, doggedly, not always graciously," Wanda recalled, and was inclined to be quarrelsome.

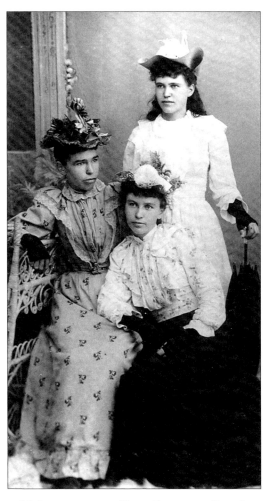

24. LEFT TO RIGHT: MARY, ELIZABETH (LISSI), AND ANNA BIEBL, C. 1890.

siblings. Grandma was the dominant figure in this potent world, although in no way dominating (fig. 23).

> How beautiful is a grandma! They are always old—any child knows that—but Grandma walks as straight as can be—she is neither fat nor thin. Her hair is graying but it waves in a girlish way from each side of the middle parting to the ears. Her eyes are large and—kindness. . . . She has a sweet smile—it is the smile of an intelligent peasant.[33]

Grandpa was, in contrast, a shadowy character. As an immigrant in Pennsylvania he had worked as a section hand on the railroad, a "fallen state," Wanda later realized. His mind and imagination remained either in the past—he spoke often of the Old Country—or in a vision of the future. (He would talk of going to Kentucky or Virginia, where he was sure good fortune could be found.) He was "earthy, innocently inelegant at times," which Wanda found distressing.[34]

25. ANTON GAG STUDIO, LENA BIEBL, C. 1895.

ization that Johnnie, the young boy who was supposed to be Mary's youngest sibling, was actually her illegitimate son. Mary displayed a poignant admiration for her son, who left school to become a railroad brakeman, and for his bride, Nora, "the prettiest girl in Wisconsin."[36]

Lena was the antithesis of Mary: idle and dreamy where Mary was compulsively busy, impractical where Mary was shrewd, and pre-occupied with her looks (fig. 25).[37] As a child, Wanda saw Lena as Cinderella awaiting her prince, although she came to see her more as the great "clinger-to-illusions." Unlike Mary, Lena was always available to play; she retained a childlike spirit that made her a perennial comrade in the children's make-believe world.

Mary was not by nature difficult, according to Wanda; circumstances had made her so. In another unpublished reminiscence, "How Many in the Family?" Wanda traces her gradual real-

Wanda's two uncles were so taciturn as to be figures of mystery. As a young man, Frank had been a photographer in Iowa but returned to

26. TOY CAROUSEL MADE BY FRANK BIEBL, N.D.

him to decline the offer. His drawings and watercolors, some quite competent, adorned the Biebls' parlor (fig. 29). Nostalgic for Harrisburg, he returned there in 1891—walking most of the way—and sketched the Biebls' former neighborhood in the suburb of Steelton as well as views of the city (fig. 30). He augmented the family larder by trapping and fishing. Like Frank, he was a superb craftsman who could make willow furniture, rowboats, toys, and doll furniture.[38] During Wanda's childhood he seemed content to stay at home, yet he continued to learn about the world through travel magazines. He was also a student of geography and astronomy, interests he shared with the children.

At the Biebl farm, "one was in a familiar place but yet not at home with its responsibilities," Wanda wrote. One imagines that there was little in the way of discipline or direction from these abstracted adults who appeared to

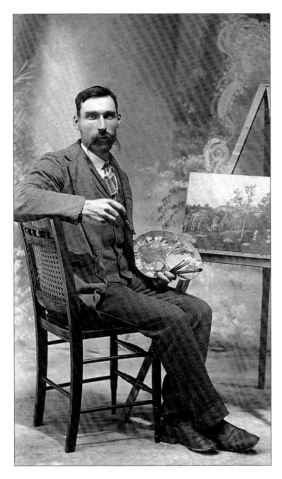

27. SATTLER AND MEYER STUDIO, FRANK BIEBL, C. 1895.

New Ulm to help with the farm. He was handsome, with black hair, a handlebar mustache, and deep-set blue eyes. He had a workshop down by the river where he made all sorts of things, some useful (such as gunstocks and furniture) and some creative (such as a small-scale toy carousel; fig. 26). Frank still took photographs and also painted in oils (fig. 27). Like Anton, he had the Bohemian gift for music and accompanied himself as he sang on instruments he had made himself.

Uncle Josie was a slight, sensitive man who, like Frank, rarely spoke (fig. 28). As a youth in Harrisburg he had shown enough artistic promise that someone had offered to send him to art school, but his retiring nature led

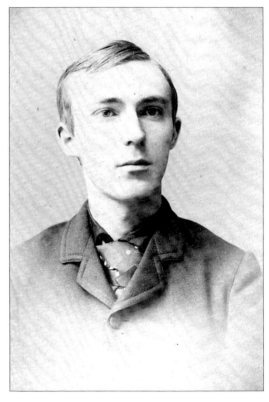

28. JOSEPH ("UNCLE JOSIE") BIEBL, 1891.

Wanda "three-dimensional, monumental in their simple integrity."[39] There were undercurrents of emotion in this carefree world, however. As a child Wanda was struck by some "saddish, not-there-ish" quality to Grandma's Place. Years later she realized why. Whereas everything at the farm—the bounteous pastures, the teeming barnyard, the green grounds—teemed with the life force, the human beings did not. Of the four aunts and uncles who had remained at home, none had children except Mary, whose secret child was part of the sadness, the "unnatural suppression of this part of their lives."[40]

The Biebls became mythic figures in Wanda Gág's mind: objects, emotions, and processes associated with Grandma's Place would be at the heart of her work. And Wanda's later life at her New Jersey farm, All Creation, where she lived with siblings whom she tended to see in terms of their Biebl forebears, can be understood only with reference to the Biebl farm.

29. JOSEPH BIEBL, *GIRL SEATED ON A WALL*, N.D., PEN AND BROWN INK, 17 x 14 IN. BROWN COUNTY HISTORICAL SOCIETY, NEW ULM, MINNESOTA.

30. JOSEPH BIEBL, *HARRISBURG, PENNSYLVANIA*, 1891, PRINT (PROBABLY WOOD ENGRAVING), 11 x 8 7/16 IN. BROWN COUNTY HISTORICAL SOCIETY, NEW ULM, MINNESOTA.

5 ANTON AS DECORATOR
1895 – 1908

In 1895 Anton Gag joined with Christian Heller in a business firm specializing in the decorative painting of houses and churches. This venture has usually been regarded as an unfortunate obligation that took them away from "real art." Yet both artists—and Alexander Schwendinger, who sometimes joined them—came from an Old World tradition that valued decoration as an integral part of life. In the artistically rich German-Bohemian tradition from which Anton emerged, every surface was seen as susceptible to decoration. This tradition was central to his life and reflected his deepest values as an artist.[1]

No doubt Gag and his two confreres would have preferred to restrict themselves to easel painting. But as has been shown in earlier chapters, they, like nearly all their contemporaries in America, could not earn a living by that sort of painting alone.[2] Thus, one by one, they went into the decorating business, using their skills on houses, churches, and civic buildings, especially New Ulm's Turner Hall, and a great variety of smaller projects along the way.

Theirs was not the first such firm in New Ulm. Among the earliest was that of John Hirsch, who began advertising in the *New Ulm Post* in 1885 as a paperhanger and house and sign painter. Julius Krause was another longtime decorator who specialized in ceiling decoration. The firm of Pfeiffer and Lütjen opened in 1892, advertising a similar range of skills as house, sign, and carriage painters. This burgeoning of the decorating business in New Ulm coincided with a new prosperity from the city's mills and breweries. During the 1870s advertisements in the *New Ulm Review* had focused on farm machinery for men and sewing machines for women; the most prominent advertiser of clothing had been Cheap Charley. But around 1887, F. Kuetzing opened a clothing emporium advertising millinery with "the largest assortment of fine flowers, ostrich tips and plumes of any house west of St. Paul" and even such luxuries as "oriental laces and flouncings in white and ecrue."[3] As this sort of development suggests, New Ulm was no longer a frontier town preoccupied with survival.

Christian Heller (known to all as Chris) was the first of the trio to go into the decorating business (fig. 1). An 1889 article in the *New Ulm Review* on one of his early projects, the Lind residence, commends the "artistic" decoration of the dining room ceiling and explains its practicality:

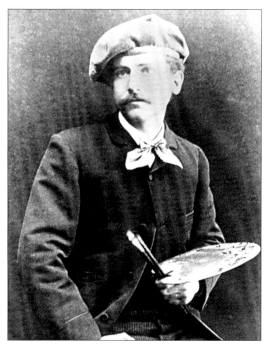

1. ANTON GAG STUDIO, CHRISTIAN HELLER, EARLY 1880S.

The decorations are executed in oil colors, after original designs, and are so much superior to paper decorations that one must wonder why more of this class of work is not executed in New Ulm. The first cost is much greater than that of paper but when you reflect that the decorations are indestructible, while paper has to be renewed every few years, it will be found that the painting is the cheaper. It is well worth a person's time to inspect Mr. Heller's work.[4]

In the early 1890s Heller teamed with Julius Krause and then with Otto Seiter.[5] In 1892 Heller and Seiter advertised their willingness to do painting, calcimining, papering, decorating, and all other kinds of decorative work "neatly and in an artistic manner." It is the designation of "artistic" that distinguishes the Heller and Seiter advertisement from those of more prosaic rivals.[6] In May 1895 Anton Gag joined the firm, which advertised as "Heller, Seiter & Gag, the leading painters" with the ability to execute "all kinds of painting, from house painting and decorations to portraits. Artistic frescoing a specialty."[7]

Anton decorated his own house on North Washington Street to display his wide-ranging talents. The exterior was painted seven different colors in accord with high Victorian taste, and the interior was also artistically painted. In recent years, much of this original work has been restored.[8] The front parlor near its ceiling has an eighteen-inch-wide band of scrollwork done freehand (fig. 3). Pocket doors leading to the dining room show fashionable "graining" that makes the pine look like oak. The dining-room ceiling was originally sky blue and enhanced with clouds from which cherubs with the faces of the artist's children peeked forth. On the wall of the staircase leading to the second floor are two ornamental borders: one, a series of stylized flowers, the other (near the ceiling) a

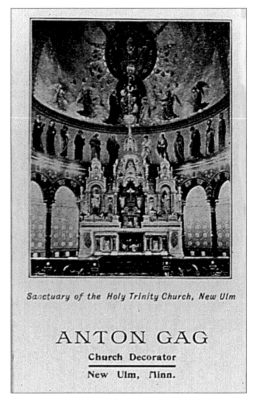

Sanctuary of the Holy Trinity Church, New Ulm

ANTON GAG

Church Decorator

New Ulm, Minn.

2. ANTON GAG'S BUSINESS CARD, C. 1896.

series of lions rampant. Even the newel caps have floral designs. Throughout the house, Anton painted walls and woodwork in an artistic manner, achieving deep shades by using a myriad of tiny brushstrokes, like a fresco painter, rather than the usual broad strokes. The upstairs hallway has three shades of brown with gradations of color that relate to the play of natural shadow and light.[9]

The firm did similar work in other houses in New Ulm and the surrounding area. In the spring of 1902, for example, the *Sleepy Eye Herald* noted

3. DECORATIVE WALL BORDER IN THE GAG HOUSE, 226 NORTH WASHINGTON STREET, NEW ULM (DETAIL).

that Anton Gag, "the scenic artist," was in town, repainting and touching up wall and ceiling paintings at the home of Henry Berg.[10] The firm did commercial work as well. In 1901 Heller and Gag completed a set of banners for the Burg cigar company advertising Blizzard and Nan Wilkes cigars. They painted an advertising sign on the exterior side wall of the Model Drug Store. In 1902, the fortieth anniversary of the Dakota Conflict, Anton fulfilled a commission from the Eagle Roller Mill Company for a commemorative scene painted on a barrelhead, which was sent to the editor of the trade journal *Northwestern Miller* in Minneapolis. Heller and Gag designed floats for the anniversary parade, which moved an admiring writer for the *New Ulm Review* to comment that "these gentlemen have made themselves illustrious by their art and though they are not appreciated as they should be their work is none the less admired."[11]

Gag and Heller became the leading artists in the firm, which sometimes employed up to thirty workmen. Both men were exacting craftsmen who were subject to outbursts of temper if work was not done just right. They also were known for their integrity and generosity, and were greatly admired by their crews. The firm was not a financial success, however, despite diligent work by Anton Gag and Chris Heller: some employers (particularly churches) were inclined to underpay the firm, and its business methods, overseen by Chris Heller, were sometimes slapdash.[12]

The work of the firm was, however, an artistic success. A notable example is the mural cycle for St. Patrick's Church in West Albany, Minnesota, a small, rural church in American Gothic style. Commissioned by the Reverend John Schwartz, an immigrant from Austria and one of Anton's friends, they were completed in

1898.[13] The four large-scale murals in the nave on the arches of the barrel-vaulted ceiling that Gag, Heller, and Schwendinger painted focus on the Nativity, the Transfiguration, the Descent into Hell, and the Assumption of Mary. These standard subjects are rendered in bold, simple compositions with dramatic colors in an Italian Renaissance style that shows the artists' grounding in the academic tradition. *The Transfiguration*, which depicts Christ rising above several of his disciples, bears a passing resemblance to the *Transfiguration* of Raphael (1517, Vatican, Rome); Raphael also used the device of clouds made up of angels' faces in the *Sistine Madonna* (1513, Gemäldegalerie, Dresden). *The Assumption* recalls Titian's *Assumption of the Virgin* (1516–18, Santa Maria Gloriosa dei Frari, Venice) and reflects a Venetian emphasis on rich color in the red and blue of the Virgin's garments and her golden aureole. It is probable that Anton saw the important fresco on the same subject at Assumption Parish in St. Paul, completed in 1887 by a German artist from Covington, Kentucky.[14] *The Descent into Hell* (fig. 4) is notable for its skillful use of perspective: the viewer (sharing the point of view of the damned) looks up at Christ and his angels on horseback for a dramatic sense of their supernatural force.

The firm's most important commission came from the Cathedral of the Holy Trinity in New Ulm. Heller, Schwendinger, and Gag worked for several months in 1903 on paintings and other decorative work throughout the church, often standing or lying on scaffolding. Wanda Gág recalled accompanying her father on the job to try to learn how to be a painter and worrying that she could never do such work in a skirt.[15] This project, in contrast to the austerely simple St. Patrick's, was splendidly Baroque. The focus of the decorative scheme was the high Baroque altar, constructed by E. Hächner of Lacrosse, Wisconsin, and installed in 1901. The artists designed a grand fresco behind this

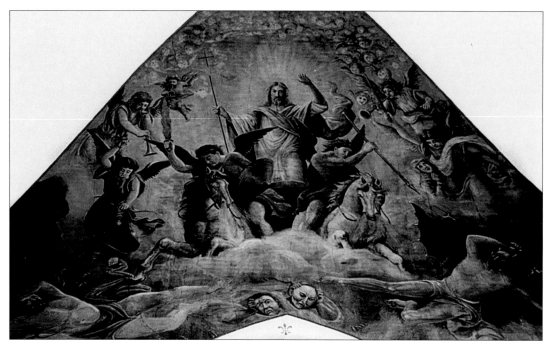

4. GAG, HELLER, AND SCHWENDINGER, *THE DESCENT INTO HELL*,
1898, ST. PATRICK'S CHURCH, WEST ALBANY, MINNESOTA.

altar with an iconic Father, Son, and Holy Ghost surrounded by saints and cherubim. It is necessary to look at photographs of Holy Trinity taken in the early 1900s to see the original paintings, which underwent extensive renovation—and simplification—in 1959 (fig. 5). Those photographs also reveal extensive geometric patterning on the sanctuary walls and graceful floral designs on the arches and entablature of the ambulatory, as well as close geometric patterning on the bundled pillars and ribbed vaults of the nave (fig. 6). The project must have resonated deeply with Anton, despite his agnosticism: the decorative scheme echoes the Rococo splendor of the church in Pernartitz he knew in childhood. And it is entirely in character that he endowed several of the angels in the apse fresco with the faces of his own children.[16]

Anton's most important long-term source of patronage was Turner Hall. As we

have seen, his Turner connections began with August Schell, J. B. Vellikanje, and August Berndt. Although German-Bohemians and Turners did not usually mix socially in New Ulm, Gag eventually became a member of the *Turnverein*.[17] His children also participated in programs, such as the Turning School (gymnastics classes) and kindergarten.

Anton was an active promoter of the theater at Turner Hall, and, for at least part of his career, commissions to paint scenery and photograph productions kept him solvent. First built in 1858, the theater was central to the Turner mission to promote German language and culture. It was recognized as one of the few Minnesota venues outside the Twin Cities where one might see productions from New York, even Germany.[18] In 1873 the distinguished soprano Madame Methua-Scheller performed in Donizetti's *Daughter of the Regiment*. Her husband, an Italian painter named J. Luigo Methua, created sets for the production and decorated the Turner Hall rathskeller with a series of murals

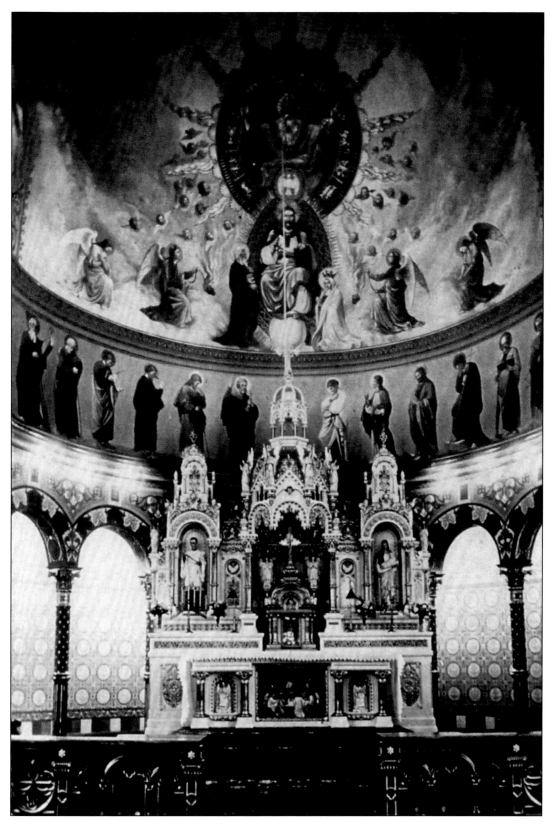

5. APSE OF CATHEDRAL OF THE HOLY TRINITY, NEW ULM, C. 1910.

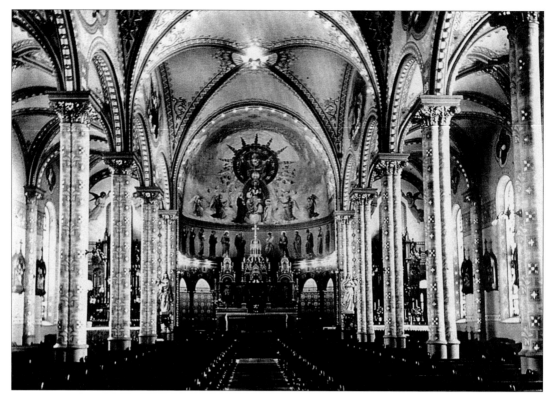

6. INTERIOR OF CATHEDRAL OF THE HOLY TRINITY, NEW ULM, 1910.

depicting castles in Germany. Later, however, the theater fostered local talent, and its play-bills featured a succession of Fischers, Pfaenders, and Seiters (fig. 7).

The firm's greatest opportunity came in 1901, when the *Turnverein* built a new hall for the extravagant sum of $25,000 (fig. 8). The brick-and-stone structure, with its 112-foot-tall facade, contained a state-of-the-art theater seating 800.[19] Heller and Gag created a drop curtain representing the Bavarian mountain town of Hallstadt (fig. 9). The subject had deep personal meaning for Anton. The picturesque site was a place "not only of great beauty, but of culture, peace, and religious tolerance—qualities he considered necessary for happy living," his daughter Wanda said.[20] Anton also painted a backdrop representing a forest, which—like so many of his paintings—evokes the beauty of the Böhmerwald. The first audience to see it burst into spontaneous applause.[21]

Over the next few years Heller and Gag finished the interior decoration of the theater with assorted projects such as an asbestos curtain

7. HUGO FISCHER AND ELLA SEITER IN THE PLAY *PFEFFER-ROSEL* AT THE TURNER HALL THEATER, 1893. SCENERY PAINTED BY ANTON GAG.

8. TURNER HALL, NEW ULM, DEDICATED 1901.

with a portrait of Frederick Jahn, the founder of the *Turnverein*, wall paintings, and medallions with portraits of Goethe, Schiller, and Shakespeare. Finishing work was so extensive (involving twenty-nine thousand feet of lumber) and costs so much higher than expected that on July 4, 1906, the Turnverein seriously debated whether it could afford to proceed. In the end, the money was raised by public subscription.[22]

Both Anton Gag and Chris Heller also reworked and added to the murals in the Turner Hall rathskeller. Luigo Methua's subjects, which were based on woodcuts, included the city of Heidelberg, Rheinstein Castle (home of Siegfried), Mount Kyffhaeuser in Thuringia (final resting place of the Holy Roman emperor Frederick Barbarossa), and Lichtenstein Castle, near the German city of Ulm. Each place, as explained in an 1887 series of articles in the *New Ulm Review*, figured importantly in the cultural history of Germany.[23] The articles also described new work in the rathskeller by Chris Heller, who added two paintings of castles in his native Switzerland and also did some restoration work on Methua's fourteen-year-old panels, which were already deteriorating.

In 1901 Heller and Gag did further work on the murals (fig. 10).[24] They are believed to have added new scenes, but determining exactly what they painted is problematic: no contemporary

9. GAG AND HELLER, PRELIMINARY STUDY FOR HALLSTADT DROP CURTAIN, TURNER HALL THEATER, 1900, WATERCOLOR, 14 X 19 IN. BROWN COUNTY HISTORICAL SOCIETY, NEW ULM, MINNESOTA.

photographs have been found, and all the murals were painted over during World War I, when anti-German feeling ran strong in Minnesota. Restoration work done in 1994 revealed heavily damaged surfaces.[25] One panel can plausibly be attributed to Gag and Heller, however: the view of Pappenheim Castle, which was not mentioned in the extensive description of the works published in 1887. Unlike other sections of the mural, this view has a thick forest in the foreground. It is tempting to see Anton's hand in the emphasis on nature in this section, but the painting style—perhaps altered by Carl Pfaender—is not notably different from other visible scenes. Other decorative work included a series of medallions behind the bar, representing the four seasons, and decorative wall borders of the kind seen in Anton's house.[26]

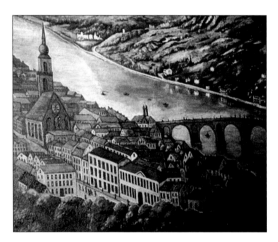

10. HEIDELBERG CASTLE, TURNER HALL RATHSKELLER MURAL (1996 PHOTO).

Anton and Lissi Gag were "rich in children," but Anton wanted a son. At last, on December 13, 1902, Lissi gave birth to a boy, Howard Anthony Jerome. Anton's joy was such that a toothache bedeviling him before the birth disappeared at once.[27] Now with six children to feed, Anton worked more doggedly than ever at his decorating business. Meanwhile, his health, never robust, began to deteriorate. Added to the vague "neurasthenia"

was a persistent problem with an ulcerated foot, which required that he bandage it when he worked and sometimes use crutches; he had at least one operation.[28] The business also involved certain hazards: paint chemicals, implicated in certain lung diseases, and long hours of work in buildings that were often cold and damp began to damage his lungs.

By 1906 both Anton Gag and Chris Heller were diagnosed with "occupational tuberculosis." That year Anton journeyed to Oregon in search of a cure, a destination probably recommended by Chris Heller, who had visited his brother there for several months in 1896 to better his health.[29] Anton stayed several weeks, taking the opportunity to paint a number of landscapes capturing the gentle atmospheric effects of the northwestern scene (fig. 12). Upon his return Anton worked as hard as ever, spending the winter and spring of 1906–7 decorating churches in Mankato. Even such a devoted father as Anton could not be entirely pleased when a seventh child, Flavia Betti Salome, was born on May 24, 1907. Wanda was then fourteen, and Lissi Gag, worn out by childbearing and financial cares, turned the care of this child over to her. "It was just about *my* baby," Wanda wrote later in the proprietary spirit that would characterize her attitude toward her six siblings.[30]

About a week after Flavia's birth, Anton, who was away working, wrote Wanda a letter that is one of the few extant documents in his hand. It shows his warmth and affection for this precocious daughter; it also shows that he was instructing her in the mechanics of photography:

My dear Wanda,
Received your lovely letter and am pleasantly delighted that mamma and baby are in good spirits, also that Bubi [Howard] is doing well. Today was

Decoration day, but took no note of it, had to be busy the whole day. . . . Dear Wanda, you write that you cannot get the plate out of the frame, but I told you in case you do not get it out by hand, then take a pocket knife, press the spring down, as far as you can, and try to get the point of the knife up stuck in between the glass and the wood [to] get it out. . . . When I come home [you] should make an attempt sometime . . . with my supervision. So now enough, with heartfelt greetings to all of you taken together, I am Your and all of your, Papa[31]

The following year Dr. Ludwig Bell of New Ulm examined Anton Gag and told Mrs. Bell that the artist would soon die.[32] In April 1908 efforts were made to save his life by sending him twice to St. Paul for medical consultations, but these were of no avail. Anton spoke movingly of the pleasure he gained from his last sight of the Minnesota countryside.[33] His decline was rapid.

11. THE SIX GAG CHILDREN, C. 1906. FRONT, LEFT TO RIGHT: HOWARD, ASTA, AND THUSNELDA. BACK, LEFT TO RIGHT: STELLA, DEHLI, AND WANDA.

The downstairs parlor was converted into a sickroom so that he could be near his family. Before his death on May 22, Wanda kept vigil

12. ANTON GAG, HOUSE ON HILL—MIST (OREGON), 1906–7, OIL ON CANVAS, 8 1/2 X 13 IN. PRIVATE COLLECTION.

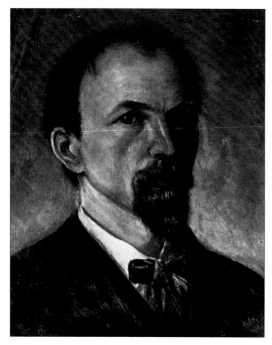

13. ANTON GAG, SELF-PORTRAIT, C. 1903, OIL ON
CANVAS, 9 1/2 X 7 1/2 IN. PRIVATE COLLECTION.

painting through the night.[34] He died that night, three weeks short of his fiftieth birthday.

Anton's obituary in the *New Ulm Review* identified him as a "photographer and great lover of the beautiful in nature."

His studies at the art schools were limited, to be sure, but such was his natural genius for painting and decorative work that he soon acquired a reputation all over the state. Today there stand, not one, but many public buildings, notably the Turner Theatre and the Catholic church, as monuments to his skill with the brush. . . . The sympathy of a community, that was just beginning to appreciate Mr. Gag at his true worth, will go out to them [his family] in their bereavement.[35]

by her father's bedside. Anton's last words to his eldest child became the touchstone of her career: *"Was der Papa nicht thun konnt, muss die Wanda halt fertig machen."* ("What Papa was unable to accomplish, Wanda will have to finish.") He then became delirious and spoke disjointedly about color, or light and shadow, as if

The death of Anton Gag would end the "paradise" his children had enjoyed. Lissi would not adapt to his loss, nor would she continue developing her artistic gifts. But Anton left seven talented children whose drive to create and nostalgia for the way of life he and Lissi had provided would shape their lives.

6 WANDA'S MINNESOTA YEARS
1908 – 1917

After Anton's death the family's financial state quickly became precarious. With savings depleted by his long illness, their assets consisted of the house on North Washington Street, about $1,200 in insurance money, and $8 a month from the county. According to Wanda, the Gags felt "dazed and helpless."[1] In October she began keeping a record of the family's financial accounts in an old ledger of her father's. Such a record was necessary: Wanda had in effect become the family business manager. (Lissi had little "executive ability."[2]) But her vibrant inner life "spilled over," and the ledger became a copious diary, selections of which were published in 1940 as *Growing Pains*.

Lissi Gag coped as well as she could with the demands of seven children. Diaries and memoirs by both Wanda and Flavia describe their mother's creative cooking with sometimes-scant supplies and her spunky efforts to maintain Bohemian holiday customs, such as presents from Kris Kringle. But her health was not strong, and after a doctor prescribed a "beer cure," she became increasingly dependent on alcohol.[3] *Growing Pains* does not deal with Lissi's condition directly but rather alludes to her being "unwell" and to things "going crooked"—code words for her addiction. She grew increasingly reclusive. Flavia, the youngest child, would later write that she could remember her mother leaving the house only three times.[4]

Growing Pains, our principal source of information on Wanda Gag and her family from 1908 to 1917, gives the sense of a family mostly on its own, resisting charity, refusing any offer of help that might split them up. As for

relatives, the children felt kindly only toward the Biebls, who supplied produce when possible and continued to welcome the children for visits. The children tried to turn privation into a game. For instance, they drew lots to divvy up food when it was scarce or remade hand-me-down clothes so skillfully that they excited the envy of the townspeople. Like Louisa May Alcott's *Little Women, Growing Pains* has a spirit of enterprise and exuberance that engages the reader, although Wanda also lets us know that it was not *fun* to be poor.

Wanda knew she had a real talent for drawing (fig. 1). Certainly, for all the Gag children drawing was a completely natural activity, as was being musical. (In fact, Wanda was so talented musically that Anton had wondered whether

1. WANDA GAG, *GIRL WITH FLOWERS* (SKETCH OF DEHLI GAG), 1908–9, INK, 6 1/4 x 5 IN. BROWN COUNTY HISTORICAL SOCIETY, NEW ULM, MINNESOTA.

she would turn out to be a musician.) Stella had a penchant for drawing fairies and cupids. Dehli specialized in tiny pictures and poems that she "published" in a miniscule newspaper. The siblings sent each other illustrated missives in a "postal box" made from a shoebox as part of entertaining themselves on slender means. But Wanda differed from her sisters and brother in having a fierce need to draw that burst forth in what she called "drawing fits" or "drawing streaks." She also was subject to a dreaminess that interfered with her ability to concentrate in school, a trait that Anton had

2. WANDA GAG, FASHION DRAWING, 1910–11, WATERCOLOR, 6 1/4 x 3 1/2 IN. BROWN COUNTY HISTORICAL SOCIETY, NEW ULM, MINNESOTA.

found acceptable, even admirable. Wanda associated this dreaminess that made her different from other people with her father.[5]

Indeed, Wanda had been her father's special protégé. She had followed him around everywhere to watch him work. He taught her primarily by example. Rather than prescribe subjects in formal lessons, he allowed her to draw what she wished. He praised her drawing when it pleased him but remained silent if it did not. He approved of straightforward drawing from memory or imagination but indicated that drawing from nature was best. On the other hand, he *disapproved* of any false or fancy effects. Anton seemed to value what the British Pre-Raphaelites of the mid-nineteenth century called "truth to nature," though neither he nor Wanda used that term.[6] Like her father, she responded strongly to nature. One of the pleasures of reading *Growing Pains* is following Wanda's growing attunement to natural beauty, as reflected in this description of a sunset from 1909:

> The outlines of the trees became more distinct, and the inside more solid, a black mass like ebony, with their outlines cut sharp and clear against the fiery background; oh it was all too beautiful to explain. All I could do was to watch and get out as much as possible of the beauty of it all; and perhaps I did feel a little bit sentimental. . . . Things went crooked, generally, after that, but it isn't the use of taking notes of your troubles. You're better off if you forget them.[7]

Now that it was necessary to augment the family income, Wanda, along with Stella and Thusnelda (Nelda), set about drawing and making things to sell. With the same industry and enterprise they had observed in their father, they made place cards, "postals" (postcards), and other decorative items. They

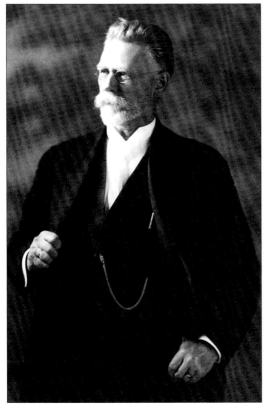

3. ROBERT KOEHLER, 1916.

submitted drawings and stories to *Journal Junior*, the juvenile supplement of the *Minneapolis Journal*. Wanda published so often that in 1909 she was invited to do a series, "Robby Bobby in Mother Goose Land." Her art supplies were scant—mainly the leavings in Anton's studio—and the *Journal Junior* editor, knowing this, sent a package of Bristol board, India ink, and a draftsman's triangle along with payment for the work.[8]

The house was filled with Anton's unsold paintings. Occasionally someone would buy one—surely a welcome source of revenue as well as an indication of his continuing reputation as a fine artist. From Wanda's point of view, however, such purchases were a depredation. "Why do we have to sell pictures?" she wrote in September 1909. "I feel as if I wanted to take all the paintings and put them somewhere so that no one could come and buy them. While I

was at grandma's this summer, mama sold one too, and I just know we didn't get enough for it, so there!"[9]

Wanda did not go to school in the fall of 1908 because of her responsibilities at home. She managed the house and cared for the smaller children, reading and drawing in what little spare time there was. She was indignant about gossip charging that she did nothing but read and draw. She was able to enter high school in January 1909. Wanda was very bright and, though her diaries record the usual adolescent anxieties about physical attractiveness, knew quite well how pretty she was. Her spirit was ardent. She expressed a hunger for art and literature, though her tastes tended to run toward melodramatic newspaper serials such as "Beverly of Graustark." She also read magazines when she could get her hands on them, doting on work by popular illustrators such as Howard Chandler Christy, Rose O'Neill (originator of the Kewpie doll), and Jessie Wilcox Smith. But her real models around this time—not only for her sense of artistic style but also for her own ideal of personal beauty—were the successful fashion images of Harrison Fisher and Charles Dana Gibson (fig. 2).[10]

Wanda received her first public recognition as an artist in April 1910, when the Minnesota State Art Society's annual exhibition was held in New Ulm. Presented in a different town each year, this juried show was designed, as Wanda wrote, "to find all the 'mute, inglorious Michelangelo's [*sic*] and Raphaels and Rosa Bonheur's' [*sic*]. . . . Would that I were one."[11] Two months before the exhibition, Robert Koehler, head of the art society and director of the Minneapolis School of Art, came to the Gags' house, accompanied by Alexander Schwendinger, to select some paintings by Anton Gag. Koehler also took notice of the teenaged Wanda and paid her the honor of choosing some of her drawings as well.

4. WANDA, 1910.

Soon after the exhibition, Wanda entered a drawing contest at the St. Paul School of Art and won a bronze medal. The prize-winning drawing, a sketch of one of her sisters, was published in a local German-language newspaper, the *Volksblatt* (people's newspaper), and Wanda had her first publicity photograph taken. She took a blasé tone: "Splendid things come so often, I'm learning to take them in quite a matter-of-fact way."[14]

In August 1910 Wanda began her junior year of high school. As was her way, she applied herself to subjects she liked and ignored those, such as mathematics, that she disliked. She enjoyed modern history, which at New Ulm High School included an introduction to art history. The instructor was "Mr. Doom" (Wanda used code

The springtime exhibition included more than six hundred works: paintings, prints, handicrafts, and architectural drawings. Well-known artists such as Douglas Volk, J. Alden Weir, and Koehler himself were represented, as were the efforts of amateurs and students.[12] For Wanda, the experience of seeing her father's work in this context—the first large-scale exhibition she had ever attended—was momentous. Even better, *she* was singled out at the opening-night ceremonies. Before a crowd of more than a thousand, University of Minnesota president Cyrus R. Northrop gave her a special award. (At seventeen, she was too young to compete for a regular prize.) Both Koehler and Northrop told Wanda she should go to art school—an affirmation of her most heartfelt dream. It meant a great deal to her that Koehler took both Anton and herself seriously as artists. A few months later he wrote that he thought Anton's paintings worth "$50 and more apiece." He also offered her advice as an artist that echoed her father's, to draw from nature as much as she could.[13]

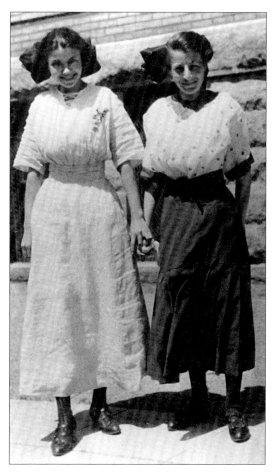

5. WANDA (LEFT) AND ALMA SCHMIDT, c. 1912.

names for most people mentioned in her diary, outside her immediate family), one of several teachers with whom she carried on an innocent flirtation. Her diary account of one class indicates that she had done a good deal of reading on her own about such artists as Mary Cassatt, Winslow Homer, and James McNeill Whistler. She felt able to tell the teacher a thing or two with her insights on "national art" as opposed to an artist's own "characteristic art."[15] Mr. Doom introduced the class to the Renaissance. Wanda admired Raphael's *Sistine Madonna* for its "gentleness and delicacy and a great deal of feeling. . . . Nearly all those artists were taught to draw when they were very young," she noted, "and there seem to be few who worked under difficulties in their youth."[16] The teacher acknowledged Wanda as an artist herself and predicted that someday she would belong to "the 'Bohemian Circle'" (a reference Wanda was glad she understood). She countered with a prediction of her own, that she would function best not as a member of a group but as an "attic artist, away from the world."[17]

Wanda's closest friend was Alma Schmidt (called "Paula" in *Growing Pains*) (fig. 5). She was good-hearted and usually willing to tolerate Wanda's effusions; her family was also very hospitable. In July 1911 Alma took her to St. Paul, where they stayed with Governor and Mrs. Adolph O. Eberhart. (Mrs. Eberhart was a cousin of Alma's mother.) This seems to have been the first visit to the Twin Cities for Wanda, who was charmed by Eberhart, a courtly man who sang "The Böhmerwald" and took them riding in his automobile. The visit also provided the young artist with fresh publicity when her sketches of the governor and his wife were published in the *St. Paul Daily News*. The pictures drew the attention of Tyler McWhorter, an illustrator who also was the business manager of the St. Paul School of Art. The governor took Wanda to meet McWhorter, who sharpened Wanda's ambitions by taking

her to visit the art school and telling her he would find a way for her to attend.[18]

Graduation from high school was bittersweet for Wanda. On the one hand, she reveled in the festivities, starring in the school play and dazzling her admirers in an exquisite dress sewn by her Aunt Lena Biebl (fig. 6). On the other hand, her ambitions to become an artist seemed thwarted by duty. By 1912 it was clear

6. WANDA'S GRADUATION PICTURE, NEW ULM HIGH SCHOOL, 1912.

that Lissi was never going to earn a living for the family and that Wanda and her next-oldest sisters would have to put that responsibility first. She had corresponded about the possibility of attending art school with both Tyler McWhorter and Charles Weschcke, a St. Paul businessman who had known Anton, but she decided that before that could happen she would need to earn enough money to help Stella, and then Nelda, complete high school. Her best opportunity was teaching school. (Alma Schmidt, meanwhile, looked forward to a grander future, departing for Chicago with the expectation of entering the University of Chicago in the fall.) Wanda spent the summer trying to pass the required qualifying examinations—a challenge, since "drawing moods" kept seizing her.

Wanda did pass the exams, however, and in early November 1912 began teaching at a rural school in Bashaw Township, near Springfield, Minnesota. It was a one-room schoolhouse for grades one through eight, and Wanda—only nineteen years old and weighing a scant one hundred pounds—felt intimated by the bigger boys.[19] But she worked hard at teaching and benefited from the experience. She was forced to study a range of subjects, including mathematics, and obliged to subdue her own wayward moods. Springfield offered some social life—dances, sleigh rides, even a flirtation or two. But her real life, drawing, was suspended for the year, though a letter she received in February from Arthur J. Russell, new editor of the *Journal Junior*, temporarily unsettled her. Russell noted that he was publishing some of her drawings and wanted to help further her studies, as well as those of Stella and Nelda.

Wanda returned home for the summer of 1913. She planned to resume teaching in Springfield in the fall, but that was not to be. In mid-June, New Ulm was the site of University Week, a series of concerts and lectures

sponsored by the University of M Minneapolis. Wanda attended, sket hand. During the week she met a y from Minneapolis with whom she an instant rapport. He was Edgar F University of Minnesota student became a physician (fig. 7).[20]

7. EDGAR HERMANN ("ARMAND"), C. 1914, WITH HIS SISTER POLLY.

Hermann was well read and articulate, and although his judgmental attitude and superior tone can be irritating to the reader of *Growing Pains* (where he is called "Armand"), he was important to Wanda as the first person near her own age who presented an intellectual challenge. He also was much more sophisticated than her New Ulm friends, his pretensions notwithstanding. They mainly spoke German

to each other, his refined use of the language making hers seem like provincial argot. With complete self-confidence he dismissed her artistic heroes, Harrison Fisher and Charles Dana Gibson, yet they found a shared devotion to the writings of Robert Browning and Thomas Carlyle. Although their impassioned conversations occurred over the course of only two days, they "almost completely revolutionized" Wanda's ideas on "art, music, literature and things in general," setting for her a "higher standard in all these things."[21]

Two weeks later, Charles Weschcke visited New Ulm, presenting Wanda with an offer of full financial support for a year at the St. Paul School of Art. In a state of painful agitation from the too brief "university influence," Wanda, not inclined to martyr herself further in the schoolroom, accepted Weschcke's offer.

The St. Paul School of Art was founded in 1894, more than a decade after Anton left for New Ulm. It was the outgrowth of a movement to establish an art school in the city led by artists active when Anton had been there, and it is poignant to contemplate his missing the opportunity for study it would provide. The school had its beginnings in life-drawing classes taught by Burt Harwood in the attic of the old Metropolitan Hotel. An 1893 photograph taken during one of his classes shows male and female students drawing from a nearly nude male model (fig. 8). The presence of women in such a class at that date was remarkable: the issue of whether women should draw from the nude model, much less in the company of male students, was still controversial in art schools in America and Europe, even in Paris.[22]

When Wanda enrolled in September 1913, the St. Paul School of Art, by that time located in the city auditorium, was still geared to the academic model of the École des Beaux-Arts in Paris, with courses in drawing, "antique," life drawing, color, and composition. But the school had changed with the times. The director was Lee Woodward Zeigler, an illustrator of magazines and historical novels, and the school

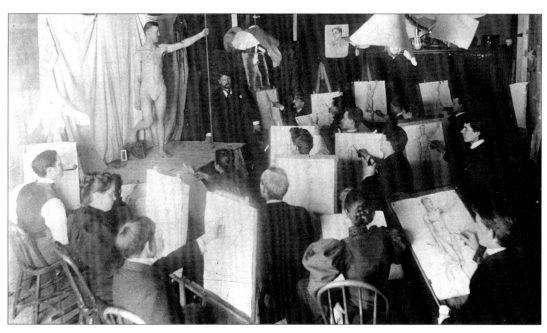

8. BURT HARWOOD'S LIFE CLASS, METROPOLITAN HOTEL, ST. PAUL, 1893.

expressed particular pride in its illustration program, touted in its catalog as "the most immediately lucrative field of art." The curriculum also included such applied arts as graphic design and ceramics, reflecting the fashionable doctrine derived from the Arts and Crafts movement that "all arts can be elevated to the plane of fine arts; when a design for a poster, a lamp, a flower pot or a fabric has need of the same lofty principles as a painting or a piece of sculpture."[23]

Wanda, enchanted with her room at the YWCA and its Mission-style furniture, embarked on the first-year course: Antique with Zeigler, Design and Water Color with Elizabeth Bonta, and Sketching with Nathaniel Pousette-Dart. At once she was made aware of her technical deficiencies and was warned of another danger, "cleverness," to which she seemed particularly liable. Worse still, how well she worked depended on the unpredictable ebb and flow of her drawing streaks. She felt she could do no work without one, a fact that few of her teachers or fellow students could understand.[24]

Life was further complicated by the reappearance of Edgar Hermann, who had been maddeningly uncommunicative since their intense initial meetings in June. He was, as before, imperious, and he also proved to be unpredictable, often calling at the last moment and simply telling her when to be ready. But Wanda found him irresistibly stimulating and meekly tolerated his peremptory ways. Since the art school offered no strictly academic subjects, Edgar undertook to be Wanda's "university." (His reading assignments ran to such ponderous works as *Barnaby Rudge*.) They went to concerts or browsed in bookstores, and one evening he bought her a book on Whistler. "I cannot remember all the things we said," Wanda wrote later, "but I know that I came out wiser in the end than I had been." Edgar understood her, she thought,

in a way that no one else did; he also understood her cherished belief that art was more important than love. In fact, art was life, she concluded, abandoning as foolish the idea of keeping a separate art diary.[25]

The main benefit of the St. Paul School of Art, it would appear from *Growing Pains*, is that it gave Wanda time to draw. Her drawing streaks, when they came, afforded her "a pleasure which is too fierce to be called a pleasure— rather one might call it a wild sort of ecstasy or exultation—a hilarity of the Soul, so to speak."[26] She valued her instructors primarily as stimuli to this pleasure. When Nathaniel Pousette-Dart remarked that one of her figure drawings showed a nice appreciation of the form under its draperies, she was pitched into a drawing mood that lasted more than a day. Tyler McWhorter took her to an exhibition of original works by some of her old heroes, among them Gibson and O'Neill. He talked of their working methods ("even our greatest artists *felt around* for the right lines") and revealed the truth that genius lay in hard work, not talent. Wanda drew all that night.[27]

She attracted favorable attention from her instructors but also concern. In February 1914, after looking over sketches to be submitted to a state art exhibition, Lee Zeigler told Wanda, "'You are just on the border-line now, Miss Gag. You have it in you to become either a clever illustrator or a good draughtsman.' He said what I needed was a lot of severe study, namely Antique." According to Pousette-Dart, she was one of those students who needed to be "sat upon" rather than encouraged. Yet he sympathized with her reliance upon drawing moods, understanding that she used her non-drawing times for observation and thought: "He said, 'Yes I think that in this art school they draw too much and don't think enough.' I am inclined to agree with him."[28]

9. ST. PAUL SCHOOL OF ART, 1914 (WANDA FRONT, FAR LEFT). THE PLAQUE READS:
"ST. PAUL INSTITUTE & NATURAL HISTORY MUSEUM; ART GALLERY 2ND FLOOR."

In truth, Wanda was experiencing great conflict during the spring of 1914. She yearned to study at the university. She was also increasingly tortured by her relationship with Edgar, which remained platonic but involved periphrastic dialogues about feelings, sex, and other imponderables. He was alternately ardent and remote. No one seemed to understand her temperament, even Alma Schmidt, now enrolled in the University of Minnesota and once again a frequent companion. Like Wanda's art school classmates, Alma occasionally lost patience with her friend's "drawing fits" and peremptory ways.[29]

Art school—so long the object of Wanda's yearning—had brought on a crisis of identity. She came to realize that she must wear a "mask" with everyone except Edgar Hermann.[30] Her true self was "Myself," her better judgment, her "permanent self." "Me," on the other hand, was her unstable self, in constant change. She had lost Myself by the end of the year, she thought. Nor did she win the prizes expected of her, and the year ended on a note of defeat.[31]

It is significant that Wanda did not regain her natural exuberance until she returned to New Ulm for the summer and once again experienced the glories of nature. "In towns Myself

10. WANDA AS A STUDENT AT THE
ST. PAUL SCHOOL OF ART, 1914.

stays wrapped up most all of the time that I choose to have it so," she explained in a letter to Edgar, "but when I am down here where everything is free and green and purple, Myself just takes a big leap out of the blanket and it *just stays out*."[32] Yet New Ulm lacked kindred spirits. As she wrote to Edgar:

They do not know that art to me means life. *It may sound egotistical for me to say so but I know that I have seen, and see every day, a beautiful part of life which the majority of them never have and never will see. It isn't egotistical when you think it over—I deserve no credit for that. It is my heritage. My father had that power before me, but because he was unselfish it could not be developed as much as Himself wanted it to be. So he handed it to me, and it's my duty to develop it. If I ever turn out anything worthwhile I will not feel like saying that "I did this," but "My father and I did this."*[33]

Wanda did not return to the St. Paul School of Art, although she wished to do so. Offers to support her at school were not renewed.[34] But at last, in late August, Tyler McWhorter responded to Wanda's urgent inquiries with the offer of a position at Buckbee Mears, a St. Paul design firm. Wanda took the job but found the work, mostly drawing figures for advertisements and sales catalogs, extraordinarily wearing, as it called for her to draw steadily all day. Her eyes became strained, and she was left with no energy to draw for herself or to read. At first, contrary to her expectations, she was not even paid, although soon she was earning five dollars a week, money that actually came from her patron Charles Weschcke.[35] Fortunately, Stella, now a rural schoolteacher as Wanda had been, was earning most of the support for the Gag children.

Wanda's "Myself" clamored for expression. She thought, in fact, that she must either express

what was inside of her or "go mad." The diaries provided some release, but she also "spilled over" to friends, who found her self-preoccupation increasingly tiresome.[36] But what was arrogance to her friends was, to Wanda, "Myself-defense," a way of dealing with the thoughts that constantly flooded her mind. She did manage to buckle down at Buckbee Mears, discovering that she actually liked detailed pen-and-ink drawing and realizing, too, that she was learning something despite the superficial subject matter. She managed to read (even at work), and her diaries mention writers of substance—Heinrich Heine, George Bernard Shaw, and William Makepeace Thackeray. But the diaries dwell mainly on her meetings with Edgar Hermann, characterized by abstruse talk and his continuing efforts to educate her. "He said," she noted, "that I seemed to have stepped out of the mediaeval ages when he met me at New Ulm." He now assigned readings in philosophy and proposed to teach her rhetoric.[37]

Wanda continued to send work to local newspapers. In late November 1914 A. J. Russell of the *Journal Junior* wrote her an encouraging letter. A visit to his office led to an important development: Russell showed some of her drawings to the owner and managing editor of the *Minneapolis Journal*, Herschel V. Jones. Jones was a collector of prints and drawings as well as an influential member of the Minneapolis Society of Fine Arts. Immediately enthusiastic about Wanda's drawings, he offered to pay her expenses at the Minneapolis School of Art. She was just cocksure enough not to accept right away.[38]

Wanda entered the Minneapolis school that December. Like the St. Paul School of Art, it had been founded on the traditional academic model, stressing disciplined work with the figure and antique casts. It, too, had expanded its curriculum to include the applied arts: in 1899

director Robert Koehler had added a department of decorative design based on William Morris's ideas of the beauty and social utility of handcrafted objects.[39] Otherwise the school was, like its St. Paul counterpart, fairly conservative. As Carl Zigrosser observed in *The Artist in America* (1942), it was "a good school—above the average—but its ideal did not extend beyond Whistler (the impact of the Armory Show of 1913 had not yet penetrated the West)."[40]

Wanda began the regulation fine arts courses but was less than satisfied. In Gustav Goetsch's girls' life class, she felt months behind; nor did Goetsch give her the personal attention she had come to expect. She also found Lauros M. Phoenix's sketch class too methodical for her taste. In general, she thought that the school did not push students far enough. The instructors urged emulation of great artists, which she thought was good, but most of her fellow students seemed to aim no higher than magazine illustration.[41]

But the Minneapolis School of Art did have one strong advantage over St. Paul: a museum. The school had been founded in 1886 by the Society of Fine Arts, which from the beginning desired a school-museum complex on the order of such leading American institutions as the Art Institute of Chicago and Boston's Museum of Fine Arts. In 1912 the society commissioned the preeminent New York architectural firm McKim, Mead and White to design such a complex, and the school and museum moved into sumptuous new quarters at East Twenty-fourth Street and Third Avenue South just a month after Wanda arrived.[42]

The Minneapolis Institute of Arts was dedicated on January 7, 1915. Wanda and her fellow students served as exhibition guards on opening night. The pictures on view formed the kernel of a collection designed to represent

all periods of art.[43] Although in the following months Wanda would spend much time in the galleries, finding particular inspiration in works by Jean-Baptiste Corot and Jean François Millet, she did not even try to look at the pictures that first night. Instead, she conversed rather grandly about art with the other students and observed "silks and satins and throats glide by us, their owners doing their best to say something intelligent or non-committal about the pictures. Of course there were some who did know something about art but I think the majority didn't."[44]

The Minneapolis school also offered Wanda the advantage of a remarkable number of gifted classmates, including Arnold Blanch, Lucile Lundquist (later Blanch), Adolf Dehn, Johan Egilsrud, John B. Flannagan, Harry Gottlieb, and Elizabeth Olds. All later moved to New York, where Wanda formed lasting associations with almost all of them. Her closest friend was Dehn, a brilliant student from Waterville,

11. ADOLPH DEHN, VIENNA, 1923.

Minnesota, who was two years younger than she (fig. 11).[45] With Marietta Fourier, an older student who was a collector and an advocate of socialist ideas, they started the informal John Ruskin Club for "rambles thru Art, Science, and Literature" that provided Wanda with some measure of the reading and intellectual discussion missing from the studio arts curriculum.[46]

As Wanda's awkward romance with Edgar Hermann petered out, Dehn began taking his place as her intellectual sparring partner. He introduced her to a new set of ideas: although he was from a small-town German background in many respects like her own, Dehn had a political awareness heretofore lacking in Wanda. He was an ardent socialist who admired Floyd Dell, Max Eastman, Boardman Robinson, and other radical thinkers based in New York's Greenwich Village; he introduced Wanda to their monthly magazine the *Masses*. They attended lectures given in Minneapolis by such figures as Eugene V. Debs, Emma Goldman, and Margaret Sanger and even submitted drawings to the *Masses* (which were always returned). They were more successful with local submissions, their work appearing regularly in *Minne-haha*, the University of Minnesota humor magazine (fig. 12).

Wanda's schoolwork followed the same pattern as in St. Paul. Without a drawing mood she did no work, and she missed so many classes that some considered her a shirker. But, she insisted,

> I must have freedom. *I guess if I ever wish to do anything, I must rely upon my individuality to do it. I cannot bear to think of following in the footsteps of others. And that is what they are teaching us to do here in Illustration. We are doing covers for the Saturday Evening Post, and everyone has a Leyendecker cover at their side which they consult and worship while working at their own sketch."*[47]

Again, her sponsor grew critical of her lack of progress. Herschel Jones criticized her for doing too many "scratchy lines on brown paper" and, with some discernment, pointed out that children seemed to be her long suit and recommended that she apply herself to "child illustrations."[48] Wanda maintained that such criticism did not shake her—she was as "earnest and arrogant" as ever, yet filled with doubt about her larger aims. "Construction, action, resemblance or spirit" she was confident about, but she feared "landscapes, animals, and interiors" (the very subjects that would dominate her mature work).

12. WANDA GAG, COVER FOR *MINNE-HAHA*,
UNIVERSITY OF MINNESOTA HUMOR
MAGAZINE, FEBRUARY 1916.

By her final year in Minneapolis, Wanda was applying herself more seriously to the set lessons.

> [Dehn] tells me that I have become terribly academic and that I am actually becoming mediocre. A necessary stage. I

*suffered too keenly from lack of con-
struction knowledge so I had to become
meek and modest for a while. Since I
have accepted the "approved" method,
things are swinging better for me and I
am regaining my self-confidence.*[49]

When Wanda went to New Ulm for Christmas
vacation in 1916, she found Lissi Gag very ill.
Shortly after returning to school, Wanda was
summoned back home: her mother was dying.
The children were told that Lissi had "gallop-
ing consumption," and at 4:45 a.m. on January
31, 1917, she died. Wanda was at her bedside.[50]
Wanda, now head of the family, made the
funeral arrangements. On February 10, howev-
er, she returned to Minneapolis, where she sur-
prised herself by maintaining her stoic calm, at
least in public: "Everybody tells me that I am so
brave," she wrote. "The trouble is that I am too
brave for my own good. It is very wearing to
hold yourself in check." In fact, she was close to
utter discouragement.[51]

But the Gags had a plan: the four youngest
children, Asta, Dehli, Howard, and Flavia,
would finish high school; Wanda, Stella, and
Nelda would work to support them. Wanda's
plan to work as a commercial illustrator as long
as necessary to get the children through high
school meant that she had to finish her degree
at the Minneapolis School of Art. But her wish
to develop her own gift—whatever that might
mean—could not be wholly suppressed. Both
Wanda and Adolf submitted drawings to a
scholarship competition at the Art Students
League in New York City.[52]

Wanda Gag and Adolf Dehn were two of only
twelve League scholarship winners nationally
that year—an intoxicating triumph for the pair
who prided themselves on being "untamed"
by the Minneapolis School of Art. Yet the tri-
umph was mixed with anxiety over whether
either could actually accept. Wanda agonized

over her responsibility to her family. Dehn wor-
ried about being drafted, which became a real
possibility after the United States entered World
War I in April 1917. Both were pacifists, though
they were not inclined to discuss their views
publicly lest they be seen as pro-German; they
also constantly discussed whether Adolf should
declare himself a conscientious objector.[53]

In the end, both of them took the scholarships.
Herschel Jones offered to pay Wanda's room
and board in New York. Adolf's draft status
remained uncertain. After graduation Wanda
returned to New Ulm, determined to sell the
North Washington Street house and relocate
her six siblings in Minneapolis so that they
might have better opportunities for education
and employment.[54] Adolf Dehn and Lucile
Lundquist visited New Ulm that summer to
help with the extensive work of painting the
house. Wanda also worked on her first profes-
sional book project, illustrations for an ele-
mentary English text to be used in schools writ-
ten by Jean Sherwood Rankin, the wife of a
University of Minnesota professor. The twelve
drawings in *A Child's Book of Folklore* were
"mostly goose pictures" but also images based
on sketches of Flavia and a cousin, Dolores
Biebl (the daughter of Johnnie and Nora). The
project brought "publicity, practice and much
joy," if little cash.[55]

Despite all efforts, the house did not sell.
Toward the end of the summer, the family
made a brave decision in the face of this finan-
cial crisis: Stella and Nelda would get jobs in
Minneapolis, but the four youngest—Asta,
now eighteen; Dehli, seventeen; Howard, fif-
teen; and Flavia, ten—would stay on in the
New Ulm house. Fortifying herself with the
idea that study at the Art Students League
would enlarge her employment opportunities
as well as make her a better artist, Wanda
honored "Myself" by proceeding with plans
for New York.

7 WANDA IN NEW YORK CITY
1917 – 1923

Wanda Gag moved to New York City in September 1917. She was one of thousands arriving in the metropolis during this period; its population doubled between 1910 and 1930. A number of the newcomers were artists, writers, actors, and other creative individuals drawn by the city's publishing industry, galleries, and theaters. Whereas in 1880, when Anton Gag went to Chicago, New York had been just another regional capital, by the late 1910s it was preeminent among American cities and on its way to becoming the cultural capital of the world. (Artists and writers fleeing the European war—Jean Crotti, Marcel Duchamp, and Francis Picabia among them—contributed to this development.) Wanda's progress from the provinces to New York exemplifies what Christine Stansell, in *American Moderns: Bohemian New York and the Creation of a New Century*, calls "the defining cultural journey of the country for most of the century."[1]

Wanda's first impressions of the city were negative: it looked artificial, and she was oppressed by the glare and the "high unnatural key of things."[2] It was not the attractions of Broadway or Fifth Avenue that began to reconcile her to the city after the first few weeks but rather the Lower East Side, with its mix of immigrant populations. Her first lodgings, arranged by her benefactor Herschel Jones, were at the YWCA's Studio Club on 78th Street. But later that year, disturbed by news from the "kids" in New Ulm that they were barely scraping by, she moved to a cheaper room at 859 Lexington Avenue—actually an old kitchen, which she decorated with sketches and artfully draped fabric and gamely called the Salon.[3]

Wanda enrolled in the Art Students League on West 57th Street, where she quickly realized how conservative her previous art schools had been. "The surroundings of the Middle West are not affected enough by the *waves* of progress and revolution in art," she wrote. "If anyone had told me that last year, I should have risen in indignation, but it is so, nevertheless."[4] The League was determinedly antiestablishment. Formed by students in 1875 rebelling against the traditionalist National Academy of Design, the school was strongly associated with the ideas of Robert Henri, one of its prominent teachers and guiding spirit of the group of painters known as the Eight.[5] Henri opposed the academic tradition of drawing with its antique ideal and instead promoted a fresh new realism based on observation of everyday life. (Many of his followers, such as Everett Shinn and John Sloan, began their careers as newspaper illustrators.) His opposition to "art for art's sake" resonated strongly with Wanda, whose diaries often express her insistence on life and ideas in art. Henri's notion of the artist-genius who must find his own personal expression also suited her emphasis on the self.[6] The League had no set curriculum and gave no diplomas but rather operated along the lines of a Parisian atelier, giving students the opportunity to work together in a studio setting with models.[7] Its shifting collection of teachers tended to stress individual development. "I consider the Art Students League of New York a better and freer school than any I knew in my time in Paris," Henri wrote in 1928.[8]

Once again Wanda proved to be an ambivalent student. She attended the classes of Charles Chapman, Frank Vincent DuMond, Ernest Haskell, Kenneth Hayes Miller, and Mahonri

1. WANDA GAG, *SELF-PORTRAIT, THE LIBERATOR*, FEBRUARY 1922.

Young as well as occasional sessions offered by such prominent members of the Eight as George Luks, John Sloan, and Henri himself. She would stay in a class only long enough to understand the instructor's point of view, then move on. She also posed as a model for some League classes, particularly those of Jane Peterson; occasionally she stayed away from school to earn money by doing commercial work.[9]

With Adolf Dehn she visited the Metropolitan Museum of Art and such exhibition venues as Alfred Stieglitz's gallery at 291 Broadway. She was respectful but wary of the European modernism on view in New York. In November 1917, for example, she and Dehn attended an eclectic showing of works by Arthur B. Davies, William Glackens, Pablo Picasso, Charles and Maurice Prendergast, and Max Weber at the Penguin Galleries. "Many of these pictures I do not understand and still I get much out of them," she wrote in her diary. "I try to be very tolerant when I look at them." Her technical knowledge

of Cubism and other modernist innovations was "very meagre, or rather incipient," but when all else failed she looked for "'form,' motion, sensations or elemental characteristics."[10]

Wanda's relationship with Dehn intensified, occupying considerable space in her diaries from 1918 to 1921 (fig. 2). Indeed, her relationships with men claimed her primary attention during these years. "Art is my greatest passion, but at the present, just plain everyday passion is at the head of everything," she wrote in March 1921.[11] This aspect of her life was not available to most students of Wanda's work until 1993, when Audur H. Winnan included some ninety previously unpublished pages of excerpts from the artist's letters and diaries in her catalogue raisonné of Gág's prints. These are quite explicit about the sexual relationships that began during her early years in New York.[12] Like many "modern" women, Wanda struggled with her desire for freedom and for her own significant work.[13] Frank talk about

2. ADOLF DEHN AND WANDA, 78TH STREET, NEW YORK CITY, 1919.

sex was one of the hallmarks of the New York avant-garde culture, and Wanda, who began to acknowledge her sexual desires, was proud of her ability to speak freely about them; yet she and Adolf were, in practice, surprisingly prudish. As late as the spring of 1920, toward the end of her third year in New York, Wanda was still debating about whether they should have sexual relations. She did not want a conventional marriage, and though she wanted children (sometimes acutely) she thought marriage and children inconsistent with being an artist. Her father had subordinated himself to his family. And her mother, with her constant childbearing and decline under the burdens of widowhood, was an even stronger negative example. A crucial issue was birth control: how to get it and whether it was effective. She also actively feared sex, even while she was obsessed with it.

Dehn, meanwhile, immersed himself in radical left-wing politics. He supported the Bolshevik revolution of November 1917—an increasingly dangerous attitude in this wartime climate—and spent much energy worrying about the draft and its relationship to his beliefs.[14] Wanda accompanied him to mass meetings and other political gatherings, and, while she sympathized with his convictions, she was more focused on their hand-holding at meetings than on the messages from the platform. (Eroticism for the puritanical Wanda was still largely a matter of "playing" with a man's hands.)

At the same time, both Wanda and Adolf were making tentative steps toward forming their own artistic styles. The Art Students League emphasized printmaking, a democratic medium in that it produced works of art that the lower classes could afford.[15] Dehn pursued this line actively: for him, printmaking was an instrument of social comment. In the winter of 1917 he contacted Floyd Dell, who put him in touch with Boardman Robinson (1876–1952), the well-

3. BOARDMAN ROBINSON, *HAIL, THE WORKERS' PARTY!*, LITHOGRAPH, *THE LIBERATOR*, FEBRUARY 1922.

known cartoonist and lithographer (fig. 3). Dehn became Robinson's protégé. Wanda's initial prints were more tied to her perennial quest for self-expression. She made her first prints—etching and drypoint—in the spring of 1918, probably under the instruction of Mahonri Young. She did her first lithograph in the spring of 1920 with Adolf as her guide.[16] These efforts are devoid of social comment. The subjects are children and young women in wilting postures that partake of the same vague art nouveau mode as her Minneapolis work.

In the summer of 1918 Wanda returned to New Ulm to see after her "youngsters." They enjoyed an interlude in Waterville, where, as guests of the Dehn family, Wanda and her siblings swam, sketched, and put on plays. Adolf was finally inducted into the U.S. Army that summer. Although he had declared himself a

4. LEFT TO RIGHT: EARLE HUMPHREYS, WANDA,
AND ADOLPH DEHN, C. 1923.

conscientious objector, he was sent to boot camp in Spartanburg, South Carolina, where he was subjected to psychiatric examinations, threatened with prison, and vilified by fellow recruits. But he made friends among his fellow

conscientious objectors, particularly Earle Humphreys, a recent honors graduate of the University of Pennsylvania who was interested in art and literature (fig. 4). Adolf's letters to Wanda and his family made light of his tribulations in a mocking spirit that presages his later work.[17]

Again the family worked to make the house on North Washington Street attractive to buyers. At last, in August, it sold for $3,500—a grand sum in those days—and the plan to move the family to Minneapolis went forward. In early October Wanda felt able to return to New York City, but now she defined herself as an artist rather than a student—and she was determined to succeed. "It's a darned hard world for women to make any headway in," she wrote, "and I'm just dissatisfied and tenacious and rebellious enough to want to show them that there are a few women that can do something."[18] Later she called this time her "sink or swim period," during which she scrambled for any sort of artist's job. Wanda was down to her last six dollars when, in November 1918, she got a

5. WANDA AND LUCILE LUNDQUIST, NEW YORK CITY, 1928.

job painting lampshades and a place to stay in the workroom of the business's owner.[19]

The next month Wanda began rooming on East 30th Street with her former Minneapolis School of Art classmate Lucile Lundquist, who was now in New York on the same Art Students League scholarship Wanda had won the previous year (fig. 5). They struggled to find a more affordable place, which was difficult in view of the postwar housing shortage and their own lack of funds. Finally, in January 1920, through the good offices of a commercial artist named Fletcher, who also had attended the Minneapolis school, they found an apartment in a "model tenement" at 527 East 78th Street. It was a fifth-floor walkup overlooking the East River in "Little Bohemia," a neighborhood bordering on Yorkville populated by Czechoslovaks, Hungarians, and other Middle Europeans.[20] Perhaps it was this milieu that encouraged Wanda to cultivate what she referred to as a "Slavic" or "gypsy" appearance, which capitalized on her dark eyes and glossy black hair (fig. 6). Here Wanda, Lucile, and Violet Karland, another young artist from Minnesota, established a domestic routine. Wanda acted as bookkeeper, which meant (schooled as she was by the rigid economies of her teenage years) recording expenditures down to the half-cent, according to Lundquist's rather bitter recollections.[21] They also created a cheap but artistic decor, taking great care over the shade of paint for their secondhand furniture, designing their own clothing, and arranging artificial flowers Japanese style.

Adolf Dehn, discharged from the Army in the summer of 1919, took an apartment nearby on 79th Street that he shared with Earle Humphreys and Minnesotans such as Arnold Blanch and Harry Gottlieb. He also spent a good deal of time with John B. Flannagan. Johan Egilsrud, another Minneapolis classmate who had turned to writing, was also on the fringes of

6. WANDA, 1931.

what Wanda came to see as their own colony of artists.[22] The group habitually ate together, continuing the intense soul-searching discussions she thrived on during these years. Gradually they developed the liberated spirit of the artistic coteries in Greenwich Village, perpetually talking of art, politics, and their relationships with each other. Wanda, in constant turmoil over whether she and Adolf should "love each other completely," was taken aback when Lucile Lundquist announced that she and Arnold Blanch were "free lovers." But they were "Conventional Bohemians," Wanda wrote in her diary dismissively, as preoccupied with looking *different* as the despised bourgeois were with looking alike. She shared their Bohemian contempt for "middle-class smugness and allegiance to the normal" but felt no need to conform to *any* type.[23]

Wanda took the occasional class at the Art Students League and tried to draw, but her main imperative was to earn money. In November 1919 she did a series of advertisements

for Majic Dye Flakes (a soap made by the Berriam Company). She also created designs for the YWCA magazine. It took a couple of years to work her way into fashion drawing, but by 1921 her drawings began attracting the attention of such stores as Gimbel Brothers, which flooded her with assignments.[24] Fashion advertising was a major market for commercial artists since the manufacture of women's garments was then New York's biggest industry. Fashion had burgeoned in the early twentieth century as women's clothing changed in character from a set of costumes associated with one's social class to an instrument of choice for constructing one's image. As Whitney Chadwick has argued persuasively in *Women, Art, and Society*, fashion now signified modernity. The New Woman wore short skirts along with her bobbed hair and was thus a significant consumer type.[25] But Wanda had no sympathy for these commercial styles, nor for her own renderings of them, which she called "slinky ladies" and "Stylish Stouts." She also deplored the "ubiquitous paint" worn by the women in the city.[26] Yet Wanda was very interested in clothing and the construction of her own image. Even in 1914 she had understood the psychological dimensions of clothes:

> I am wearing my beloved plaid dress. . . .
> I don't believe I'd be afraid to meet the King of England in that dress—I feel so very natural in it. Aside from the way clothes look, I like them for the way they make me feel. I don't mean whether they're comfortable or not . . . [but] the things they make me feel, the thoughts they give me while I'm wearing them, the height to which they make my spirits rise.[27]

Like her mother, Wanda had a natural flair for dress, and the dressmaking skills she had learned from her mother and aunts helped her dress "artistically" in New York with little money. Wanda even tried to market her skills.

In December 1917 she and Adolf had seen a crafts exhibition at the Art Alliance; like many avant-garde exhibitions in the wake of European movements such as Der Blaue Reiter (Blue Rider) and the Russian Neo-Primitivists, it included textile and clothing design.[28] Intrigued by batiks, they conceived the idea of making batik waists, neckties, and shirts. Their batiking, which occupied many an evening, never made much money but was at least a commercial enterprise with personal meaning.

Another such scheme was a project that sprang from a genuine personal impulse and pointed the way toward Wanda's later work. In 1921 she teamed with Janet Rankin Aiken (daughter of Jean Rankin, the Minneapolis author for whom she had done her first book illustrations) and Janet's husband, Ralph Aiken, to form the Happiwork Company to manufacture toys and cutouts for young children. With the prospect of earnings from sales of the items, Wanda created an imaginative format for stories, a flat cutout that could be folded into a box.[29] The way her designs transformed a two-dimensional story into a three-dimensional object was reminiscent of her description of making paper dolls at Grandma's Place; the stories drew on the *Märchen* (fairy tales) she had heard as a child. Perhaps the best part of the project was that it took her out of the city: much of the work was done at the Aikens' country place in Ridgefield, Connecticut, where the "corporation" assumed a family air. Wanda stayed at their rustic guest house, called Tophole. She entertained the Aiken children with stories, which she filed in an "idea box" for future projects.

Wanda was chagrined that Adolf Dehn seemed to be progressing more rapidly as an artist than she. He spent more and more time outside the city, at the Croton-on-the-Hudson

home of Boardman Robinson. In 1920 Robinson introduced Dehn (and Wanda) to George Miller, the first printer in America to devote himself exclusively to fine art prints.[30] Adolf also came to know Carl Zigrosser, director of the Weyhe Gallery on Lexington Avenue and an avid promoter of the graphic arts. (Dehn would introduce Wanda to Zigrosser at a concert at the Metropolitan Museum.[31]) Zigrosser began showing Dehn's prints in 1921, but sales were disappointing. Like Wanda, Adolf struggled financially, taking such odd jobs as night watchman or errand boy, and even, like Wanda, as a lampshade painter.

Meanwhile, Wanda was feeling increasingly dissatisfied with her commercial work. On an outing up the Hudson River in May 1920 she was overcome by the sight of the hills. "It seemed too cruel and bitter," she wrote, "that with such landscapes being there for the taking and contemplating, people like I should have to be part of a big city, helping to advertise needless needs and necessary unnecessities."[32] She did her own work as much as she could, sometimes selling drawings to Greenwich Village–based periodicals such as the *Liberator* (the short-lived successor to the *Masses*, which had been suppressed by federal authorities under the wartime Espionage Act in December 1917) (fig. 7). Adolf was developing into a satirical artist whose drawings reflected his increasing cynicism about human behavior (fig. 8). Wanda's drawings were usually self-portraits or figure studies, although she did occasional sketches of street life in the mode of the Henri school. One 1922 drawing depicting a young working woman in her off-hours is reminiscent of John Sloan (fig. 9).

Around 1920 Wanda made the decidedly feminist decision never to marry, also not to have children. She aired these decisions in a letter to Dehn that refers to her artistic vocation as "some

7. WANDA GAG, COVER, *NEW MASSES*, MARCH 1927.

driving thing in me . . . this tyrant."[33] The renunciation of children was painful to her: "But six youngsters and no money to give them an education proportionate to their capacities seems to me to be quite enough for one lifetime. And it is always a woman's art that has a hunk of

8. ADOLF DEHN, *IN HYDE PARK: "QUEER-LOOKING, THESE AMERICANS,"* INK, *NEW MASSES*, OCTOBER 1927.

9. WANDA GAG, *HER FIRST SPRING DAY*,
DRAWING, *THE LIBERATOR*, MAY 1922.

That winter, her fourth in New York, she at last began to loosen up: she went to parties in Greenwich Village, drank contraband whiskey, smoked cigarettes, and flirted—reveling in the physical and seeking ecstatic experience. Alcohol (readily available in New York during these early Prohibition years) produced pleasurable distortions, and she invented the term *ovals* for its fascinating effects. Dancing released an "animal wildness" in her. Thus began Wanda's "lascivious" period, which she knew to be temporary but which she saw as a necessary step to finding her way in art.

Meanwhile, Wanda was also finding ecstasy in certain intellectual discoveries. She was becoming obsessed with *form*, something not directly addressed in her academic studies so far. Thus it was sculptors—the ancients, Michelangelo, and, above all, Auguste Rodin—who taught her the most. A major revelation came from an article on Rodin she read in July 1919. It discussed "growth forms," or essences, as one of several ways an object should be seen (the others being physical form and spiritual form). Growth forms coincided with an idea that Wanda had arrived at herself. It meant that each form had within it the seeds of its different "curves, forms and planes" and grew in accordance with the tendency of its own particular life force. She tried to draw human figures in accord with this idea but failed; she turned to plants, trees, clouds, and rocks in the belief that it would be "easier to grasp the main lines of growth of an apple tree than of a human being." Still she could not get the idea on paper but now felt sure that it was "all a matter of essences, of growth forces." She did not care who else had discovered it:

> [T]his idea of growth forms is my own. It came to me gradually like a long slender ray of light which is long in coming and travels from some far away place. For the idea of pure physical form, I am more or less indebted to vague rumors and

years taken out of it—while the husband . . . can go on comparatively uninterrupted." Wanda saw a clear choice between being a wife and mother and being an artist. This outlook was certainly affected by the hardships of her youth, but her speculations on the subject also address feminine stereotypes that assume a woman will put husband and children first, indeed, that it is only natural for her to do so.

Yet Wanda passionately wanted an active sex life, believing that it would enhance her work. "It is not a matter of morality to me," she proclaimed in her diary, "it is a matter of health and art." In August 1920, she visited Margaret Sanger's birth-control clinic and obtained a contraceptive device.[34] Although her forays into sex with Adolf, when they now finally came about, proved frustrating, they nevertheless unlocked something within her, helping her rediscover the élan vital of her girlhood.

thoughts that I found floating about the League and elsewhere.

"Originality signifies nothing," she noted in her diary from the article on Rodin. "If the temperament of the artist is truly steadfast, he always finds himself after the necessary 'study.'"[35]

Wanda had assumed that such study would include time in Europe. Even if she was rather indifferent to further formal training, she believed wholeheartedly in the notion, then still current, that the aspiring young artist must go to Europe. Because of her father and the milieu in her childhood home, she felt a particular pull toward Germany.[36] Dehn was eager to travel and Wanda was determined to go with him, but in October 1921 he sailed for France without her. Although she intended to join him later when her Happiwork profits materialized, she was nevertheless despondent. Johan Egilsrud was already there; soon Lucile Lundquist and Arnold Blanch would go, too. Wanda did not want to be left behind.

Yet she soon discovered a powerful compensation for the lack of this *Wanderjahre*. In November she fell into a rapturously physical affair with Earle Humphreys, who exhibited a sexual fire quite different from Adolf's more generalized intellectual and emotional appeal. At first this affair did not seem to affect her feelings for Adolf. But soon Wanda explicitly connected the sexual passion she experienced with Humphreys to a renewed, even entirely new, response to nature, one that had a direct impact on her serious artistic work. "My high pitches of aesthetic emotion were amorphous and groping compared to what they are now," she wrote to Humphreys in the autumn of 1922. "The motifs of things seem to be more clear-cut now, their masses more definite, and their rhythms more intelligible."[37]

Sexual fulfillment would prove to be central to

Wanda's conception of her artistic vocation. The idea that creativity was connected to sexual freedom was current in the early decades of the century, particularly under the influence of Sigmund Freud. Artists saw in his writings a virtual call to find freedom by breaking sexual taboos. As well, sexual liberation for women was a central tenet of the radical Greenwich Village set even before World War I. Yet for Wanda the struggle to acknowledge her sexual needs and the place they would have in her art had been a long one.

On a visit with Humphreys to the Aikens in Connecticut in the spring of 1922, Wanda experienced what felt like an artistic rebirth. She was reading Roger Fry's *Vision and Design* (1920), which would supply language for her nascent ideas about rhythm and form. She also was reading Clive Bell's *Art* (1914) and responding to his influential ideas on "significant form." In addition, she was looking at reproductions of Cézanne's experimental late works. There, in the country with Humphreys, whom she nicknamed Cabun, or "the C.," the various elements of her recent growth—ecstatic experience, intellectual inquiry, and the example of other artists—began to coalesce. On May 3 Wanda wrote in her diary:

On my wall are three drawings which I made under the influence of ovals, and while entwined among the C-'s bare legs.

Heaven knows where my brains were when I drew them. If I knew, I would relegate them to that locality quite often. I drew with my emotions—with a mixture of my aesthetic and physical emotion. Or perhaps if physical emotions were swiftly translated into aesthetic ones, and in that more or less pure state transmitted to the paper.

I have been dividing my time for the past several hours between studying these

10. WANDA GAG, *TWO TREES*, 1923, LINOLEUM CUT, FIRST STATE, 9 3/16 x 10 1/16 IN.
PHILADELPHIA MUSEUM OF ART.

unhampered expressions of an ovally, sex-drenched soul, and reading a book on Post-Impressionists of Eddy.[38]

When she compared her three drawings to works by Dehn—an old habit—it came to her that his form of expression was so different from hers that such comparisons might not help her development, that, in fact, she might be better off without him entirely. Although Earle Humphreys was not an artist, he was, she realized, far more stimulating to her work than Adolf had ever been. Their "experiences of a non-Euclidian variety," as she jok-ingly referred to the distorted visions evoked by their lovemaking (not unlike the "ovals" elicited by alcohol), were as valuable as a trip to Europe.

No doubt a new continent can open countless vistas to a person who is eager for constructive points of departure. But look at Cézanne. He evidently travelled very little. He extracted whatever he was always extracting, from himself and from most any simple object about him. It is true that he came into contact with some of the biggest personalities of the age—and

yet it is not impossible that he might have managed well enough without them.[39]

That summer Wanda submerged herself both in nature and in the study of art theory, groping toward a "unison between life and art."[40] Her search, and refreshed state of mind, are vividly reflected in a diary entry from June 1922 in which she describes her response to being among daisies on a hilltop:

There is an exuberance and lavishness about the foliage that is intoxicating and the lascivious plenitude of their form fills me with primitivism. . . . I want to tear off all my clothes and lie among the grasses. . . . Or else I want to run—fast and senselessly. . . . I also like to sit and watch the forms and rhythms of the clouds and the essence-form of trees and hills, and I like to let my eye create compositions wherever I direct it, with curved and diagonal force-lines, inter-relation of spaces and forms, all complete.[41]

Wanda's relationship with Humphreys grew. She had despaired of finding a man who could sustain her interest both physically and mentally—and understand such matters as artistic form. Humphreys, however, was intellectually active and physically attractive and vigorous. (He was a fine athlete who seemingly could win at any sport.) Like Dehn, he sympathized with the Bolshevik revolution and supported the Communist Party. He wanted to write about his experiences as a conscientious objector, meanwhile taking "day jobs" such as hotel busboy to make ends meet. He and Wanda shared the desire to live outside bourgeois bounds, and thus they set out on a "free love" relationship based on honesty rather than conventional marriage vows. Humphreys understood her work and in fact contributed to it in practical ways. He helped her print etchings. He also contributed ideas for money-making schemes, even collaborating with her at one point on a short-lived series of crossword puzzles for children. They produced a pamphlet, *Batiking at Home: A Handbook for Beginners*, published in 1926. As time went on he served as her agent and handled business affairs. In short, he was a partner in her work as well as in love. Wanda had clung to the relationship with Dehn in the belief that at bottom it was an ideal match. But the new relationship with Humphreys soon made her see that "to live the precarious love-life that Ado had been handing me interfered too much with my art and my getting plumper."[42]

The following winter Wanda continued earning a living with commercial work, including the Happiwork project. But an opportunity to exhibit her art at the East 96th Street branch of the New York Public Library for six weeks beginning in mid-February 1923 provided an incentive to concentrate on drawings and on a new medium, the linoleum cut, which fostered a more dynamic style than etching. A work such as *Two Trees* shows a significant new style (fig. 10). It is a landscape—as potent a subject matter for Wanda as it had been for her father. Forms are simplified and slightly askew; tonal contrasts are stark. Unlike her Art Students League etchings, *Two Trees* has a vigorous folk art quality akin to the prints of the German Expressionists, Russian Neo-Primitivists, and other avant-garde groups that adopted populist styles. Stark forms and tilted planes give the image an energy lacking in the wilting, enervated forms of her first prints, and show the distortion she had come to associate with physical and mental excitement. For the first time, Wanda's German-Bohemian roots can be felt in her work.[43]

With the close of the exhibition, which brought favorable attention from print enthusiasts and even some attention from the New York press, Wanda took the bold step of canceling

her commercial commitments and departing for the country. She stayed at Tophole from April to October, rediscovering the joys of total absorption in drawing. She was still mulling over the possibility of going to Europe, despite the fact that her long relationship with Adolf Dehn had come to a rather bitter end when he wrote that he had fallen deeply in love with a Russian dancer. Yet this option was suddenly closed off when, late in 1923, the Happiwork Company failed. Wanda had calculated her earnings at more than $1,000 but was able to salvage no more than a few hundred. To a young woman who budgeted her hard-earned money to the half-cent, such a loss was devastating, and she cried for weeks.[44] Europe, which still seemed essential for her artistic development, appeared to be lost. But as things turned out, travel would never figure vitally in Wanda's work. A statement she wrote in 1928 on the value of European study for art students describes the path she would take:

What difference does it make where you sharpen your tools, so to speak— for in the end it is usually necessary to fashion an entirely new set anyway. The important question is, "Where can you best find yourself?" and I believe this is most easily accomplished in one's natural environment, which at least has the stability of the familiar. . . . When he has learned to see through his own eyes, instead of vicariously through the eyes of people who are the logical result of entirely different conditions, why then let him go—go to Europe or anywhere else![45]

8 WANDA AND THE YOUNGSTERS
1923 — 1930

It was above all immersion in a series of country residences near New York City that gave Wanda Gág her direction. Influenced by her reading of Knut Hamsun's novel *Growth of the Soil*, Henry David Thoreau's *Walden*, and Walt Whitman's *Leaves of Grass*, she would go, quite consciously, back to nature. In the summer and fall of 1924, she lived with Earle Humphreys in a rented house in Chidlow, Connecticut. Trees were a particular focus for Gág's élan vital: among her code names for a sexual experience was "treetop," and one subject she drew obsessively that summer was a bare old tree. She drew it repeatedly, sometimes on sandpaper. Unable to afford lithographic stones or other printmaking equipment, she even experimented with sandpaper as a matrix for prints (fig. 1).

Wanda's diaries contain lengthy speculations about technical matters: "form" was a particular obsession and, since she wished to create a sense of roundness, "space" also. "There is, to me, no such thing as an empty place in the universe," she asserted in 1929, "and if Nature abhors a vacuum, so do I—and I am just as eager as nature to fill a vacuum with something—if with nothing else, at least with a tiny rhythm of its own, that is a rhythm created by its surrounding forms."[1] Proper depiction of space required the use of perspective:

> *Perspective has for many years had an ecstatic effect upon me—I remember again the time that I had a climax (in the midst of a treetop with Earle) while and because of thinking of the mathematical recession of planes which is perspective. The inevitableness of it, its potential thereness even in space, its utter rightness—all these things excite*

me, not only aesthetically but apparently emotionally too.[2]

Wanda's probing into these matters often involved pages of diagrams. On the one hand, she identified with the intellectual speculations of Paul Cézanne, whose paintings' clear testimony to that artist's "Search" excited her. On the other hand, she recognized that she was untutored in these matters and was merely casting about: "Wouldn't it be a joke on me," she mused amid a long diary meditation in 1929, "if all this were already discussed in solid geometry? I have no idea what solid geometry is about, beyond the fact that it deals with solid forms, of course."[3]

In 1925 Wanda rented a farmhouse near Glen Gardner, New Jersey, that she dubbed Tumble

1. WANDA GÁG, *CHIDLOW*, CONNECTICUT, 1924, BRUSH AND INK ON SANDPAPER, 11 1/16 X 8 15/16 IN. MINNEAPOLIS INSTITUTE OF ARTS.

Timbers. It would become her home, with Earle, that summer and for several summers thereafter. The place was dilapidated, with no electricity or running water, but Wanda delighted in its ramshackle appearance, going so far as to argue the landlord out of repairing the sagging porch (fig. 2).[4] She found the house and its homely contents, quite like those of "Grandma's" house, fascinating and the source of an almost constant drawing fit.

Two prints from this prolific period, *Tumble Timbers* (1926, fig. 3) and *Gumbo Lane* (1927, fig. 4), show her maturing style. In *Tumble Timbers* Wanda condensed the form of the house, making it more compact, and simplified the textures of the wooden sides and tin roof. Other surfaces, such as the ridges of the porch roof and the fence boards, are at once

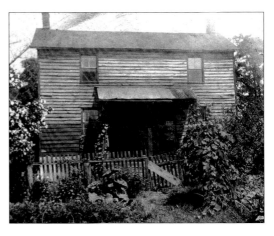

2. TUMBLE TIMBERS, C. 1926.

schematized and exaggerated. Most strikingly, the contours of house and fence are markedly curved. Furthermore, the house is embraced by a garden and even seems to be an outgrowth of that garden, so that what is achieved is the

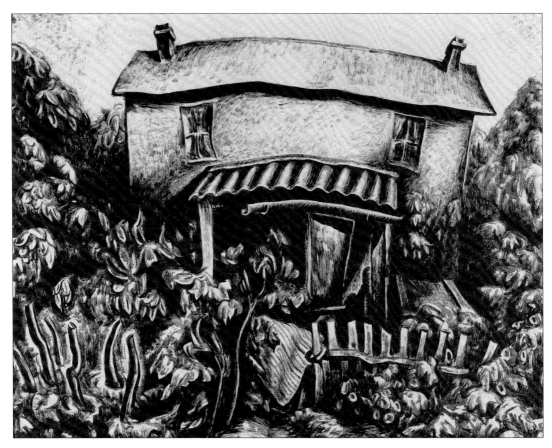

3. WANDA GÁG, *TUMBLE TIMBERS*, 1926, LITHOGRAPH ON ZINC PLATE (WASH), 8 3/4 X 11 1/8 IN. MINNEAPOLIS INSTITUTE OF ARTS.

kind of organic unity Wanda had written of in a 1921 letter as the "glorious fitting together of things, round, smooth faces with corresponding sockets" and "long tendrilly jutterings-out to receive and organize all the helpless fringes and frayed edges of our groping lives."[5] Such description, also seen in many passages of her diaries, strongly suggests that Wanda's idiosyncratic style reflected her sexuality. But that style also served to unify all aspects of her emotional and intellectual life. Wanda had always believed that the content of her work determined its style. "They draw, and forget to *think*," she had written a decade earlier of her fellow students at the St. Paul School of Art. "They do not realize that art is sorrow, love, *Life*—considering it merely a matter of putting their pencils to the paper and making marks."[6]

Although Wanda was determined to express her own ideas and feelings without imitating the work of others, her art, at this time and later, bore clear affinities with that of certain expressionist artists. The humble subject matter drawn from everyday experience and the folklike naiveté of her style, with its simplified forms, bold lines, and strong contrasts of light and dark, link her work with the German printmaking tradition, to which her father's books of German art had introduced her. She also saw work by contemporary German Expressionists at the Weyhe Gallery in New York. As well, she had begun a study of Vincent van Gogh, whose peasant subjects and sincere approach provided constant inspiration. Like these artists, Wanda began in the mid-1920s to simplify and distort to intensify the message, which in her case, as noted, was often related to heightened

4. WANDA GÁG, *GUMBO LANE*, 1927, LITHOGRAPH ON ZINC PLATE, 9 15/16 X 12 13/16 IN.
MINNEAPOLIS INSTITUTE OF ARTS.

perception. She has also been connected with the Regionalists of the 1920s and 1930s, particularly the rural regionalism of artists such as Thomas Hart Benton, John Steuart Curry, and Grant Wood. Yet unlike them, Wanda had no wish to propound an American mythology. Rather, she took a more generalized romantic approach that exalts individual identification with the landscape through the senses.[7]

It is tempting to try locating a peculiarly feminine sensibility in the rounded forms of such works as *Gumbo Lane*. The subject of this print is the garden behind Tumble Timbers that Earle planted and tended. Yet it must be borne in mind that many male artists make use of rounded organic forms, especially to convey sensuality.[8] It is perhaps more useful to link Wanda Gág with artists who, regardless of gender, use biomorphic forms to express archetypes. Arthur Dove, Georgia O'Keeffe, Edward Weston, and others in the Stieglitz circle did so, as did Wanda's former Minneapolis School of Art classmate John B. Flannagan. By the early 1920s, Flannagan was committed to sculpture; he searched for "the image in the rock" (often an ordinary fieldstone) and usually found the rounded form of an animal or—his other preoccupation—a mother and child.[9] Linda Nochlin and other art historians have argued persuasively that work by women artists is more like that of other artists of both genders in their own time and place than the work of women artists as a whole.[10] The idea of a "feminine imagery" or "feminine sensibility" remains a means of complimenting work that

5. WANDA GÁG, BED AT TUMBLE TIMBERS, C. 1926, DRAWING (INSCRIBED "TO CARL"), CHILDREN'S LITERATURE RESEARCH COLLECTIONS, UNIVERSITY OF MINNESOTA, MINNEAPOLIS.

seems to capture a significant aspect of feminine experience—"At last! A woman on paper!" as Stieglitz famously remarked of the drawings of Georgia O'Keeffe—although critics today tend to agree that there is actually no such thing.[11]

Gumbo Lane might also seem Surrealist, with its swollen forms and surging rhythms, almost nightmarishly intense. Indeed, Wanda's art can be connected with Surrealist thought in the broad sense that Surrealists saw sexuality and the unconscious as the routes to art; certainly, she saw their works in New York galleries. The similarities could be taken as proof of the Jungian notion that any artist responsive to the subconscious is likely to produce biomorphic forms.[12] In any case, Wanda invested what might have been a decorous domestic scene with animal energy, turning Tumble Timbers into a jungle, but a benign one, suggesting the "equanimity and rightness of things."[13]

"*Tumble Timbers* was our happiness," wrote Wanda's youngest sister, Flavia, in an unpublished family memoir. The farmhouse in New Jersey is important not only as the location of Wanda's most prolific period of printmaking but also as a new center of the Gág family, which, beginning with Nelda in 1922, gradually migrated to the East Coast. From this point on, Wanda would live in close connection with her sisters and brother.

During her first year in New York, Wanda had worried about "my youngsters," and it is easy to get the idea that they were a brood of children for whom she bore full responsibility. But they were not really youngsters any more (fig. 6). In January 1918, Stella was twenty-three, Nelda was twenty, Asta eighteen, Dehli seventeen, Howard fifteen, and Flavia ten. Only Flavia was really a "kid," and she continued for years

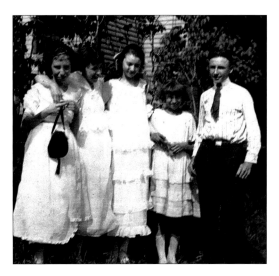

6. LEFT TO RIGHT: NELDA, ASTA, DEHLI, FLAVIA, AND HOWARD, C. 1917.

to be the kid sister, called Flops or Flopsy. Both Stella and Nelda were teaching in country schools, as Wanda had done, and bearing most of the financial responsibility for the younger ones. Although both had shown artistic talent and, like Wanda, even published their work in the *Journal Junior*, neither went to art school or became a professional artist. Nor did either write letters or diaries on the scale of Wanda or Flavia; hence they tend to be shadowy figures. We know that Stella was serious and thoughtful, with many of Lissi Gag's personality traits; her sisters considered her wise.[14] Thusnelda, called Nelda or Tussie, was noted for her nurturing spirit and her domestic energy: she looked out for the family, insisting on cleanliness and order in the spirit of Aunt Mary. Wanda tended to treat Stella and Nelda as little sisters, although they were close to her in age.[15]

All the siblings were remarkably industrious and talented. Asta, petite and graceful, aspired to become a dancer. Her imagination had a winsome and comical turn (fig. 7). Dehli, called Dale or Dell, could write and draw. Her gentle sweetness and beauty caused Wanda to think of her as a "perfect person," like Grandma Biebl.[16] Howard resembled his father, and, like

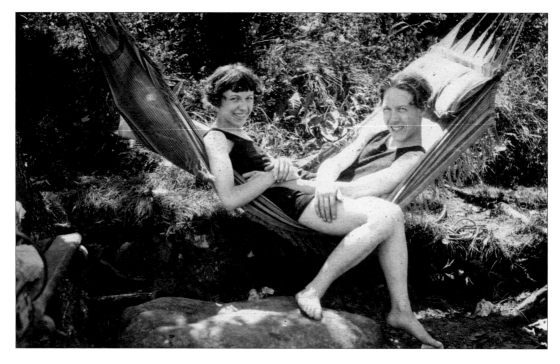

7. ASTA AND HERBERT TREAT, C. 1925.

Anton and also his Biebl uncles, he was from an early age a versatile craftsman and musician.

Flavia also had multiple talents (fig. 8). She was the only child not to have known her father, as she was barely a year old when he died. Also, she was just eight when Lissi died. Wanda mothered her from the beginning, as we have seen, and they maintained a special bond. Flavia's various unpublished memoirs reveal how she longed for Wanda after her older sister left for art school in 1913. When Wanda returned home in the summers, Flavia followed her around obsessively. "Flavia is a queer little morsel," Wanda wrote in 1915. "She reads marvelously well, has a fine little brain, and draws much. She sketched me today and I was surprised and delighted to find that, at the age of eight, she had already discovered that things must be drawn as they *seem*, not as they *are*."[17]

Flavia's copious letters and memoirs give us a picture of the Gág family's life after Wanda's departure for New York. The first winter, when the four youngest ones were fending for themselves in New Ulm, was wretchedly difficult. The labor of washing, ironing, lugging coal, and scraping together meals—particularly after the pipes burst and they were left without running water or heat—was exhausting; later all the siblings would be chronically underweight and often ill. The following year, after they moved to an apartment on First Avenue South in Minneapolis, was easier. Flavia, Howard, and Dehli entered public schools in south Minneapolis. Asta, finished with school, stayed home to keep house. The older sisters worked, Stella at something more artistic than teaching school—painting satin pillow covers at Blum Brothers—Nelda as a secretary.

The family enjoyed Minneapolis. Flavia provides no evidence of homesickness for New Ulm. Their apartments—on First Avenue South, then on Columbus Avenue—had modern conveniences: a gas stove, an ice box, hot running water, and, above all, a bathroom with a white enamel bathtub so delightful to

Flavia that decades later she made it the central motif in an autobiographical children's book, *A Wish for Mimi* (1958). They appreciated the ready availability of books at the public library. They also enjoyed being among more English-speaking people. Flavia's letters describe neighborhood gatherings and family parties that included suitors for the older girls. They had fun—letters to Wanda mention ice-skating, concerts, and parties—but they worked hard, and their accounts give a poignant sense of an earnest and conscientious band of orphans.

The love of art and music that characterized Anton and Lissi was developed most fully, among these younger Gágs, in Howard and Flavia. Howard was taciturn, and his rare letters show that he did not share his sisters' verbal gifts. Nevertheless, they reveal a wry sense of humor and let us know that he was serious about music. In an unusually long letter to Wanda in 1920, he describes playing the ukulele and the "banjo mandolin" and his efforts to teach himself to read music. "Before I get old I will have about 67 kinds of instruments," he wrote as he described and illustrated a "guitar harp or contra-bass guitar" that Uncle Frank Biebl was making for him.[18]

Flavia wrote stories and made little books. "I dote on humorous stories, such as Stephen Leacock writes," she wrote Wanda at age eighteen, referring to her particular interest in writing as "foolish bits of things, such as those silly letters I sent to you, Toot [Nelda] & your drifter [Earle Humphreys]. I have made up millions of things."[19] Flavia's temperament was more difficult and variable than the equable Howard's, however. She struggled with acute longings, such as her desire for a bicycle, never obtained, and she was so intensely social that she could not bear to be alone. Flavia's overwrought reactions to physical discomfort and illness also reveal a certain morbidity.[20]

Nevertheless, Flavia's writings show an attractively eager sensibility and a strong desire to excel (fig. 9). She did well at Central High School, particularly enjoying English and French. She aspired to be an artist, but focused on the more practical subjects of stenography and typing. She found her job in the school office irksome, however, and began a pattern of rejecting routine work. Her talents were strong but unfocused. A friend remarked, "You know, you're entirely too bright to be good for anything." Flavia mused to Wanda:

8. FLAVIA, C. 1915.

It always strikes me so funny that so many people somehow, somewhere get the idea that I am so extremely bright and capable of anything. Most folks are peculiar. Many think I am a seasoned dress maker, poet humorist, musician, stenographer, typist, novelist, good sport, good girl, scholar & artist, all in one. But I'm proclaiming to the world in accents wild that "Somebody's Wrong!"(If only someone could think I am beautiful, how happy I would be.)[21]

9. FLAVIA, C. 1920.

"Flavia's queer name, plus her artistic soul, will surely bring her to some great goal," read the caption by Flavia's yearbook picture in 1925, the year she graduated from Central High.[22]

With Flavia's graduation, the family's grand plan was fulfilled. There was no money for college, but another attractive opportunity presented itself: Wanda asked her siblings to join her in New York. (It was clear by the early 1920s that she was going to stay.) Beginning with Nelda in 1922, the Gágs moved east. Asta went in 1924, Dehli and Flavia in the spring of 1926, and Howard the following fall. Only Stella, who had married William Harm in 1923, remained in Minneapolis. It was an updated example of chain migration, with one member of the family going to the land of opportunity—in this case New York City, which by the mid-1920s offered even more opportunities in music and the arts than in 1917, when Wanda had arrived—and the rest following later.

Flavia, who later described herself upon arrival in New York as "green as the tall waving corn out in the Tall Corn Country of Minnesota," found Wanda's apartment on East 78th Street thrillingly Bohemian with its candles, incense, gauze curtains, and brightly painted furniture. Nelda and Asta, who had preceded her to the city, were wonderfully sophisticated to her eyes with their bobbed hair and grown-up jobs. Nelda was again working as a secretary, and Asta was employed in that old standby occupation, painting lampshades. But Flavia found Wanda by far the most glamorous, "sleek and gypsy-like" in filmy black garments and a long string of beads (fig. 10).[23] The four younger sisters moved into the East 78th Street apartment; Wanda moved to a new apartment at 1061 Madison Avenue, near the Metropolitan Museum of Art.

Flavia and Dehli got work as stenographers, but Flavia disliked the routine of office work and moved quixotically from job to job. (She was sometimes a secretary but also a switchboard operator and cafeteria counter girl.) It

10. WANDA, NEW YORK CITY, 1928.

was only in the evenings that she could pursue her real interests: drawing, writing, and playing the banjo.[24] She also produced a monthly "magazine" called *Fried Ice* (typewritten, with cover and illustrations in color). When Wanda offered Flavia and Dehli employment at Tumble Timbers for the summer of 1926—cooking, cleaning, and other domestic chores, it seemed like a glorious liberation. Wanda gained the freedom to work on prints and drawings for a solo exhibition to be held that fall at the Weyhe Gallery; Flavia and Dehli got room and board.

Flavia's memoirs give homely details about the setting for Wanda's most prolific period as a printmaker. Living conditions were simple: they used boxes and crates for cupboards, cooked on a kerosene stove, and brought water indoors from the spring. (They had no running water or bathroom; they went outside to a privy, which Flavia called the "little grey house at the end of Gumbo Lane," visible in Wanda's print.[25]) They raised vegetables and ate the wild quince, apples, blackberries, dewberries, cherries, and strawberries that grew on the place. Wanda was absorbed in her work for the Weyhe exhibition but also took time to mentor her siblings. "We have a Gag art class in design now," she wrote to her friends Harold and Doris Larrabee in August 1927. "It meets every Monday evening—all the Gags except my brother who cannot always be there. . . . He plays the banjo and is in a vaudeville act at present."[26]

Wanda's relationship with the Weyhe Gallery would be a turning point in her career as a fine artist. Although she had known Carl Zigrosser, the gallery's director, since 1920, it was not until he saw drawings Wanda had done at Tumble Timbers in 1925 that he took her work on consignment and offered her a one-person exhibition. They also began a close friendship in which Wanda poured out her musings on the mysteries of nature. Carl, for his part, encouraged her as an artist and endeavored to become her "cavalier."[27]

Her first major solo exhibition was at the Weyhe Gallery in November 1926. It comprised fifty works, mostly watercolors and drawings, but also six lithographs including *Tumble Timbers*. Reviews, generally admiring, focused on their homely vitality. "You may have seen thousands of dishpans and kitchen chairs rendered on paper," Murdock Pemberton wrote in the *New Yorker*. "But when you see Wanda Gág's you will jump. We have seen no lithographs or drawings we liked as much since the show of Matisse, two years ago."[28] Wanda gained some important admirers, particularly William Ivins, curator of prints at the Metropolitan Museum of Art, who bought *Elevated Station* for the museum (fig. 11). In 1927 that image was also selected as one of the Fifty Prints of the Year by the American Institute of Graphic Arts (an honor Wanda would receive annually until 1943).

But her most important patron was Zigrosser, who would have a decisive impact on her career. He figures vitally in the development of American art as the director of a gallery that specialized in prints at a time when the fine arts print was just emerging as an important form of American art. New York now had a small number of master printers. (Lithography, in particular, requires the services of a professional printer.) Conservative American art schools and museums were also slowly recognizing the importance of prints.[29] Zigrosser staged exhibitions of prints by eminent European artists, such as Kathe Köllwitz, Édouard Manet, and Henri Matisse. He also promoted a number of American printmakers, such as Peggy Bacon, Howard Cook, Rockwell Kent, and Paul Landacre. In fact, he created a

11. WANDA GÁG, *ELEVATED STATION*, 1926, LITHOGRAPH ON ZINC PLATE (TRANSFER), 13 1/2 X 16 IN. MINNEAPOLIS INSTITUTE OF ARTS.

stable of artists for whom the Weyhe became an important source of income, much as Alfred Stieglitz had done for the circle of artists he promoted through his 291 gallery.[30] Zigrosser was also important to Wanda personally. He fully supported her artistic aims and understood the difficulties she faced as a woman. Zigrosser was known for his feminist sympathies. Indeed, he was one of only two men who belonged to the feminist organization Heterodoxy. Its female members particularly admired his unusual capacity for listening.[31]

The Weyhe gave Wanda a second exhibition in March 1928. Her work now attracted the notice of Ernestine Evans, children's editor for the new publishing house Coward-McCann, who expressed interest in producing an illustrated

book by Wanda Gág. "You have to *make* luck," Wanda once exhorted Flavia, and in this instance she had done the work that enabled her to present Evans with three manuscripts to consider the very next day.[32]

One of these stories was published as *Millions of Cats* later that year. This charming book, which was an immediate and lasting success, had two important sources. First, it sprang from Wanda's childhood memories of fairy tales from the Old Country. "Once upon a time there was a very old man and a very old woman," the story begins. "They lived in a nice clean house which had flowers all around it, except where the door was. But they couldn't be happy because they were so very lonely." Like a character in a fairy tale, the woman

makes a wish—for a cat—yet the resulting search, undertaken by the loving old husband—has quite unexpected consequences: "Cats here, cats there,/ Cats and kittens everywhere,/ Hundreds of cats,/ Thousands of cats,/ Millions and billions and trillions of cats." The idea that people must be careful what they wish for is a leitmotif of German-Bohemian fairy tales.[33] Anne Carroll Moore, a specialist in children's literature who was an early champion of Wanda's work, asked her whether the book was based on a particular source. Wanda replied that it was not. "I invented it, pictures and all, for some children in Connecticut who were always clamoring for stories," she said. "The way of telling it may have been influenced by the *Märchen* I heard as a child. They were the stories I knew best. What we have known and felt in childhood stays with us." Moore believed that Wanda retained the ability to see as a child—an unusual gift that "rarely survives rigorous training in schools of art."[34]

Yet Wanda also used her "outward eye," as Moore perceived. Not the sort of artist to rely on stock forms, she modeled her images on real cats, which Earle Humphreys obtained for the purpose from friends. These two cats—the black-and-white Snoopy, and Snooky, a silver-gray cat—became important members of the household (fig. 12). Flavia's family memoir describes how Wanda would put the two kittens in the middle of the kitchen floor after dinner and sketch them as they played.[35] She also used the beautiful mountains of Connecticut, which she drew while visiting Janet and Ralph Aiken in Ridgefield in the early 1920s, to evoke the Central European forests that appear in the backgrounds of *Millions of Cats*.

Like much of Wanda's work, *Millions of Cats* was a family affair. With the tight deadline of two or three months to finish some thirty drawings, Wanda felt it necessary to carve out a period of protected time. She moved to Tumble Timbers to get away from the time- and energy-draining distractions of the city. As they had two summers earlier, Flavia and Dehli came to cook and clean. Humphreys did his part to keep the household going by running the two miles from Tumble Timbers to Glen Gardner and back for supplies.[36] He also served as sounding board for the text, suggesting the use of certain rhymes and refrains to make the text memorable, even hypnotic. Wanda elected to use black-and-white line drawings, a medium that harked back to nineteenth-century magazine illustration (and to her own work for periodicals such as the *Liberator*). Hand-lettering suited this medium, and, when Wanda disapproved of the work of the draftsman suggested by Coward-McCann, she had her brother, Howard, hired for the job.[37]

12. WANDA AT 1061 MADISON AVENUE WITH SNOOPY, MODEL FOR *MILLIONS OF CATS*, SPRING 1930.

Millions of Cats was immediately recognized as opening a new direction in American children's literature (fig. 13). As biographer Karen Hoyle demonstrates, the black-and-white drawings were startlingly original since almost all children's books at the time used color plates. The hand-lettering also was unusual. The result is a work that has the handcrafted appearance of a woodcut, with all its associations with German popular literature and with the revival of the woodcut by German Expressionist artists. The double-page spreads, so well adapted to the depiction of a journey, help this comfortable book draw in young readers.

Wanda exerted the same perfectionistic care on *Millions of Cats* as she did on her prints and drawings. She was at all times aware of the child's point of view. "I aim to make the illustrations for children's books as much a work of art as anything I would send to an art exhibition,"

Wanda said. "I strive to make them completely accurate in relation to the text. I try to make them warmly human, imaginative, or humorous—not coldly decorative—and to make them so clear that a three-year-old can recognize the main objects in them."[38]

Wanda did not, at first, realize how much work remained to be done *after* the completion of the text and drawings. "I innocently thought that all the launching of my little book would mean, would be the writing and drawing of it, with possibly one trip to town for the purpose of wrangling with the engraver," she wrote to George Biddle in November 1928. "But I have had to make at least a dozen trips to New York this summer for interviews, business conferences and what not."[39] Nor had one trip to town sufficed for overseeing the engraving process: she made at least four, in addition to her painstaking work with page proofs sent to

13. FROM *MILLIONS OF CATS*, BY WANDA GÁG, ©1928 BY WANDA GÁG, RENEWED ©1956 BY ROBERT JANSSEN. USED BY PERMISSION OF COWARD-MCCANN, AN IMPRINT OF PENGUIN PUTNAM BOOKS FOR YOUNG READERS, A DIVISION OF PENGUIN PUTNAM INC.

New Jersey. As always, she was concerned about materials, campaigning for a better grade of paper than Coward-McCann was prepared to use to keep the price to the standard $1.25.

She achieved a partial victory: the publisher agreed to issue 250 boxed sets of the book, which were printed on fine paper and also included an original woodcut, signed by the artist. Yet the struggle to have her subtle ideas and techniques rendered properly in print went on. At the second printing, Wanda was so horrified at changes in the colors used on the cover and several other "calamities" that she was led to doubt whether she would ever be able to get a good printing job on a low-priced book. "It just bothers me so to see my fine careful lines come out heavier, and my blacks (which are composed of literally thousands of pen-scratches so as to keep them from being flat and heavy) come out either solid or else pale black," she wrote in her diary. "I know my drawings are difficult to print. . . . But still, as I say, with the best service it could be done."[40]

Wanda Gág's reputation as an artist had been established by the two Weyhe Gallery exhibitions, but Millions of Cats brought her wider fame. It was a particularly good time to publish children's books, with more and more of them coming out each year and libraries starting to establish children's rooms.[41] The book was enthusiastically promoted by Coward-McCann, which ran a full-page ad in the New York Herald Tribune. Also, Wanda read the story over a New York radio station. It received numerous reviews, including in the Saturday Review and the Nation. The latter was written (with questionable propriety) by Ernestine Evans, who compared the story to those of Hans Christian Andersen and the Brothers Grimm. The book was runner-up for the Newbery Award—an annual prize for the most distinguished contribution to American children's literature, established in 1922 and yet

another sign of the growing éclat of this field. Remarkably, Wanda would never win the Newbery, or, later, the Caldecott Medal (established in 1938). Nevertheless, she remained at the forefront of the children's book field and, in fact, helped advance its development.[42]

Coward-McCann pressed Wanda to produce a successor to Millions of Cats quickly. But with characteristic self-confidence, she delayed, expressing her determination to write only one children's book a year. Her second, The Funny Thing, was published in the fall of 1929. Like Millions of Cats, it has the trappings of a fairy tale, telling of a curious dragonlike "aminal" that eats children's dolls (fig. 14). Unlike Grendel or other dragons of myth, the aminal is benign (and was based on Wanda's beloved dog Purple).[43] The Funny Thing is also similar to Millions of Cats in that the story presents a problem—a "monster" that steals from children and a hero, a kindly old man named Bobo. Bobo disarms the aminal, not by force but rather by giving a food called jum-jills. (Like Lewis Carroll, Wanda retained a childlike love of nonsense words.)

In the fall of 1929 Wanda, by now a celebrity to the audience for children's books, was sent on a midwestern promotional tour by Coward-McCann. Enthusiastic crowds greeted her in department stores in Chicago and Minneapolis, and The Funny Thing sold well. Wearing a fur coat from Macy's and her fashionably bobbed hair, Wanda cut a glamorous figure. She approached her book-tour appearances with characteristic energy and discipline. In Minneapolis she appeared at Dayton's department store, despite the fact that a blizzard was raging and that she had a case of flu.[44]

On Thanksgiving Day, Wanda went to New Ulm. She traveled in style, in a taxi provided by Coward-McCann. It was as a successful artist and author that she made this journey, and she

14. WANDA GÁG, THE "AMINAL" FROM *THE FUNNY THING*, COWARD-MCCANN, 1929.

looked at the "Grandma Folks" with a broad new perspective yet also with deep feeling. "There are some houses which one can always . . . approach without a thrill of emotion," she observed, "and there are others which no matter how many hundreds of times one has seen them, never fail to send a tingling shiver of pleasure thru one's body. Tumble Timbers is such a place, and so is Grandma's house." Being in this house would, in fact, cause her to draw "frantically."[45]

Wanda was struck by the physical appearance of the Grandma Folks. Despite her too-white face powder, Aunt Lena—gifted seamstress, indestructible romantic—still looked youthful. (Wanda thought that the Biebls simply did not age as other people did.) Uncle Josie, too, seemed remarkably youthful, and she was impressed anew by his handcrafted furniture and toys as well as by his scholarly pursuits. But the most powerful presence for Wanda was that of Uncle Frank. Her diaries occasionally

mentioned artists, especially Cézanne and van Gogh, and, among the living, John Marin, Georgia O'Keeffe, and Diego Rivera. But nowhere did she write as extensively about an artist as she did about Uncle Frank. Being an inarticulate peasant (a term Wanda used with the utmost affection and admiration), her uncle cannot explain the creative urge; he only *has* it. Wanda, drawn to his workshop and compelled to draw it, attempted to verbalize his attachment to the little space crowded with "contours square, flat, curved, curled, fluted, ridged and rippled," which convey "something ineffably sweet, overwhelming,—unexplainable":

Oh, Uncle Frank!—if you only knew how much more you are an artist, how much more deeply so than many, many "artists" I have met—if you could realize how close are you and I—I with my years of studies, with my knowledge of Cézanne, Renoir, Michelangelo, abstract form, dynamic rhythm, inter-relation of

objects—you with a tool you have carved yourself, running your rough, gnarly hand over its negative curves, in complete appreciation of the primitive forms it will carve in wood; not realizing how close you come to—let us say, Archipenko!—with his concave forms in a statue, which one is expected to translate, aesthetically, into convex ones.[46]

Uncle Frank's Workshop (1935, fig. 15), one of three prints Wanda made several years later to commemorate this visit, depicts the tools, the wood suspended from the ceiling to be seasoned, the boards, the half-finished wooden furniture, rags and varnishes, the stove, which carry these complex emotional associations of honesty and authenticity, and which serve as tangible connections to the past. In New Ulm, Wanda also saw many of her father's oil paintings and noted that he rose in her estimation as a painter.[47]

Wanda had already begun seeing the story of her life, as well as the objects that embodied it, as the stuff of art. In 1927, soon after the start of her rise in the art world, she was invited by the editors of the liberal magazine *The Nation* to contribute an autobiographical piece to a series called *These Modern Women*.[48] Her essay, "A Hotbed of Feminists," which appeared in the June 22 issue, was, like the other sixteen articles in the series, published anonymously. Although she would later express dissatisfaction with this sketch for its brevity and lack of frankness, it provides the most important facts about her youthful struggles.[49] The title refers in its most literal sense to the childbed of Elizabeth Gag, her mother, who gave birth to baby after baby in an attempt to satisfy Anton Gag's desire for a son. Wanda describes her childhood in New Ulm, calling it "New Swabia" (the Gags are

called the "Muhrs") and depicting it as full of civic virtue but hopelessly Philistine.[50] After recounting the family's struggles, the essay, which reads like a fairy tale, has a happy ending: the writer herself became an artist, and indeed, each child "became more a Muhr," that is, achieved an individual identity. Her father might not have been so set on having a boy had he recognized that his household was such a "hotbed of feminists."

The essay reveals a good deal about Wanda's brand of feminism. She was never formally connected with any feminist groups (she tended to avoid organizations as distractions from her work), though she was outspoken in her support for women's suffrage and open in her admiration for independent women such as

15. WANDA GÁG, *UNCLE FRANK'S WORKSHOP*, 1935, LITHOGRAPH ON ZINC PLATE, 12 15/16 X 9 1/16 IN. MINNEAPOLIS INSTITUTE OF ARTS.

Isadora Duncan and Emma Goldman.[51] Since her identity as the author of the piece was an open secret, its appearance began to establish her as a feminist heroine. For one thing, Wanda's success in becoming an artist unhampered by marriage and children was unusual, even among the sixteen other high achievers chosen to contribute to *These Modern Women*. As Elaine Showalter points out in her introduction to the reprint anthology of *The Nation* series, American feminism had reached a turning point in 1925: women had won the right to vote in 1920, but the world had not changed. Showalter notes that a major theme running through the essays is disillusionment over the possibility of real freedom and equality for women. Wanda's independent stand on sex also was remarkable for her day, as indicated by a note she received from Egmont Ahrens, editor of the *New Masses*: "Be more explicit about your relationships with men. The way you solved that problem seems to me the most illuminating part of your career. You have done what all the other 'modern women' are still talking about."[52]

"A Hotbed of Feminists" also establishes the importance of Anton Gag in shaping Wanda's career. She presents herself as a daughter carrying on her father's work. (The article includes the oft-quoted deathbed injunction.) Alfred Stieglitz responded strongly to this aspect of the essay, writing to her in March 1928, "Your father has been much in my mind since I read your contribution in *The Nation*." Stieglitz enclosed a check for $100. Wanda replied that his letter had helped in the seemingly impossible process of making "some of the sympathy and appreciation which was denied him in his lifetime" *flow backward* to her father. "My own feeling was deep enough, I think, only I didn't know how to make it flow back, wave on wave, to my father. You did know, and now I have a great feeling of peace about him."[53]

By 1929 Wanda was thinking about turning her early diaries into an autobiographical volume. To this end she hired Flavia to transcribe and type them—often a difficult job since her handwriting loosened into a flowing form of shorthand as she thought.

Flavia herself began keeping a detailed diary in August 1928. More systematic and earthbound than Wanda's record of her inner life, Flavia's diaries record daily events and her own states of mind.[54] Early entries focus on her yearnings for romance during her first years in the East. Less inhibited than Wanda had been at her age, Flavia saw herself as a "young modern" who was willing to be seduced by a suitably compelling man; she seems to have had none of the internal debates that had obsessed her older sister. She was not beautiful, but she was attractive to men (fig. 16). She thought her secret was "pep": "So often at parties I see young girls who should be just bubbling over

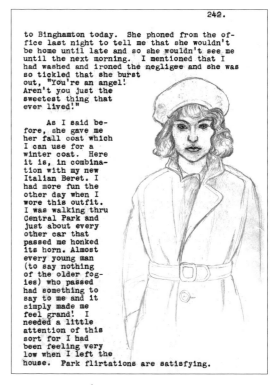

242.

to Binghamton today. She phoned from the office last night to tell me that she wouldn't be home until late and so she wouldn't see me until the next morning. I mentioned that I had washed and ironed the negligee and she was so tickled that she burst out, "You're an angel! Aren't you just the sweetest thing that ever lived!"

As I said before, she gave me her fall coat which I can use for a winter coat. Here it is, in combination with my new Italian Beret. I had more fun the other day when I wore this outfit. I was walking thru Central Park and just about every other car that passed me honked its horn. Almost every young man (to say nothing of the older fogies) who passed had something to say to me and it simply made me feel grand! I needed a little attention of this sort for I had been feeling very low when I left the house. Park flirtations are satisfying.

16. FLAVIA GÁG, DIARY DRAWING, OCTOBER 18, 1930, PENCIL, 5 X 2 1/2 IN. PRIVATE COLLECTION.

with the spirit of life sitting around like so many old hens. *I* can't keep still at all. I *have* to be racing around, laughing, dancing, engaging in gay repartée." For a while her most persistent suitor was a Minneapolis man, Phil Hammer, but she found him irritatingly dull. She was greatly smitten with his best friend, Gordon Farcas, yet this romance ended after a year of agony during which he stood her up time and time again.[55] She then entered what the family considered a dangerous liaison with Frank Hopper, a psychologist living in Greenwich Village who was a "lecturer on sex" and self-styled master of lovemaking.

Flavia's main creative interest began to crystallize: she wanted to be a composer. Like Howard, she was self-taught. Her lyrics and melodies, discussed at length in the diaries, are light, often banal. For example, there was "Don't Blame Her—'Cause She's an Artist," written about Wanda "to show what an eccentric person she is."

> If her biggest wish is getting out of dishes,
> Don't blame her—'cause she's an artist!
> If she thinks it's funny that you work for money,
> Don't blame her—'cause she's an artist![56]

But since this was the heyday of Tin Pan Alley, a time when lyrics that rhymed "June" and "moon" were plentiful and popular, Flavia's aspirations to sell her songs were not necessarily foolish.[57] She had "composing fits," which were probably to some degree emulations of Wanda's "drawing fits." Nevertheless Flavia's preoccupation with songwriting was absorbing enough to drive her other artistic ambitions away.[58] For a brief time, she seemed to be on the brink of success. In 1929 an elevator operator representing himself as an agent in the "music game" persuaded Flavia to give him a sheaf of original manuscripts. Wanda and Earle were horrified, and there followed several months of anxiety about piracy. Yet

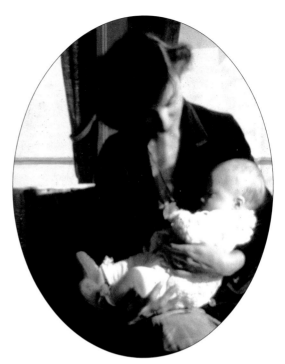

17. STELLA AND GARY HARM, C. 1930.

the man probably played a role in having one of Flavia's songs performed at New York's Roseland dance hall on September 11, 1929. (It is typical of Flavia that she could not be there that night because she was ill with the "grippe.") Later she was careful to copyright her songs, a number of which would be published and performed.[59]

In late September 1929 Flavia went to Minneapolis to help Stella Gág Harm, who was expecting a baby that fall. She enjoyed returning to the city's neat, quiet streets and reveled in the status of being "from New York." She also liked visiting Central High School and discovering just how famous *Millions of Cats* had made Wanda locally. Stella's child, Gary, was born on November 19 (fig. 17). Although Flavia greatly enjoyed the baby, she had severe nervous reactions to his crying and began complaining of exhaustion from housework and inadequate sleep.[60] Also, at ninety-eight pounds, she was painfully thin. (Like Wanda, Flavia was perennially trying to gain weight.) In late January 1930

she underwent a series of medical tests at the University of Minnesota. The doctors—interested in Flavia because of her famous sister—found nothing wrong but anemia and prescribed good food and cod liver oil.[61]

By early February Flavia was ready to return to New York. Wanda had offered to pay the fare, yet as the time grew near she attached a condition: Flavia had to give up her Greenwich Village lover, Frank Hopper. Wanda's sometimes domineering attitude toward her youngest sibling is clearly revealed in a January 1930 letter:

> It is not that I want a return *for my generosity or help,* but it seems to me that if I am willing to cooperate with you in this matter [the return fare] it would be unkind & selfish of you not to spare me some of the worries you gave me last winter—I mean in the many uneasy hours & days you gave us last year because you would not take my well-meant advice about men etc. . . . if I was obliged to keep your welfare in mind for 18 or 19 years, I should not be blamed for wanting to save you from disaster after that.[62]

Wanda also demanded that Flavia "take up something" upon her return, suggesting the completion of a project she herself had no time to finish, a book for girls on how to sew. Flavia was deeply disturbed by this letter but a few days later wrote agreeing to every point. "I'm trying my darndest to be a good Gág," she assured her sister.[63]

Before she could depart, however, Flavia fell ill. The illness proved to be the beginning of a severe nervous breakdown.[64] When she was able to travel, she left Minneapolis for New Ulm, staying at the Biebl farm with Aunt Lena. She was immobilized in bed, *"vie einer halbtot"* (like one half-dead), in the words of her aunt. At first, Flavia did not have the courage

to confide the extent of her illness to her eldest sister. Missives hinting at her condition elicited fussy letters from Wanda exhorting Flavia not to "sponge" on the Grandma Folks and further outlining plans for the projected book on sewing. Finally, in early March, Flavia attempted to convey her true state of mind. Wanda replied a few days later: "Well it's been a trying winter for the Gág family—here's hoping that the old saying about the darkest hour being just before the dawn, will get busy & carry out its boast. A little dawnishness would be acceptable to us all, I'm sure."[65]

Flavia returned soon thereafter to New York City, where she recovered slowly from this mental and physical collapse. Wanda, meanwhile, had her own problems. The idyll at Tumble Timbers had ended, and her relationship with Earle Humphreys, so gloriously simple in the beginning, had grown more complicated. He wanted to write but could not buckle down: he was a master of procrastination, so adept at becoming distracted that the family had nicknamed him "the Drifter." Also, he had begun to drink heavily.[66] Another source of difficulty was that Earle had had an affair with another woman in the spring of 1929, an infidelity that was painful to Wanda despite her convictions about the value of free love. As a consequence, she and Earle had arrived at the idea of taking periodic "vacations" from each other. In Flavia's estimation, her sister was now "run-down, thin, and nervous."

The summer of 1930 brought some relief. Lewis Gannett, editor of the *Herald Tribune Book Review* and Wanda's choice as a lover on her first vacation from Earle, offered Wanda and her siblings the use of his country home on Cream Hill in West Cornwall, Connecticut, which he visited on weekends. It was a handsome Colonial cottage, charmingly furnished—a temporary paradise for the family that had pinched and struggled for so long.[67] Dehli, Howard, and

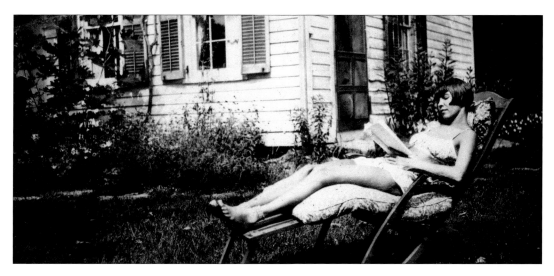

18. WANDA AT CREAM HILL, WEST CORNWALL, CONNECTICUT, SUMMER 1930.

Flavia were the regular residents with Wanda. Nelda and Asta visited frequently, along with Robert Janssen, a young German-born business-man with a serious interest in photography who was paying court to Dehli. Wanda rested and worked on her next children's book, *Snippy and Snappy*, but for once she did not push herself to draw (figs. 18 and 19).

"There is rarely a sharp or harsh word between us," Flavia wrote of the family that August. "People always tell me that we don't act like sis-ters and brother—we act like friends, good friends, intimate friends, ideal friends. And I have long realized this in a vague sort of way—I never knew just what it was, tho, that made us seem different from other families."[68] Each

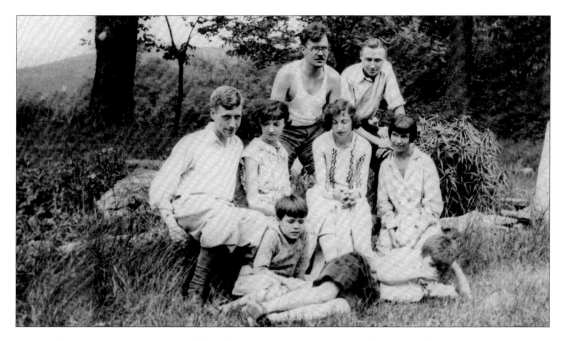

19. CREAM HILL, SUMMER 1930. FRONT ROW (LEFT TO RIGHT): RUTH AND MICHAEL GANNETT.
MIDDLE ROW (LEFT TO RIGHT): ROBERT JANSSEN AND DEHLI, FLAVIA, AND WANDA GÁG.
BACK ROW: LEWIS GANNETT AND HOWARD GÁG.

pursued individual interests: Dehli and Flavia took up mushroom collecting, which was particularly salubrious for Flavia, who developed her drawing skills by making numerous spore prints. The siblings were bound together by abiding shared interests, particularly music. In the evenings they sang German, "Low-Dutch," and English songs to the accompaniment of Howard's guitar or banjo (fig. 20). One evening at Cream Hill Lewis Gannett's young son, Michael, offered his violin to Howard. Although Howard had never played the violin, he looked, as Flavia wrote,

> *awfully sweet while wielding the bow as though he were a professional. He had such a wistful expression in his eyes, and he looked so terribly serious. His small sensitive face was lit up by the lamp, and just for a moment I saw sitting there a future genius. It is easy to imagine that about him because he has just the right sort of face, figure and hands.*[69]

The Gágs had achieved a stability of sorts. Wanda's success as an artist and author of children's books solidified her financial position and made her the mainstay of the family. In her biography of Wanda, Alma Scott remarked that "by

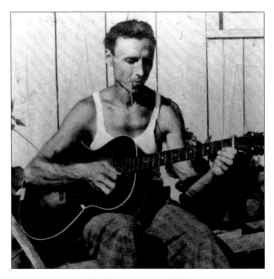

20. HOWARD, C. 1930.

21. DEHLI, SUMMER 1930.

this time all the family problems of the seven Gágs had dissolved."[70] Yet there were underlying difficulties. During the summer of 1930, Flavia, still suffering acutely over her romantic losses, became infatuated with a dashing figure named Sedgwick Gold, who was a local "gentleman farmer." She was seriously disturbed when, on his visits, Wanda dominated the conversation, although he was "a youngster compared to the men she likes and he doesn't mean a thing to her." Wanda modified her behavior after Flavia worked up the courage to confront her, and Flavia was mollified. "Dale [Dehli] and I decided the other day that the reason [Wanda] talks so much about Art is that she wants to show him *we* know something too," she wrote in her diary. "[W]e know many things which are totally foreign to him." In any case, the romance came to naught.[71]

Flavia was hypersensitive and emotionally vulnerable. Dehli, too, was delicate and had problems with depression that would soon worsen sharply (fig. 21). "None of us are *really* happy," Flavia wrote privately, "and most of us seven are miserable. . . . And poor of course. If we weren't as poor we wouldn't be so sick. That I know for certain."[72]

9 ALL CREATION
THE 1930s

The economic catastrophe known as the Great Depression did not represent a great change for a family that had long operated on the edge of poverty. Fervent supporters of Franklin Delano Roosevelt and the New Deal, they coped with the privations of the Depression by applying the habits of frugality they had developed in the years after Anton's death. By the 1930s Wanda was in a strong professional position. She published a children's book every year or two and—since the market for these relatively inexpensive books actually grew in this period rather than declined—she had a reliable means of support.[1]

1. WANDA OUTSIDE THE WEYHE GALLERY, FALL 1930.

Wanda also continued her printmaking activities. Her third exhibition at the Weyhe Gallery opened on January 13, 1930 (fig. 1), and was the occasion of a special issue of the gallery's publication, *The Checkerboard*. "This being the bad stock market era—I was prepared to sell nothing at all," Wanda wrote in her diary in March 1930. "That was not what I had the show for, really, I wanted 'to see if there were any ripples,' as Katherine Mansfield put it." But several drawings and watercolors—$400 worth in all—were sold. *Lamplight*, one of the most popular prints in the show, went up in price from $15 to $50 (fig. 2).[2] By this time Wanda was being widely exhibited, both in the United States and abroad. Her works were in the collections of the Art Institute of Chicago, the Victoria and Albert Museum, and the Bibliothèque Nationale, among others.[3]

The younger Gágs, on the other hand, felt the impact of the growing Depression more directly. As Flavia wrote in her diary in January 1931:

For the past few months I've been doing

2. WANDA GÁG, *LAMPLIGHT*, 1929, LITHOGRAPH ON STONE (WASH), 10 3/4 x 8 7/16 IN. MINNEAPOLIS INSTITUTE OF ARTS.

everything in my power to land a job; but the unemployment situation is enough to make one weep. The few cents I manage to scrape together all go for phone calls and subway rides to the G[overnment] agencies. And then one isn't even treated civilly. There are such hordes of girls registered at each agency that no one gets much consideration.[4]

From Flavia's point of view the early 1930s were perilous and insecure: she scraped by on fifty cents a day. For a time she shared Wanda's apartment at 1061 Madison Avenue with Alma Schmidt, who had moved to New York and worked at the United Parents Association. Dehli Gág moved in with them temporarily—they all tended to "float" these days—and worried Flavia considerably with psychological difficulties that, with Wanda's financial help, were being treated by a psychoanalyst. By January 1931 Flavia had escaped this over-crowded situation by moving into an apartment on West 156th Street with Howard, who was now getting fairly steadily work with bands and orchestras.

That same month Flavia got a temporary position at United Parents with Alma, but in April both young women were let go. She then took assorted other secretarial jobs; her diaries give long accounts of torturous relations with bosses she portrayed as tyrannical or manipulative. In 1932 she became the secretary and general factotum for Christine Frederick, who wrote a household-advice column for newspapers. The job involved Flavia's staying periodically at the Fredericks' home in Greenlawn, Connecticut, an arrangement she found congenial. Her diary testifies to the Depression's impact in 1933 on even such a well-heeled family as the Fredericks.

Mrs. Frederick went to the bank to cash a check so as to be able to pay me, and

returned with the news that all the banks in New York State were on a three day "holiday" during which time no money could be withdrawn. Five dollars was absolutely all she could scrape together in cash and I took it with a feeling of fear as to how I would be able to pay for a room in New York and live besides—all on $5.[5]

Wanda, on the other hand, managed to save money. In 1934 the Roosevelt administration announced that anyone who had hoarded more than $100 in gold would be required to turn it in. Wanda, who had $300 in a safe-deposit box, did not scruple to arrange with Flavia and Howard that each would, if called upon, claim to own $100. (She later turned in the full amount after Roosevelt issued a call for all privately held gold.[6])

Years of practice had made the Gágs skilled at economic survival. The occasional domestic accounts in Flavia's diaries are calculated to the penny. For example, when visiting each other the six siblings paid scrupulously for their own food. When Flavia worked for Wanda she kept time sheets of finicky accuracy. ("1 hr. 55 min. sewing. . . . 3 hrs. cleaning up and down stairs. . . . 5 hrs. working generally.") They also continued pursuing the various cottage industries that had brought in spending money when they lived on North Washington Street: Flavia made Christmas cards and sent prospectus letters to a long list of friends and supporters but received more letters pleading poverty than orders for her cards.[7] Howard also turned out wooden dogs or "whatsies," children's toys of the sort his uncles always made (fig. 3). Wanda stepped in with advice on how to work with new materials, such as black plastic, and requested that he put his project on a businesslike footing by drawing up a list of production costs. But Howard seems to have had the lackadaisical business instincts of the

Biebls as well as their talent, and so hopes of money from this quarter came to naught.

Wanda focused her efforts on Flavia, who she thought "was about the only one in the family who would ever earn a lot of money."[8] She was determined that Flavia stop scattering her efforts among writing poems, composing songs, and drawing (especially nature studies). In the fall of 1930 she wrote Flavia a letter that is worth quoting at length for what it shows of Wanda's way with her youngest sister and also for what it tells about her own approach to creative work:

> You have talent in writing, I think, and in spite of your idea that you find it hard to write from a child's point of view, I think that's probably the place to start. After all you're not adult enough to write for grown-ups. . . . Drawing still-lives etc. comes fairly easily to you, you have a pretty good idea of form— but you're weak on composition. The latter does not require a teacher, it can

be studied easily by looking at good pictures by other artists and noticing how they divide the space on their paper. . . . I don't think you have a strong poetic sense—you sometimes have good ideas and images in your poetry, but poetry is a pretty involved science, one might almost call it. If you ever thought of poetry seriously (and it's just about as unlucrative as song-writing and so I wouldn't recommend it except for people whose expression is just naturally very rhythmical and lyrical) it would be necessary to study all the rhyme schemes, and the sound-values of words and phrases etc. In other words your poetry has ideas and images, but not form.

The upshot of this merciless examination of Flavia's talents was the following:

> A person with several almost equally balanced talents, like you, will just have to choose one, or at most two. For instance you'll never make any headway if you

3. HOWARD GÁG, DOGS OR "WHATSIES," C. 1930.

write a little prose, write a little poetry, paint still-lives, illustrate your own writings, and write and compose songs besides. That is, you may do them all in the course of a life time, but you'll have to take them by one's or two's. For instance writing and illustrating stories go really as one unit, and this of course is the path I would recommend to you as a start. Another alternative would be to get some kind of a half-day job and study art seriously.[9]

Flavia did embark upon the book about sewing that Wanda had proposed, *Sue Sew-and-Sew.* Asta and Dehli were enlisted to help (fig. 4). Published in 1931, the book is an actual manual that gives basic instructions on how to make a complete wardrobe for a doll. (The idea had come to Wanda from Grandma's Place, where she and her sisters selected scraps from the "patch barrel," and Aunt Lena helped them learn to sew for their dolls and themselves.[10]) Asta figured out the topics for each of the book's lessons, Dehli made the illustrations, and Flavia wrote the text. Wanda sent detailed advice.[11] Flavia found the writing surprisingly difficult since every concept, even something as basic as basting, had to be explained in terms a child could grasp.

The title page of *Sue Sew-and-Sew* gives as authors "the Three Gags," and the dust-jacket blurb presents them as a trio of active young artists in New York, where Asta paints lampshades, Dehli studies etching at the Art Students League and textile designing at the New York School of Design, and Flavia, though "obliged to do secretarial and stenographic work," produces her own magazine (an informal creation she called *Fried Ice*) and composes popular songs. Flavia is given credit for presenting the project to the other two. (Wanda's role is not mentioned.) Indeed, she believed she had done most of the work and that she

and Wanda deserved most of the royalties. The book sold well, surprising Flavia and proving Wanda right about the continuing market for children's books, despite the Depression.[12]

New York City had provided Wanda with many elements of her success—further art education, the stimulation of museums and galleries, a circle of influential friends—but she decided that she needed to leave the city to continue her work. (The experience of nature was vital to her, as we have seen, but she was among many artists and writers who felt the need to escape New York by the end of the frenetic decade known as the Roaring Twenties.[13]) Wanda's fortunes were strong enough that in May 1931 she and Earle Humphreys were able to buy a 125-acre farm near New Milford, New Jersey, with a 100-year-old house that needed remodeling but was basically in good condition (fig. 5).[14] She paid $3,000, a reduced price, as the barn and other outbuildings had recently burned down. The property had a brook, fine trees (including a big horse chestnut beside the house), and good views of the surrounding hills, which, interestingly, resemble those around New Ulm. Here Wanda and Earle set themselves up as a couple, Wanda asking friends and relatives to address letters to "Mrs. Earle Humphreys"; only a few members of Humphreys's family even knew he was living with her. Wanda called the house All Creation, a name that came to be applied to the property as a whole.

The house was not so isolated as the amount of acreage might suggest: there were several neighbors within sight of the house, but it was four miles to New Milford. Wanda and Earle bought a 1929 Ford sedan and Humphreys taught himself to drive. They spent the first five months cleaning, painting, and beginning renovations. The importance to Wanda of creating

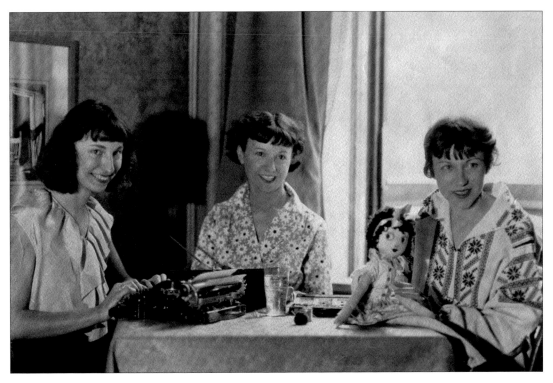

4. LEFT TO RIGHT: FLAVIA, DEHLI, AND ASTA GÁG, PHOTOGRAPH FOR DUST JACKET OF
SUE SEW-AND-SEW, 1931.

5. ALL CREATION, NEAR NEW MILFORD, NEW JERSEY, C. 1931.

this, her first permanent home, is reflected in the fact that she did not draw at all during these months. They installed plumbing and heating, and they knocked out walls to create a gracefully proportioned living room with arched doorways and stairway (fig. 6). To ensure that several people could work undisturbed at the same time, each of the three bedrooms upstairs was provided with a bathroom. Here Wanda painted murals, stamping the house with her own artistic personality in the manner of Vanessa Bell at Charleston (fig. 7). She and Earle also landscaped the house with a vegetable garden and flowerbeds, and they reforested a hillside with fifteen hundred fir seedlings. The brook was dammed to create a "swimming pool." Most important, there was the private studio they built atop the hill behind the house.

The studio was deliberately placed some distance from the house to discourage interruptions in Wanda's work (fig. 8). Nor did she want

7. ONE OF WANDA'S BATHROOM-WALL MURALS, ALL CREATION, 1931.

6. LIVING ROOM, ALL CREATION, C. 1935

domestic responsibilities. (According to Flavia, Wanda could not stand the feel of a wet dish-cloth in her hands.[15]) As he had at Tumble Timbers, Humphreys helped a great deal, but now he began to spend more time away. Virginia became a favorite destination for his writing endeavors; the climate was more agreeable there and, he claimed, it presented no distractions. Flavia also worked at All Creation between jobs in the city. But Wanda needed a year-round resident manager for the 125-acre farm. Howard, who was then working in an orchestra, was the most likely candidate, and in early February 1932 Wanda embarked on a relentless campaign to get him to come. Addressing him as "Lieber Bruder," she told him of her need and listed the attractions of All Creation: use of the Ford, a good radio, indoor plumbing, mail delivery, and readily available milk. She also promised him "quite a lot of work, carpentering, painting etc. so you could even save some money if you cared to." She concluded: "It would certainly be good for

your health. The only time I've seen you look at all normally healthy was at the end of the Cream Hill summer."[16]

At first, Howard refused. "I would lose all my connections," he explained, going on to note that he usually was "busy most of the time. I'm supposed to get some ocean trips very shortly—that is, within 2 or three weeks—either a world cruise or several Mediteranian [sic] cruises. . . . I sure would hate to lose out on that." He added his fear that if he were to accept her offer, he would "get too darn lonesome for the things I seem to be most interested in—hearing, playing and talking music. . . . When I was in [Cream Hill] Conn. I enjoyed myself for quite a while but at the end of a couple of months I had gotten to the stage where I would have paid somebody to let me play in an orchestra for a night."[17]

"Of course I can see your side of it perfectly," Wanda replied, adding that New Milford offered musical opportunities, such as a girl who played the banjo and was in a group that played as far afield as Atlantic City. "Maybe if you came here you could find an orchestra and romance besides!" Wanda soon began pressing harder. "Couldn't you come for a few weeks—it's Lent—there can't be much doing," she pleaded. And a month later she wrote: "If you were out here and heard of a nights' playing job in N.Y.—or even if you just wanted to go in for a visit for a night or two, that is very easily arranged with the car. . . . we are not nearly as isolated here as we were at Tumble Timbers or Cream Hill—for one who doesn't mind driving, 75 or 80 miles isn't a great deal." She also promised "*lots* of chunks of wood left—for carving dogs & such! Also all sorts of shelves & things to be made which you'd enjoy doing, I think."[18]

Finally, at the end of March, Howard agreed to come but "with the understanding that I can

8. WANDA IN THE STUDIO AT ALL CREATION, c. 1935.

leave whenever I want. . . . When a person leaves N.Y., most of the musicians that are so-called friends forget you ever existed."[19] But if Howard worried that decamping for All Creation might harm his musical career, there was at least one reason why he was glad to leave the city. Alma Schmidt was now married to Omer Scott, a businessman perpetually on the verge of getting rich in the "oil business" but in the meantime always needing to borrow money—a real source of tension for the thrifty Gágs. Alma and Omer had moved into the West 156th Street apartment that Howard and Flavia shared; in fact, they had taken it over.[20] Howard would not live in New York City again until World War II.

Shortly before Howard moved to All Creation, Wanda tried another arrangement to create the perfect living and working environment. In early March 1932, with Humphreys away in Virginia, she asked Howard Cook and

his wife, Barbara Latham, to spend a few months on the farm. Cook was another print-maker in the Weyhe Gallery circle; his wife was also an artist. Wanda wanted Cook's help with an etching press she had recently bought, and initial work in the studio proved very stimulating, both professionally and per-sonally.[21] On the morning of March 8, Flavia was met in the kitchen by Barbara, who said her husband had informed her the previous night that he and Wanda wanted to start an affair. Barbara, whom Flavia thought "the pleasantest of pleasant people," was hurt and furious. Her husband had recently won a Guggenheim Fellowship to work in Mexico that he was now quite ready to abandon. He was enthralled by Wanda, who had been "angling" for him since their arrival, Barbara said. Flavia, shocked and angry, censured Wan-da in her diary as "irresponsible where men are concerned" and "likely to do anything" she felt like doing.[22]

Although Flavia rarely confronted her oldest sister, this time she did. That evening she told Wanda "how she could never keep her hands off of any one's man." Wanda seemed gen-uinely surprised. As she saw it, Barbara had never been excluded from her lengthy discus-sions with Cook about art and artists; and it had been Cook, not she, who suggested the affair. It was important to their work, she said, although Flavia questioned why this should be so.

[Wanda] answered that I wasn't old enough to understand this; but that it did matter immensely. "When you have lived with one man for about five years, matters become humdrum, there is no excitement, nothing to fill you with re-newed life. But when there is someone new to occupy your mind (this does not mean at all that you have lost interest in the one you have chosen as your life com-panion) things take on a different light.

"Take yourself for instance. Whenever you fall in love anew, doesn't the world appear to you in a new light? Isn't all changed, all joyous, all filled with fire and zest?"

When she put it that way, I suddenly understood.

So did Barbara Latham, apparently, after a long talk with Wanda (although the Cooks left soon thereafter, and the affair never took place). Flavia concluded that Barbara had misread Wanda in the beginning. Barbara "admitted" she was monogamous, while Wanda of course admitted herself to be polygamous."[23]

Howard Cook and his wife left All Creation on March 30, yet he had stayed long enough to help Wanda complete the etching and aquatint *Yucca Lily and Ferns* (fig. 9). This work exhibits the qualities Cook later ascribed to Wanda: "her love of life and the surging vital-ity and activity of all growing things, [with a] magic passion in which even the most com-monplace objects seemed to possess an inner organic sense of aspiring."[24] As for Cook's own work while he was within Wanda's ambit, Fla-via wrote in her diary on April 4 that Carl Zigrosser had seen the watercolor Cook did the day he made his "proposition" to Wanda and was amazed at its "dynamic force. . . . Carl thinks it has more power than any other water color H. has ever done! What an effect that woman has on men!"[25]

Wanda needed stimulation for her work, even for so apparently simple a project as *The ABC Bunny* (1933). Coward-McCann had asked her for an alphabet book, and she decid-ed to alter the standard approach by having her alphabet images tell a story. She chose a lit-tle rabbit as her protagonist. Each image cost

9. WANDA GÁG, *YUCCA LILY AND FERNS*, 1932, ETCHING AND AQUATINT, SECOND STATE,
5 5/16 x 7 1/8 IN. PHILADELPHIA MUSEUM OF ART

her as much effort as a fine art print—no matter that these were pictures of bunnies for children—and she was further hampered by the publisher's insistence that she create the images on white paper rather than, as she preferred, on zinc plates.[26] In the end these images did not reproduce satisfactorily, and Wanda went to great trouble to redo them on zinc. Intense summer heat further complicated matters.

At the height of "tussling" with her ABC book, Wanda began an affair with Hugh Darby, a physician and medical researcher in New York City whom she called her "Spanish Cavalier" (fig. 10). Wanda wrote in her diary of enchanting nights with Darby spent in the seclusion of her studio. She depicted them trooping up the hill in the dark, carrying a lamp and pail of water, while Darby's wife, Eleanor (called Kappy), who also was a doctor, slept in the house below. (She was more sanguine about her husband's dalliances than Barbara Latham.) The affair, which would continue for five years, rejuvenated Wanda and, she believed, helped her draw. She told Darby that he could consider himself responsible for *The ABC Bunny* after the letter "J" (fig. 11). Indeed, as she wrote him in June 1933:

> *The impetus you have given me has taken me not only beyond J but beyond Z, beyond the abc book altogether—that*

10. HUGH DARBY, c. 1935.

is into the realm of my other drawing and painting. I hope this impetus can last until I get the abc off my chest, for if it does I'll do something. During the past several years I have of necessity been too occupied with book illustration and getting my farm fixed up into half-ways livable condition. I have had practically no time or leisure to build up outside (that's in painting) what's been piling up inside of me. I'm about ready for a renaissance. Book illustration's all right—I'm in a strong position there, luckily, and can do just about what I please, and of course it's what I'm living on—but what I like to do best of all is to make myself receptive to the rhythm and forms about me and to record them in as intense yet logical a way as I am capable of.[27]

As on previous book projects, family members played a part in producing the ABC book.

Howard hand-lettered the text and titles. Flavia wrote a song for the endpapers. This opportunity, alas, brought her little joy: she found composing a song for children quite as taxing as writing *Sue Sew-and-Sew*. "It must be catchy and a bit unusual," she wrote, "and yet must be simple enough for a child to quickly grasp and retain in its memory. And to confine oneself to one octave and to major chords is extremely annoying."[28] Whereas Wanda loved the process of working—settling down to a day's work with the idea that it was going to be *fun*—Flavia was oppressed by concentrated work and deadlines. "What feverish moments!" she noted. "I didn't think I would last through it. There was the blocking out, the arranging, the lettering, the notes to be written out—oh heaven above! was I frantic and in a sweat."[29] The final product, carried out in an effective red-and-green color scheme, may have convulsed the house, but the efforts of Wanda, Flavia, and Howard Gág produced a

seamless whole. *The ABC Bunny* was a success for Wanda, second only to *Millions of Cats*.

Wanda's work time was sacrosanct, but when it was over she loved to play. Guests came frequently to All Creation, particularly Nelda, Asta, and Dehli, who sometimes stayed for extended periods in the summer. (All three were now married: Nelda to Richard Stewart, who worked for CBS in New York; Asta to Herbert Treat, from Minneapolis, who worked at the Sinclair Oil Company; Dehli to Robert Janssen.) Every evening included singing and parlor games such as charades, sometimes played in elaborate costumes, or the drawing game Exquisite Corpse. At Christmas the family gathered at All Creation or a sister's home. The family typically celebrated with "ten-cent presents," the occasion for much ingenuity and mirth.

Any discussion of the Gágs' family life in the 1930s must include their cats. Snoopy and Snooky, originally acquired as models for *Millions of Cats*, dominated the early part of the decade. Sketches of Snoopy and Snooky were the basis for Wanda's 1937 lithograph *Siesta*, the print that more than any other conveys her

11. FROM *THE ABC BUNNY*, BY WANDA GÁG, ©1933 BY WANDA GÁG, RENEWED ©1961 BY ROBERT JANSSEN. USED BY PERMISSION OF COWARD-MCCANN, AN IMPRINT OF PENGUIN PUTNAM BOOKS FOR YOUNG READERS, A DIVISION OF PENGUIN PUTNAM INC.

12. WANDA GÁG, *SIESTA*, 1937, LITHOGRAPH ON ZINC PLATE, 9 15/16 X 12 1/8 IN.
MINNEAPOLIS INSTITUTE OF ARTS.

sense of homey bliss (fig. 12). Snooky, the silver-gray one, figured in a family crisis. The cat was in Flavia and Howard's New York apartment when it was robbed in May 1932. The robbery traumatized Flavia, who retreated to All Creation for two months afterward. (It is about this time that the reader of Flavia's diaries begins to weary of the prolonged emotional upsets and frequent illnesses.) By her account, the cat was also traumatized, manifesting its distress even on the train ride to New Jersey the following day. When Flavia and the cat arrived at All Creation, Wanda refused to let the animal inside because she feared it might "misbehave"; Snooky ran away. After anguished searches and prolonged grief, Flavia gave Snooky up for lost.

But two years later he appeared at a neighboring farm, nearly starved and blind in one eye. He recovered but died a year later after further mishaps.[30]

The black cat, Snoopy, was the protagonist in events quite as serious to the family as the misadventures of Snooky. In January 1933 he spent the night outside and appeared the next morning with frozen paws. There ensued an ordeal of several months involving the infection and amputation of a foot. His death from distemper the following September plunged Flavia into a wild grief that Wanda seems to have shared. But there would be other cats: Carl Zigrosser gave them Dusky, a sweet-tempered half-Persian. And Liesl, one of Dusky's offspring,

was celebrated in family lore for her frisky charm. Yet no cats ever took the place of Snoopy and Snooky; they have a larger presence in the family writings of the early 1930s than Nelda or Asta.[31]

The Gágs also maintained their connection to New York City, which was about two and a half hours away by train. In fact, they usually spent winters there, with a small apartment at 250 West 22nd Street as their base. Wanda went into the city when necessary to see to the printing of a book or the mounting of an exhibition. She also attended the occasional party in New York with Carl Zigrosser. Sometimes these occasions led to stimulating encounters with other artists, as in 1933 when they visited the studio of Diego Rivera. There she saw a large photograph of his mural for Radio City in Rockefeller Center and admired its diagonal "force-lines."[32] In February 1935 Wanda and Earle attended the trial in Flemington, New Jersey, of Bruno Hauptmann, the German carpenter charged with having kidnapped Charles and Anne Morrow Lindbergh's son three years earlier. The Gágs strongly believed in Hauptmann's innocence.[33]

Occasionally Wanda and her family circle made excursions to New York City to enjoy nightlife. For example, in October 1933 a festive group made up of Flavia, Wanda, Robert Janssen, and Hugh and Kappy Darby went to a Halloween party at the Meeting Place, a social center for the Greenwich Village avant-garde.[34] Wanda and Flavia were decked out in exotic finery, Wanda in a form-fitting jumper and Russian blouse, Flavia in a "new bodice dress of challis with flowing flame-colored sleeves which I had just frantically finished," silver earrings Carl Zigrosser had brought her from Mexico, and a pair of Wanda's hand-me-down dancing slippers. Flavia was gratified when someone at the party mistook them for professional dancers. But they were disappointed at the stodgy

"band"—a guitar, piano, and two *violins*—and, eager to dance, set forth in Darby's Auburn Eight convertible (rather too chilly in late October) for Harlem, where they went to the Savoy club. Wanda lost herself in dancing again—an infrequent pleasure now—and the whole crowd caught the spirit that night. Flavia was thrilled at "hearing that irresistible music and watching those marvelously rhythmic dusky couples on the floor. The . . . high degree of utter joy in living and dancing which everyone seemed to be imbued with, left me intoxicated."[35]

Wanda would be worn out by the city after a day or two, but Flavia was more ambivalent. On the one hand, she yearned for it when she was working at All Creation, yet when she was there it frazzled her nerves. At least one short-lived job in New York brought on another serious depression.[36] One motive for going to the city was her need for a "cavalier," as she expressed her often-acute yearning for love. Meanwhile, she was making progress in the children's book field, turning out an impressive amount of work in the mid-1930s. She had finished the manuscript for a book of children's songs by 1934 (her favorite: "Silver-Grey Snooky"). Composing gave her pleasure, unlike writing, but she struggled with such elementary technicalities as key changes, which Howard had to explain. Illustrations for the book gave her the usual agonies, but the problems were solved, and *Sing a Song of Seasons* was published by Coward-McCann in 1936.[37]

Flavia produced illustrations for various children's magazines, such as *Junior Red Cross News, Story Parade, Church School*, and *Junior Weekly*. (Children's magazines, like children's books, were an expanding market during the 1930s.) She did not handle this work easily— deadlines and the detailed follow-up of publishing brought on paroxysms of complaints— but she persisted. She also provided striking

13. FLAVIA GÁG, DRAWING FOR *THE STORY OF KATTOR*, BY GEORGIA TRAVERS (ALMA SCHMIDT SCOTT), 1939, INK, 4 1/4 x 5 5/16 IN. CHILDREN'S LITERATURE RESEARCH COLLECTIONS, UNIVERSITY OF MINNESOTA, MINNEAPOLIS.

illustrations for a book by Alma Schmidt Scott (writing as Georgia Travers), *The Story of Kattor* (1939), another cat story, inspired by two Gág family felines, Mutzi and Liesl (fig. 13).

Flavia had a flair for illustration, and Wanda encouraged her to study art more seriously. As Anton Gag had done for her, Wanda served as mentor for Flavia, sometimes setting her tasks in composition, as in 1932, when she challenged Flavia to draw various states of mind: Peace, Joy, Sorrow, Chaos. In February 1936 she saw to Flavia's registration in the American School of Art in New York; Flavia enrolled but, pleading trouble with her eyes, stayed only a few weeks.[38] In March 1937 she tried again, enrolling in the Art Students League. Letters to Wanda were, typically for Flavia, full of complaints:

They have the same model for a week at a time, which isn't at all what I wanted, and it's just my luck that the model is an Indian, fully clothed. Heavens, I don't want to sit there and draw nothing but clothes a whole week. Everyone seems to be doing portraits in oil, and of course the last thing in the world that I am interested in—that is, now at least—is doing portraits or one large finished drawing in a week.[39]

"Try to get something out of it," Wanda counseled. "[I]t's something one has to get used to in Art School, *very often* the pose is uninspiring. But you can listen to the criticism (not only of yours but that given to others). . . . Now please just . . . make every effort you can to get into a good attitude about art school."[40]

Flavia did try but conceded that she felt "terribly inferior at school. I'm not doing very well, and even with a clear head it would be hard, for doing things in public and on such a large scale is hard somehow." By April 15, she was "all through at school" but assured Wanda that she had made a lot of headway.[41] She had also accomplished another goal, the acquisition of a cavalier. He was George François Gendron, a Canadian who was half Indian, half French. There was some disparity in their ages—he was thirty-five, Flavia twenty-nine—and there appears to have been some apprehension of a disparity in social class in Flavia's careful description of him to Wanda as an "expert mechanic" who worked for General Motors, supervising forty men.[42] Wanda opposed Gendron on the grounds that "the French Indians are apt to be a pretty impetuous race, and I think this one is definitely too old for you, even though he looks younger. You need, if anything, a man several years younger than you, it seems to me. . . . *Watch your step*," she went on, "& don't wear your heart on your sleeve. Has Dehl or anyone seen him? Don't go anywhere but the most public places with him, & don't get fancy." Flavia defended Gendron as "extremely decent" and "capitalism-conscious . . . certainly not a Republican!"[43]

In June 1938 Flavia rented two furnished rooms in Brooklyn with George, but, not surprisingly,

14. FLAVIA GÁG, CARICATURE OF HARRIET ASHBROOK, AUTHOR OF *A MOST IMMORAL MURDER*, 1935, PENCIL AND INK, 7 X 9 IN. PRIVATE COLLECTION.

this venture into an independent life was abortive. Just two days later she moved out, complaining of stomach problems. Also, she "just couldn't bear the 'furnished room' atmosphere. . . . And the strange district—*Brooklyn* of all places—didn't help matters any either."[44] Wanda took her to task:

> *You did not act very "grown up." . . . I know those furnished rooms are not so good, but you should have tried to look at it with a little more sense of humor. It doesn't help you to let yourself go like that, and it isn't fair to the people about you. I think you are old enough to begin thinking a little more of other peoples' comfort & happiness, instead of acting as tho you were the only one who had troubles.*[45]

But Flavia wasn't the only Gág sister with such problems. By the early 1930s Dehli Gág Janssen was almost unable to function. She was often ill and absent from family gatherings and was also frequently in acute psychological distress and under the care of psychiatrists. Nevertheless, Flavia liked to visit the Janssens' apartment in Manhattan, which she described as tiny but beautiful and peaceful, and Dehli remained a beneficent spirit in the family despite her afflictions.[46]

Wanda had difficulties of her own. She still regarded Earle Humphreys as her life companion, but as the 1930s wore on, his personality seemed to deteriorate because of his increasingly heavy drinking. In May 1933, during one of his extended absences, Flavia wrote: "I hope it will be even longer, for I dread the meals with their many cocktails, and the awful time Wanda and I have trying to keep him from taking too many. He so often overdoes it—just when he reaches the state where he is talkative enough and is beginning to stumble over his words, always at that point he feels 'just

15. WANDA GÁG AND EARLE HUMPHREYS, C. 1935.

another' would make him feel just that much better."[47] Some months earlier she had written:

> *One is somehow afraid to criticize him in any way, and Asta, Dehli and Nelda feel the same about this matter. I believe even Wanda does for she doesn't often tell him things. There may of course be a reason for this as she believes the best way to keep a man is not to tie him down and not to try to run his life for him. This is all very well when only you alone live with him but it is unfair to others living in the same house.*[48]

By 1934 Earle's behavior had become so outrageous that Wanda did occasionally speak out. Flavia knew the situation was serious when even the normally reticent Howard exchanged a few words with him on the subject one night. The next year, when Flavia rued the changes in Earle since the happy days at Tumble Timbers, Wanda acknowledged his deterioration and

"confessed that she would have kicked him out long since if she didn't have proof that basically he was not what he seemed to be."[49]

But despite all the emotional turmoil, the Gágs made steady progress at All Creation. Because of their steady labor and financial prudence, they had a secure home throughout the Depression and were free of debt. All Creation became increasingly comfortable. By 1934 the house had electricity and other amenities. Flavia was not surprised when a newly arrived guest (an aspiring novelist who lived in less style) announced that the first thing he wanted to do was take a bath. "[I]t has only been recently," Flavia wrote, "that we out here have had the pleasures of a good heating system and constant hot water in the pipes without having

always first to run down to the cellar and light the kerosene heater." In 1935 Howard finished building a guest house, for which they bought an old upright piano. Arrangements for guests and their own constant comings and goings between New York and New Jersey became considerably less complicated in 1939 with the installation of a telephone.[50]

At the same time, however, Wanda's work was less focused than it had been in the prolific Tumble Timbers period. Whereas she had produced thirty-five prints and hundreds of drawings and watercolors in 1926 and 1927 alone, between 1934 and 1939 she made only fourteen prints. Almost half of these were based on earlier works. (*Uncle Frank's Workshop* [1935, p. 129], one of the most successful, was drawn from her fall 1929 visit to New Ulm.) Others were created in response to invitations, such as

16. WANDA IN THE LIVING ROOM AT ALL CREATION, 1938.

Progress (1936, fig. 17), done for the American Artists Congress. A satire of materialistic advertising images in a country still weakened by the Depression, *Progress* serves as a rare example in Wanda's work of the kind of social commentary associated with the rural Regionalists. In the past, she had been inspired by her surroundings to draw, but in the 1930s she did very few works of this sort. According to Audur H. Winnan, only three of Wanda's prints from this decade—*Steep Road* (1934), *Snow Drifts* (1934), and *Ploughed Fields* (1936)—were "seen" and composed in the spontaneous way of the Tumble Timbers years. Most tended toward the picturesque.[51]

Drawing moods now eluded her. "Only one thing is gratifying about this," she wrote in her diary in September 1933,

> *namely that I seem to have outgrown a great many of the old viewpoints. When*

I asked myself, "What subjects shall I choose for my next lithographs and woodcuts? What do I want to build my drawings around?" I was sure of one thing—"certainly not stoves, fireplaces, lamps." Light and shade will still interest me I imagine, because form is made visible by it, and it is everywhere around me. But I believe I have covered that lamp and stove viewpoint to my satisfaction (or shall I say satiety?) and besides my surroundings are somewhat different, now that we have a furnace and electricity. But even if it weren't for those two modern factors, I believe I would be thru with those things.

The entry ends on a poignant note: "Supposing I've said all I have to say?"[52]

Wanda's response to this impasse is reminiscent of Anton's response to loss: she walked through

17. WANDA GÁG, *PROGRESS*, 1936, LITHOGRAPH ON ZINC PLATE, 8 3/16 X 11 3/4 IN.
MINNEAPOLIS INSTITUTE OF ARTS.

the fields, sketch pad in hand, drawing only the essential lines; the next day she would return to the same place and try again. She spent the whole winter of 1934 in this mode, doing only studies, "striving, working with thoroughness, never realizing, as Cézanne put it." The studies were often "very abstract research work," although she believed the results would eventually be embodied in "fairly representational" drawings.[53]

She also read a great deal in the 1930s, focusing on R. H. Wilenski's *The Modern Movement in Art* (1927), Max Doerner's *The Materials of the Artist* (1921), the journals of Eugène Delacroix, and, most profitably, the letters of Vincent van Gogh. For Wanda, van Gogh was the most interesting, lucid, and vivid thinker of all on the creative process, writing with his "life's blood" rather than mere pen and ink. Her own drawings in 1938 and 1939 took on the dash-and-dot technique of van Gogh (which he, in turn, had adapted from Japanese ink drawing).[54]

In addition, Wanda revisited basic drawing techniques. The mysteries of perspective continued to haunt her, as in 1931 when she stood on 34th Street opposite the Empire State Building, struck by how the immense new skyscraper seemed to lean toward her rather than recede: "This no doubt has to do with the fact that one's eye really creates a *curve* of vision, but why doesn't this same thing happen as when one is far away, in which case it seems to me, the top (which is outside of the curve of vision) seemed to recede."[55] She also investigated perspective as it relates to organic form by studying gourds to discern how outward form reflected inner growth. She believed herself to be at the opposite end of the spectrum from the Cubists; they had aimed to break down forms, while her aim was to build them up. "Once more I live in a world of my own constructions," she noted, "within self-created,

compactly felt symbols. Again I am drawing from within to without."[56]

As well, Wanda intensified her efforts to master oil painting. It was a logical step for someone renowned for prints—oil being a more "important" medium, in the traditional view—but it was also a medium associated with her father. The connection was made explicit in a letter she wrote to Flavia that included a caricature of herself mixing paint, wearing her father's beloved gray "cape-coat."[57] She struggled with color, trying to capture the colors she saw but also fighting to free herself to treat color as freely as form. She worked with watercolor and tempera as half-measures by way of working up to oil. As in 1923, she found that sandpaper helped: "I clung to it because I needed something with a *tooth* in it, because I was afraid of canvas, and had not yet found oil sketch paper or large canvas boards."[58] With a sense of inadequacy akin to her father's, Wanda believed she had insufficient education to succeed as a painter:

> I am very sorry, in many ways, that I had to spend my art school years (and later ones too, of course) in trying to perfect myself in illustration and commercial art. . . . I learned literally *none of the few big principles of oil painting.* . . . I never had money enough for such an expensive process. While I was in the [Frank Vincent] DuMond class I again was held back by the financial part of it. I worked on a few little canvases (15 x 20 or less) with whatever colors were left from Papa's paint box, and with a very inadequate assortment of tiny tubes which Edurmina Dumus gave me. . . . I was surely not taught how to use them. Not to mix cool with hot, how to avoid mud, how to lead harmoniously from one color to another, even how to keep the brush from being all bunched up with paint (this happened

because I mixed all my colors on the palette with the brush), if a few such things had been taught me, I might have been spared years of floundering in oily mud.[59]

She was much more successful in experiments with an entirely different medium: words. Writing involved none of the problems of the techniques and materials of art and allowed Wanda to revisit her formative years as recorded in her diaries. As early as 1929 Coward-McCann had asked her for an autobiography, but she had declined in order to work on the project on her own terms.[60] The text of course already existed, and Flavia had typed it. The task now was to make selections, disguise identities, and guard family secrets. When that was done, editors at Coward-McCann reduced the manuscript by two-thirds.

Still, *Growing Pains*, published in 1940, provides a lengthy account of Wanda's life from 1908 to 1917. The tone, as biographer Karen Nelson Hoyle has observed, often seems naive, and, although the narrative voice matures in the course of nine years, the later pages, by a young woman of twenty-four, seem the work of a much younger girl. Yet the book filled a need for coming-of-age stories by women artists, and it found an audience, particularly among young women.[61] The diarist never wavers in her desire to be an artist. That she never seems to wonder whether, as a female, she has the ability to become an artist is a testament to the egalitarian spirit of the household created by Anton and Lissi Gag. Nor does *Growing Pains* present any evidence that Wanda's art school teachers in Minneapolis, St. Paul, or New York suggested that her career would be limited by her gender. Wanda embraced her femaleness without question (not for her, as for Rosa Bonheur, the donning of mannish

clothes) and concentrated on establishing her own personality. The much-longed-for art school—when the possibility of attending it finally arises in 1913—is seen as more of a threat to this prized "Myself" than a means to develop it. The lesson for the young woman artist is to believe in herself and put art first. Another important theme of *Growing Pains*, of course, is the triumph of hard work and determination over poverty and the limitations of provincial life. Early entries create a vivid picture of small-town concerns and the end, where New York beckons, promises freedom and fame.

Another long-term publishing project, a series of editions of Brothers Grimm fairy tales, also drew heavily upon Wanda's childhood. A great deal of her time and creative energy were required by these four volumes—*Tales from Grimm* (1936), *Snow White and the Seven Dwarfs* (1938), *Three Gay Tales from Grimm* (1943), and *More Tales from Grimm* (published posthumously in 1947). The project had its roots in the early 1920s, when Wanda decided to review German in order to read works of art history and theory. Reading the Grimm tales in German, she found, was a good way to practice the language of her childhood.[62] She began her own translations in 1932. They became a true work of scholarship as Wanda, guided by the children's literature specialist Anne Carroll Moore, studied numerous other translations and considered the process of storytelling itself. Of particular aid to her was a landmark book by Marie L. Shedlock, *The Art of the Storyteller*, which had helped shape the development of children's rooms in public libraries.[63] Wanda's search for a lively, readable style required countless revisions. She worked in bed under quilts during the especially hard winters of 1933 and 1934, in a way that recalls Robert Louis Stevenson's poem "The Land of Counterpane."[64]

Tales from Grimm and the subsequent volumes

in the series are crucial to an understanding of Wanda's life and work. They may seem to be merely playful, but in fact they reflect her deepest values. She was aware of the school of thought that maintains that fairy tales are deleterious to children, or at least lacking in educational value. Yet she took the line that their "goriness"—the wolf in "Little Red Riding Hood" eating the grandmother, for instance— was clearly theatrical and served to show the triumph of good. In any case, such goriness was mild compared to the violence children heard about on the radio or saw in newspapers.[65] Fairy tales actually contained abundant information about medieval culture; they also conveyed such values as the "resourcefulness of poor people, the frequent fall of vanity, the importance of being kind to animals and wayfarers, the value of a sense of humor and of common sense, and of respect for the intelligence of quiet modest people."[66] In any case, she believed, the modern world could not dispense with fairy tales, which derive from ancient religion and mythology and spring from deep roots in the human psyche.

Wanda's retelling and illustration of a tale such as "The Musicians of Bremen," for example, draws heavily from the *Märchen* she heard as a child (fig. 18). In her introduction to *Tales from Grimm*, she recalls how she felt as a young girl whenever she was invited to sit down and hear such a story: "[E]verything was changed, exalted. A tingling, anything-may-happen feeling flowed over me, and I had the sensation of being about to bite into a big juicy pear."[67] The tales had an "intimate me-to-you quality, and that comforting solidity which makes their magic more, rather than less, believable." Although many of them involved magic and sorcery, they had a "plain workaday" character related to the substantial character of peasants. Wanda tried to imbue her text with this character. The illustrations had their sources in

18. WANDA GÁG, "THE MUSICIANS OF BREMEN," ILLUSTRATION FOR
TALES FROM GRIMM, COWARD-MCCANN, 1936.

her father's portfolios of German prints and in his own images of New Ulm. For instance, the woods of the Immelberg, where Tante Klaus lived, provided the setting for the gingerbread house in Wanda's interpretation of "Hansel and Gretel."[68]

By the end of the 1930s Wanda's reputation was high, despite her private creative doubts. She enlarged her professional activity. In 1938, for example, she served on juries for the Philadelphia Art Alliance and the American Artists Congress. In 1939 her work was included in a Museum of Modern Art exhibition, *Art in Our Time*, and she was a member of a committee that selected works for an exhibition at the New York World's Fair, *American Art Today*. Two of her own prints, Siesta (1937) and *Ceiling of the Paramount Theatre* (1928), were included.[69] Tyler McWhorter, Wanda's old mentor from St. Paul, put together a Gág family exhibition that toured from 1936 to 1938. It included works by all seven siblings, a photograph of a mural by Anton, and a watercolor by Josie Biebl. After being shown in New Ulm and St. Paul, the exhibition was seen in Los Angeles and Pasadena.[70]

Family loyalties remained strong. Flavia's diaries record rounds of visits to her sisters and their visits to the residents of All Creation. Wanda's work was put aside whenever one of her clan was threatened. In April 1936, for example, the completion of *Tales from Grimm* was suspended when Nelda Gág Stewart contracted septicemia (blood poisoning), and doctors in New York declared that there was no hope. Characteristically, Wanda took charge. She consulted Hugh and Kappy Darby at Columbia-Presbyterian Medical Center, where Kappy was researching a new medication, prontosil, which was an early type of sulfa drug. Wanda and Nelda's husband, Dick, took legal responsibility for the experimental use of this drug, which had just arrived in the country. While the family waited to learn the results, Wanda stolidly played anagrams with Robert Janssen and advised Flavia and Howard to distract themselves since there was nothing they could do. She also wrote Stella and Bill Harm and Aunt Lena Biebl about the situation but urged them not to travel to New York. (She thought it a "barbaric custom" for family members to come in such circumstances, even if worse came to worst.)[71] Miraculously, the prontosil worked, and Nelda recovered fully.

Asta was the focus of attention on October 31, 1939, when she gave birth to a girl, Barbara Jean. Wanda was delighted with this niece. She also took continuing pleasure in her nephew, Gary Harm, and would dedicate her books to one or the other of these two children—the only offspring that the seven Gágs were to have. They enlivened family gatherings and helped dispel in this family unit, with so many similarities to the Grandma Folks, what might otherwise have been a "saddish not-thereish quality."

10 WANDA'S FINAL YEARS
1940 – 1946

In 1938 Wanda, feeling the need for a different creative direction, applied for a 1939–40 Guggenheim Fellowship. In the application, she expressed several aims: to objectify theories about perspective and space, which she saw as "solidified energy"; to portray subjects in color that "demand expression in color," such as hills, trees, and flowers, "the march of the seasons"; and to reflect the life about her in terms of "home," "beauty," "right and wrong," "fun," and "work." She also voiced a rather poignant wish to travel, having been "by necessity restricted to a relatively small section of the American Scene." She now wanted to travel more widely in the United States and "to record my reactions in a form which would be at the same time a document, a comment and a work of art."[1]

Wanda was not awarded the Guggenheim, and in 1940 she earned only $250 from prints and drawings. To bring in some money, she embarked on another children's book, *Nothing at All*. The story, based on an idea that had initially occurred to her in 1926, is about an invisible dog that wills itself into visibility. It lacks the psychological and cultural depth of her fairy-tale books. Nevertheless she gamely used this genre to expand her creative range. For the first time, she worked in color lithography. "Do you remember those ground glass plates we used to have as children?" she wrote her brother, Howard. "One could trace pictures through them, with a pencil. I use a finely grained glass with a 9H lead pencil. . . . The result is like a fine crayon drawing, and since I am using black and two colors, I hope we'll get a really attractive job" (fig. 1).[2] She attempted to incorporate ideas about perspective that she had outlined in her diary, using a three-

dimensional drawing method that employed facets and meridians for drawings of tree trunks and flowerbeds. But the work was grueling. Wanda developed a painful rash on her hands, probably because the pencils had to be sharpened frequently on sandpaper, showering her hands and arms with lead. The gloves she was consequently obliged to wear hampered her ability to draw fine lines. Also, she frequently became dizzy—the beginning of health problems that would grow steadily worse. Yet she persevered, laboring ten to fourteen hours a day for four months. To characterize her dogged effort, Wanda used a Finnish word, *sisu*, meaning strong-willed patience. "It comes to me miraculously in times of stress," she wrote. "It sounds to me like what I've always referred to when I've said 'There are times when it is necessary to do the impossible.' Any Gag knows that this can be done!"[3] Published in 1941, *Nothing at All* sold more than eight thousand copies in its first year.

Meanwhile, Wanda made a number of personal appearances on behalf of her other books. In November 1940 she had gone on a book tour to Boston and the Midwest to promote *Growing Pains*. In Minneapolis she saw Edgar Hermann and his family; she also visited New Ulm and Alma Scott, who had returned there in 1936 and worked at the public library. There was a party with old friends from high school.[4] Other people who figure in *Growing Pains* reentered her life. Johan Egilsrud, who had been music critic for the *Minneapolis Star* and an English professor at the University of Minnesota, asked for an image to illustrate a book of his poetry, *Pond Image*, and she graciously supplied a drawing.[5] In 1943 Adolph O. Eberhart, the former governor of Minnesota who

By the fifth day, Nothing-at-all's eyes were visible.

By the sixth day, his nose and mouth could be seen.

1. WANDA GÁG, ILLUSTRATION FOR *NOTHING AT ALL*, COWARD-MCCANN, 1941.

had hosted Wanda on her first visit to St. Paul in 1911, wrote for advice on how to publish his memoirs. Her response, like all such letters she wrote, was warm and full of helpful detail. A. J. Russell, editor of the *Minneapolis Tribune*'s juvenile supplement, asked her how he might publish an "imaginative story for children" he had written. Wanda discouraged his use of this term, which might tap into editorial fears about fantasy and fairy tales—with which she was all too familiar—and went on to offer practical advice.[6]

Wanda received so much mail about *Growing Pains*, and so many questions about what happened next in her life, that she seriously considered producing a sequel. In late 1941 and early 1942 she spent considerable time rereading her diaries from 1917, when she arrived in New York, through the 1920s. She was dismayed at their concentration on her relation-

ship with Adolf Dehn (their "petty wrangles" and "love episodes"). She decided that her explicit descriptions of sexual activity could never be published, though she now saw this preoccupation as a "very ordinary and moral phase" of her development as a "creative type." (It was ironic, she thought, that she, who would generally be considered to be leading an immoral life, was in fact "extremely moral and conscientious" in her concern for the content of children's literature and entertainment.) She could also find evidence in these diaries that her "aesthetic and artistic side . . . [was] picking up and gaining momentum and direction."[7]

More significant during this period were Wanda's efforts to write new material about her life. Readers today might wish that she had written about New York in the years during and immediately after World War I and her

association with Dehn, Max Eastman, William Gropper, Alfred Stieglitz, and others. Instead, beginning about 1935, Wanda wrote several hundred pages of notes about her childhood before 1908. These unpublished "Childhood Reminiscences" (as they have come to be called) adopt the point of view of a child about six or eight years old and describe such simple activities as shopping in town, going to the Biebl farm, and making paper dolls. They also branch off into meditations on people (mainly family members), places, and states of mind. One section, "Wanda and God," shows the child trying to pray and otherwise deal with religious conventions—a lifelong concern.

Most of these pages demonstrate Wanda's ability to enter a child's mind without becoming mawkish.[8] As in her drawing, she was looking for a form that grew from within; it would not be a linear narrative. As early as 1929 she had used exploratory language (not unlike that of Virginia Woolf) about how she wished to present

> the beginning of slender strands early in the book, and then show how some get stronger, some remain slender, and still others break—but also to give the effect of this interweaving, and coming out here and there in beautiful complete patterns. Papa's pattern would be beautiful but incomplete.[9]

Her 1943 letter to A. J. Russell notes that these reminiscences were "not to be merely a story of my own childhood, but an attempt to explore and put down on paper Child Mind in general. After years of trying I have finally found, I *think*, the right form for it, and I find it fascinating." Regrettably the "Childhood Reminiscences" remain fragmentary, although they contain a good deal of information about Wanda's family, with an emphasis on the Biebls, who clearly obsessed her as a child and

who continued to haunt her. Given her immersion in the reminiscences, which are more externally focused than the diaries, it is not surprising that Wanda's diary-keeping slackened during the 1930s and practically ceased in the 1940s.

Wanda had numerous other projects during the 1940s. Radio was an abiding interest—it had been a vital link to the outside world at All Creation—and she turned several of her children's books into radio scripts.[10] She also continued her political activities with membership on the art committee of the ICCASP (Independent Citizens Committee of the Arts, Sciences, and Professions), a group that, as Carl Zigrosser later described it, worked for "full employment, enlightened atomic control and other worthwhile enterprises as well as a fine arts bill."[11] She turned down many requests, such as working on a WPA project or teaching juvenile writing at the League of American Writers in New York. She regularly passed projects presented to her by editors on to Flavia. The possibility of a film based on *Growing Pains* attracted her only briefly.[12]

Wanda also produced a few prints, such as *Barns* (*Barns at Glen Gardner*) (1941–43, fig. 2), although she was now dissatisfied with the medium that had once been at the core of her work. She yearned to draw with her earlier passion:

> Some of the things I wrote about art made me feel that I wanted badly to draw fiercely again, smashingly; in big, rich, frill-less powerful rhythms. I feel definitely that my work of recent years has not had sufficient power, and sometimes I am overcome with a certain fury because of it. I don't know how to describe it. I want to weep tears of fury and

2. WANDA GÁG, *BARNS* (*BARNS AT GLEN GARDNER*), 1941–43, LITHOGRAPH ON ZINC PLATE,
10 1/8 x 15 3/16 IN. MINNEAPOLIS INSTITUTE OF ARTS.

defiance as I say, "I can do it. I still have
something to say. I will do it."[13]

During World War II Wanda and Flavia spent
winters in the small New York apartment at
250 West 22nd Street that Wanda had taken
in 1940 and summers at All Creation. Howard
served as caretaker at All Creation and also
worked elsewhere as a carpenter. Earle Hum-
phreys took various jobs in New York. Family
letters of these years concern ration stamps,
shortages, and the discomforts of wartime life.
"We slipped up on one thing in re your ration
card," Wanda wrote Flavia from New Jersey in
May 1943, instructing her to look for the ration
stamp for coffee or go to the apartment and
fill a box with coffee from the pantry. "Send it
to us *immediately*. Sorry to trouble about this
but you know how much I depend on my mod-
erate but indispensable quota of coffee espe-
cially when I'm making a deadline." Nothing
ran smoothly. "My train was an hour late at
Milford," Wanda wrote Flavia later that year.

"The Trenton station was full of service men,
most of them wearing helmets." Once in New
York, Wanda found the apartment icy and
Howard sitting there, "hunched up, looking
miserable."[14]

For the first time, Wanda was led to question
the value of her work. As she wrote Johan
Egilsrud in March 1942:

I, like so many others, find it difficult to
organize myself into a creative human
being since Pearl Harbor and all that has
come after it. I have not been able to
draw at all—it seemed so futile and self-
ish when I knew that so many human
beings were being starved, imprisoned,
tortured, mutilated, blown to bits. I've
tried to do all I could in past years for the
causes I believe in, Spanish & Chinese
relief, refugees (we artists & writers have
been contributing prints, drawings, man-
uscripts, even money when we could to

such causes long before the mass of people were shaken out of their complacency) but it is still so little.[15]

Now believing writing to be her most fruitful creative outlet, she produced *Three Gay Tales* (1943) after being told that children in London bomb shelters had been cheered by her earlier editions of fairy tales. Although some artists could protest war and oppression, she did not feel she had that power.[16]

The war touched the Gágs most directly when in 1942 Howard, then almost forty, was threatened with the draft. Although it is unclear what their taciturn brother's position was, Wanda and Flavia were committed pacifists. Their feelings about this war (as with World War I) were complicated by the fact that the enemy was Germany. "When I think of the Germans in New Ulm, I sometimes wonder how those in Europe could have let themselves get into such a mess," Wanda wrote to a friend.

"[T]he only sign of anything military that I ever noticed was their childlike interest in having an old cannon in their parades. But perhaps it was this naive trait which made it possible for the Germans in Europe to allow themselves to be so misled."[17] Wanda opposed Howard's induction for other reasons as well. For one thing, she had long considered him to be physically vulnerable. (In 1931, for example, she had argued against his taking a job in Central America: "You know our family is not of the ox variety, and we can't stand some things that others can.") She also needed him to maintain All Creation. If he went into the service, she would have to give up her New York apartment and assume management of the farm herself.[18]

Asta's husband, Herbert Treat, offered to secure Howard a job as a draftsman at the Sinclair Oil Company that might be deemed valuable to the war effort. Wanda waged a campaign to get her brother to pursue this offer in a series of long letters to him. Like her correspondence with

3. LEFT TO RIGHT: WANDA, FLAVIA, STELLA, AND DEHLI, C. 1940.

Flavia in 1929 and 1930, these letters show her relentless efforts to protect and direct her siblings. She details the job, which involved lettering and copying diagrams, and also explores the possibility that Howard might not pass the draft board physical. The letters make clear that Wanda believed Howard could not speak for himself, as they attempt to script for him conversations with Treat and meetings with the draft board.[19] Howard consulted a physician, who indicated that he thought him unfit for active service. Noting that the five-foot eight-inch Howard weighed only 120 pounds, the doctor related his physical problems, which included curvature of the spine, to poor nutrition as a child.[20] In the end, Howard took the job with Sinclair Oil and was granted a Class B deferment.

Although both Howard and Earle worked some weekends at All Creation during the early 1940s, Earle seems to have been away from the farm more than he was there. Nonetheless, two factors helped bring him and Wanda closer together. The first was a medical crisis relating to a tumor in his throat (which proved to be benign), and the second was a tense situation at his workplace. In the summer of 1942 he took a job making parts at Worthington's, a machine shop in Newark. Wanda described the job to Howard as "a tough one . . . night shift, 10 hours a night and I guess six nights a week and in the maintenance dept. . . . It's $160 a week tho. Earle wrote that he was 'rather scared' as he started the new job." Problems arose not from any inability on Earle's part, however, but from the fact that he became involved in organizing his fellow workers to obtain better working conditions. His employers, unable to find fault with Earle's work, attempted to fire him because he and Wanda were not man and wife.[21]

After two trips to Poughkeepsie for blood tests and other requirements, the couple was married

August 27, 1943, at Central Baptist Church at 92nd Street and Amsterdam Avenue in New York City. Wanda described the event at some length in a diary entry the following November.[22] It is a bittersweet account of a simple ceremony, conducted by a minister of whose name she could not be sure, followed by a cocktail at a nearby restaurant. Although she had approached getting married as a formality, it created a bigger difference in their relationship than Wanda had foreseen. Paradoxically, marriage made them feel freer, she said. Earle was no longer vulnerable to charges of moral turpitude at work. He could also be more open with his family, who would have disapproved of his irregular union with Wanda. She also admitted that "it made us feel more at ease with this world of law and 'morality' in which we were obliged to move." Wanda had become deeply committed to Earle, the chief reason being her respect for his political convictions. Two years earlier, she had written in her diary about his Socialist ideals and his enduring belief in the integrity of the Soviet Union:

> *It is this . . . which has been the reason why I have been able to overlook, in the last analysis if not always at the time, various upsetting characteristics in his make-up. Many others would have been less disturbing companions to have about, many would be considered more stable islands, many would have been able to share financial burdens more equally with me, and so on—but for me, it is necessary to have a companion whose judgment on the really big matters I can respect.*[23]

At bottom, also, was the realization that "when you are as old as we are, although we do not feel at all 'settled' in the ordinary middle-age sense, you welcome rather than shy away from a moderate amount of stability in such a relationship."

4. WANDA AND EARLE HUMPHREYS, C. 1945.

The war continued to claim the Gágs' attention. "I daresay you've been more or less glued to the radio since D-Day," Flavia wrote Wanda on June 9, 1944:

> Dehl's little radio has been a boon to me, of course, because I'm not able to use my eyes for reading. There's nothing like radio news at a time like this because of all sorts of special features—actual recordings of the first planes to take off for the French coast, broadcasts from warships under German air attack, etc., all of which give one a very real feeling about the whole thing.[25]

They also continued to root for Franklin D. Roosevelt. Wanda stayed up until 3 a.m. on

November 8, 1944, to have the satisfaction of hearing Republican presidential candidate Thomas E. Dewey concede defeat in the election that gave FDR a fourth term.[26] She now did little traveling, spending as much time as possible at All Creation. In the fall of 1944 she turned down an invitation to an exhibition of her work, *Wanda Gág: Prints and Books*, sponsored by the American Association of University Women, explaining that she and Flavia were "farm-bound" while her husband and brother were away doing war work and that she was swamped by deadlines.[27] Her few visitors were family members or old friends. In December, Alma Scott and her two children, Pat and Janey, visited All Creation. Wanda enjoyed the children but, typically, structured the visit carefully with "siesta or hush hour,"

the Clean Plate Club, and a postprandial "family hour" for reading stories and playing games.[28]

Characteristically, Flavia's letters and diaries during this period chronicle a series of health woes—sinus infections, tooth problems, and mysterious ailments such as months of pain endured after a friend picked her up and swung her around at a party. Wanda, on the other hand, typically made light of any ailment of her own. In early January 1945, however, she began to admit she was ill. According to Alma Scott, Wanda believed the problem to be a bronchial infection brought on by working in her unheated New York studio.[29] At the end of that month, Carl Zigrosser wrote, asking her to accompany him to a party in connection with the National Serigraph Society's annual exhibition. "I doubt very much whether I can," Wanda replied.

> I've been feeling positively fiendish since Christmas. . . . I'm so worn out all the time and the past two weeks or so I simply pant if I walk a block. I was afraid it might be anemia or high blood pressure & went to see Dr. Hamilton last week, but it was neither. Apparently it's just the result of a long drawn out cold, thyroid deficiency, low blood pressure and, of course, the transition business. She gave me thiamin, and thyroid extract (which I have foolishly neglected to take for some time) so I'm hoping I'll beat it before long.[30]

Wanda's relationship with Zigrosser, which had lapsed for a few years, resumed now with regular correspondence. She kept him posted on her medical tests. "It was marvelous down in the X-ray section," she reported after one session. "I wanted to draw all the stuff hanging around."[31] In March 1945 she had exploratory surgery, which revealed lung cancer. In keeping with medical custom of the day, the truth was told to her husband—who in turn told Howard Gág and Robert Janssen—but not to Wanda herself.[32] "I hope you are not afflicted with some rare or unusual disease," Zigrosser wrote her on March 2. "Doctors are a bunch of guessers at best." He sent frequent letters of encouragement and entertaining books for her to read. Among these she especially enjoyed *Storm*, a novel about the weather.[33] By July Wanda could write him that she felt somewhat better. She also described another visit by Alma Scott and her children to All Creation, the main purpose of which was to help Scott gather information for a biography. "We are determined to have it authentic in every detail," Wanda informed him, "and that takes a lot of time, checking things back & forth between us—even down to weighing almost every word for the correct shade of meaning or mood." She went on to tell of her state of mind regarding her work:

> I'm longing to draw or paint but I guess I'll have to wait a little longer before I can hope to feel equal to that. Every once in a while my patience wears pretty thin. I'm able to do a little writing but that's not what I want to do right now. I haven't been able to draw or paint for about half a year and that makes me feel restless.[34]

On December 1 Wanda wrote Zigrosser that she had gained eleven pounds since June and was doing well. But the autumn had been foggy and rainy, and she wanted more sun. "Do you know anybody who knows anything about Florida? I'm looking for as dry a climate as possible, of course. We've had circulars from Miami, Orlando and Tampa. . . . Miami, of course, is practically out—we'll have to find a more plebeian place."[35] "Unfortunately I know nothing about Florida," Carl replied.

It used to be a quiet inexpensive place but it may have changed. It strikes me that all of Florida is likely to be damp, being surrounded by ocean and gulf. Have you ever thought of the desert or Southern Arizona, Tucson, Phoenix, and the like or even Southern California. There is sunshine and dry climate. I am sure inexpensive unfashionable places could be found. And I believe that the landscape and fantastic cactus forms would interest you as an artist.[36]

Despite this sensible advice, Wanda and Earle set out for Florida on Christmas Eve, 1945, after several delays due to winter conditions. After a journey made difficult by the weather and poor roads, they reached Daytona Beach, then Miami Beach. "Everything is certainly very crowded and *dreadfully* expensive," she reported, "but the climate (so far at least) has been marvelous, and the landscape very exciting."[37] Wanda was fascinated by the flora and fauna in this new part of the country. The trees fascinated her, especially the palms. She watched a forty-foot-tall coconut palm being transplanted and marveled at the smallness of its roots. She did a few paintings of palms. Wanda was also entranced by flamingoes, which she saw in quantity at the Hialeah racetrack. As she wrote Carl: "I have been interested almost exclusively in color down here—one really can't escape it—and have made a good many notes which I hope to be able to work up later. Oh, how I wish I had my full strength so that I could plunge in and really get down all I see and feel down here!"[38] Yet she knew that she had felt better in Florida than in the damp and cold of home.

Humphreys was attentive and solicitous. In her letters Wanda mentioned no problems with the excessive drinking that had troubled their relationship in the 1930s. "Earle

has learned a good deal about cooking (or perhaps I should say 'a good deal *more*')," she wrote Zigrosser, "and has taken very good care of me all around."[39] Wanda painted as much as she could and also worked on drawings for a fourth volume of tales from Grimm. She and Humphreys traveled slowly, finally turning north in April. By May they were back at All Creation.

Despite the fact that her health continued to deteriorate, Wanda evidently never knew the exact nature of her illness. "My chest feels so congested," she wrote Zigrosser on June 17, "especially on damp, humid days—and I'm wondering whether it might not be some kind of respirational spring allergy."[40] Two days later she noted in her diary that her "asthma-like breathing and wheezing and coughing has not abated. If I were in New York, I'd go to an allergy specialist and see if I couldn't track it down to its source." On June 20 she added: "We've had the doctor here & he says my reactions sound like bronchitis or an allergy. He gave me some scratch tests for ragweed, June grasses & house dust, but I had not [*sic*] strong reactions to any of these. In the meantime I'm inhaling benzine & he told me if I get some more choking coughs to use adrenaline injections."[41]

A few days later, Wanda was taken to Doctors' Hospital in New York, where she died on June 27. The city was suffering through a severe heat wave that week, and Flavia wrote Alma Scott on July 1 that the weather had "made it much harder for us to bear up under our sorrow." She described the week of Wanda's death as "sort of a dream." The funeral was simple and private. The family, wrote Flavia, chose "one very beautiful spray of simple garden flowers, a solid oval-shaped cluster (about six feet long and three feet wide) of all the flowers she loved best."[42]

11 FLAVIA CARRIES ON

At her death, Wanda Gág left innumerable papers, prints, drawings, and paintings. Sorting and assigning ownership of her work as well as attending both to unfinished and new business kept the family very busy. Earle Humphreys and Carl Zigrosser were co-executors of the estate, but the rest of the Gágs remained closely involved. One immediate task was preparing a memorial exhibition at the Minneapolis Institute of Arts that opened in 1946. Robert and Dehli Janssen, Howard, Earle, and Flavia worked for almost a week deciding what to put in the show and what to save for later memorial exhibitions at the Philadelphia Museum of Art and the New York Public Library.

Robert and Howard did the matting; Flavia typed the labels.[1]

Flavia also completed work on Wanda's last volume of Grimm translations, published in 1947 as *More Tales from Grimm*. Although Wanda had planned all the illustrations and actually drawn eight of them in ink, none was in its final form.[2] Flavia finished the drawings, then painstakingly mounted them on tracing paper and made reductions for the engraver. Her care with materials and final checking equaled Wanda's own.[3] Flavia also helped see Alma Scott through the arduous process of creating a readable biography out of her "mountain of material." The projected audience was juveniles and young adults. Thus discretion as well as accuracy were required. Earle read the manuscript and suggested major changes. Flavia also made corrections. The book was published in 1949 by the University of Minnesota Press.[4]

1. FLAVIA AT ALL CREATION, AUGUST 1942. INSCRIBED ON REVERSE: "I'VE GONE INTO THE STUDY OF INSECTS VERY SERIOUSLY AND HAVE AT LAST GOT MYSELF A MICROSCOPE. WHAT WONDERS IT REVEALS."

Those who have studied Flavia perceive that her growth was hampered by lack of education and poor health, limitations that can be traced back to her difficult childhood in New Ulm. Unlike Wanda, she did not have the benefit of knowing Anton and absorbing his passionate love of art. Instead of growing up in the warm permissiveness of Anton and Lissi's household, Flavia knew only a widowed mother who was withdrawn and ailing. At age seven, she became an orphan. Her life was governed by emotional longings that prevented, or at least retarded, her ability to study and work with an unclouded mind. Later Wanda, with the energetic force of a lioness, directed Flavia's course not only so

that she could earn a living but also so that she (and Howard) would support her own uncompromising needs as an artist. Until Wanda's death, Flavia lived in her famous sister's shadow. Yet afterward her creative spirit prevailed, and she spent the final three decades of her life in the steady production of books and watercolor paintings.

But the first years of Flavia's independence were difficult. As she wrote Alma Scott two months after Wanda died:

> Yes, the adjustment has been very hard for me to make and the void left by our little Wanda's going can never, as far as I am concerned at least, be filled. . . . For Wanda, as you know, was mother, sister, friend, advisor and comrade to me, and we shared the mutual joys and problems of our work. Besides that, she was the focal point of all our family activities and without her, there now has settled over all of us, temporarily at least, a feeling of aimlessness of purpose.[5]

Flavia filed her first tax return in 1945, when Wanda was hospitalized. Aged thirty-eight, she had never had a home of her own. All Creation had been her principal residence, although she had no share in its ownership. In New York City Flavia had habitually "float[ed] around trying to find a place," as Wanda had put it in 1945.[6] After Wanda's death, Earle Humphreys made All Creation his headquarters. There he dealt with Wanda's estate. (He wanted to save every scrap of paper, according to Robert Janssen.) Both Flavia and Howard moved back to New York. Howard occupied Wanda's apartment on West 22nd Street and, in 1950, married Ida Rubin. For about a decade, however, Flavia continued to float, living in various apartments in Brooklyn and Manhattan and occasionally moving out to suburbs such as Forest Hills or, for a time, Teaneck, New Jersey, near Asta. Gertrude Gillespie,

who was Flavia's roommate from 1955 to 1957, recalled that she was engaged full time in "artistic endeavors," with no connections to commerce, and that she largely kept to herself. She still missed Wanda a great deal and continued to have health problems. But, Gillespie added, "Flavia was a dear person who had a charming sense of humor, a pixie quality, and lived in a world of her own."[7]

The family remained Flavia's primary social unit. When Howard and Ida gave up the New York apartment in 1953, for instance, she and the other Gágs converged on the couple's new place in Huntington, Long Island, to help them fix it up; it became a frequent meeting place.[8] But Flavia also made some enduring friendships outside the family, for example, with Camellia and Peter Dykes. "Cam" Dykes was her frequent companion on outings to museums and took evening classes in French and life drawing with her.[9]

As Wanda had hoped, Flavia was able to support herself by illustrating books.[10] She now evinced a new fortitude and tenacity. For Eva Knox Evans's *Emma Belle and Her Kinfolks* (1940), for instance, she pored over public library files to make accurate drawings of the nineteenth-century settings in the story. The *New York Times Book Review* commented on the "amusing vignettes which almost look as if they had been taken from McGuffey's Readers and which will tell children practically all they will want to know of the period."[11] Flavia also did careful research for *The Christmas House*, a biography of Clement Moore, author of the poem "The Night before Christmas." She made the happy discovery that the West 22nd Street building in which she lived stood on land that had been part of Moore's Chelsea estate. In later talks to students about the field of illustration Flavia always stressed the importance of observation and research. She took special delight in studying and drawing insects (fig. 1):

2. FLAVIA GÁG, ILLUSTRATION FOR *THE WILY WOODCHUCKS*, BY GEORGIA TRAVERS
(ALMA SCHMIDT SCOTT), COWARD-MCCANN, 1946

*All the little scurrying six-legged crea-
tures underfoot are my friends, even the
naughty ones that chew up our vegeta-
bles! My room is generally cluttered
with jars and boxes containing all kinds
of insects, such as pet crickets, beetles,
and caterpillars that have gone to sleep
for the season in their cozy cocoons and
chrysalides [sic].*[12]

Flavia's illustrations emphasized individual
character. Having noticed as a child that most
children's book illustrators make all their char-
acters look similar, she took care to differenti-
ate hers. Given her own background, it is not
surprising that she had a penchant for stories
about large families, as demonstrated in *The
Davenports Are at Dinner* (1948) by Alice
Dalgliesh and Robin Palmer's *The Barkingtons*
(1948). Flavia used her own family as the basis
for the illustrations in *The Wily Woodchucks*
(1946), which Alma Scott wrote under the
pseudonym Georgia Travers. The story, about
some bothersome predators at All Creation,
features Wanda, Earle, Howard, Flavia, and

Alma herself, along with Alma's daughters,
Janey and Pat, and uses their real names and
likenesses (fig. 2). The cover image gave Flavia
particular difficulty: the colors turned out poor-
ly, even after the drawings were redone.[13] Like
Wanda, Flavia fretted endlessly over the details
of production. In later talks to aspiring authors
and illustrators, she stressed the exacting char-
acter of the work in transferring reworked sketch-
es, then the pressure of the deadline and the
ten- to twelve-hour days of continuous draw-
ing. But she pushed to the finish, attributing
her determination and drive at least in part to
lessons learned from early hardships.[14]

As Wanda had done, Flavia liked to retreat
to the countryside, where she did watercolor
landscapes. In the early 1950s she got into
the habit of leaving the city each weekend to
escape the "revolting" city air and found
herself impelled to paint, even when her
eyes needed rest. "Just expose me to a box of
paints and the great outdoors," she wrote to
Alma Scott, "and I have no choice, for paint
I must!"[15]

Flavia began to write as well as illustrate children's books. The first was *Four Legs and a Tail* (1952), which was inspired by drawings of broad-tailed sheep she had seen in an old Frank Leslie magazine. She became intrigued by the tremendous tail of this species, which requires the support of a special tail-rest, and went about her usual thorough research. The result was the story of Sing Wing, a Chinese sheep that does tricks (fig. 5). *Four Legs and a Tail* was a selection of the Junior Book Club.

Other books by Flavia grew out of her love of animals and insects. *Fourth Floor Menagerie* (1954) concerns a little girl—named, like Asta's daughter, Barbara Jean—who lives in a small New York apartment with seventeen pets. The writer for the *Saturday Review* remarked that Flavia's story reflected "amazing insight into nature, human and otherwise" and recommended

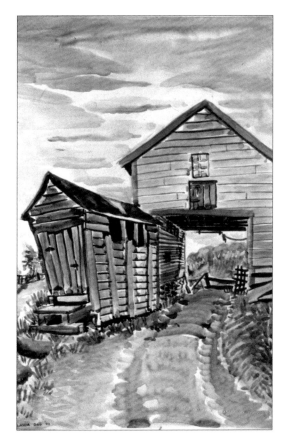

3. FLAVIA GÁG, *BARN AND CORN CRIB*. N.D., PASTEL, 14 x 11 1/2 IN. PRIVATE COLLECTION.

Earle Humphreys died unexpectedly in mid-April 1950, after a game of Ping-Pong, according to Flavia. "In spite of the fact that he wasn't in too good shape the last few years," she wrote Alma soon afterward, "he did every so often indulge himself in some tennis and ping pong, as he was so wild about the games that he just couldn't keep away from them."[16] Flavia's earlier vexation with Humphreys because of his drinking and obstreperous behavior disappeared in later years, and now she praised him warmly: "He said to me once that all he asked was to be allowed to live long enough to do a good job for Wanda, which he certainly did. He had a tremendous task on his hands, and with his characteristic thoroughness he kept everything well coordinated."[17] After his death All Creation was sold to the artist Clarence Carter.

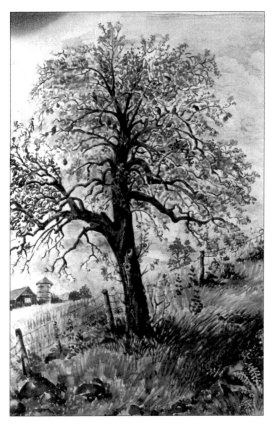

4. FLAVIA GÁG, *TREE IN SPRING*, N.D., PASTEL, 16 1/2 x 12 1/2 IN. PRIVATE COLLECTION.

5. FLAVIA GÁG, DRAWINGS FOR *FOUR LEGS AND A TAIL*, 1952, INK, 14 × 2 1/4 IN. CHILDREN'S LITERATURE RESEARCH COLLECTIONS, UNIVERSITY OF MINNESOTA, MINNEAPOLIS.

that it be read aloud.[18] Flavia also did extensive research—including a trip to Philadelphia to get sketches of gophers—for her book *Tweeter of Prairie Dog Town* (1957).[19]

Her most autobiographical story, *A Wish for Mimi* (1958), is about a young girl who is part of a large fatherless brood living in a small Minnesota town. Although their background is French-American rather than German-Bohemian, the lively, creative—and very poor—family is clearly her own.[20] As R. E. Livsey wrote in the *Saturday Review*, "Each member of the family adds to the feeling of its integrity, from the older girls, who carry the responsibility of earning

money, to Mimi, who looks forward longingly to a time when she, as the youngest, has both the luxury of enough hot water for her bath and a real tub in which to take it."[21] *A Wish for Mimi* is warm and humorous, like all of Flavia's books, yet it has a subtext of deprivation and the determination to succeed that is her constant theme.

One theme that Flavia did not deal with in her fiction was a girl's yearning for romantic love—something that continued to haunt her into later life. Her search for a "cavalier" went on through the late 1940s and 1950s. A chemist, Irving Markman, won her affection, then abruptly withdrew. Flavia herself rejected a number of other men.[22] In 1957, when she was fifty, Flavia finally found a man who seemed just right—a forty-three-year-old Austrian refugee from the Nazis who was a social worker and musician. They met at a dance in Greenwich Village, and the attraction was mutual. This relationship deepened rapidly, and they were planning to marry when he was diagnosed with leukemia. He died within the year.[23]

Following this misfortune, Flavia decided to make a move she had considered for some time. In 1954 Stella and William Harm had moved from Minnesota to Lake Como, Florida. They were attracted to the warm climate, as Wanda had been. Flavia also yearned for warmth after a lifetime of northern winters. "Daytona must be a stimulating place to live in," she had written Wanda regarding her Florida journey in 1946, "especially since it isn't so hot as to knock the ambition out of one."[24] Several visits to the Harms made up Flavia's mind: she moved to Lake Como in January 1958 and soon built a little house on their land (fig. 6). She described it in a letter to Alma Scott that June as "peachy pink" in color, with four small but convenient rooms, located in a sandy field amid rows of orange trees a short distance behind the Harms's house.

This cottage was Flavia's first home of her own, and it had a salutary effect on her. She continued to produce books and illustrations, eventually creating images for sixteen books by other authors and writing and illustrating nine more of her own. For example, she illustrated a book of folktales edited and, in some cases, retold by Rose Dobbs, *Once upon a Time Stories* (1950, fig. 7). A second such volume, *More Once upon a Time Stories* (1960), included Wanda's translation of the Grimm tale "Clever Elsie." Like Wanda, Flavia used line drawings that evoked old German woodcuts, although she did not attempt to emulate her sister's dense and complex style. Flavia's light, more conventional approach is seen to better advantage in books completely different from Wanda's, such as Walter C. Fabell's *Nature Was First!* (1952), which shows models in the natural world for

modern inventions. The illustrations are paired: on the left is a natural phenomenon, such as the sawfly preparing to deposit its eggs; on the right is a corresponding human invention, the saw (fig. 8). Flavia's clear, lively images drew on her love of the natural world and deserve a good deal of the credit for the book's success.[25]

Some of Flavia's own books have little artistic merit. In 1960, for instance, she published *Chubby's First Year*, a very slight collection of twelve poems and drawings about a kitten. Books for older children, such as *The Melon Patch Mystery* (1964) and *The Florida Snow Party* (1969), which grew out of her new life in Florida, fail to present compelling or memorable stories. Nevertheless, Flavia continued to publish in a market receptive to light,

6. FLAVIA AT HER LAKE COMO, FLORIDA, HOUSE, 1958.

7. FLAVIA GÁG, ILLUSTRATION FOR *ONCE UPON A TIME STORIES*,
BY ROSE DOBBS, RANDOM HOUSE, 1950.

entertaining stories for children ages eight to eleven. She also continued writing songs. A 1967 article in a Palatka, Florida, newspaper described her interests as writing, drawing, and composing songs for banjo and piano accompaniment. It also revealed that she was now composing rock-and-roll and "country-style" songs as well as humorous tunes for children. Some, including "Solid Gold Dream" and "Missing Person No. 599," were recorded.

8. FLAVIA GÁG, ILLUSTRATION FOR *NATURE WAS FIRST!*, BY WALTER C. FABELL,
DAVID MCKAY CO., INC., 1952.

9. FLAVIA GÁG, *LANDSCAPE*, N.D., WATERCOLOR, 15 X 22 IN. PRIVATE COLLECTION.

She sometimes also designed record covers for her songs.[26]

In her leisure hours Flavia continued painting watercolors, the sun, the vegetation, and the Spanish Revival architecture of Florida that stimulated her eye. She completed many landscapes of great delicacy and charm (fig. 9). A trip to St. Augustine in 1960 yielded watercolors of the Prince Murat House and other picturesque scenes.[27] Like her father before her, Flavia did a number of flower paintings. Stella's Hibiscus Club provided the subject for one notable watercolor depicting "Bobby," a newly bred variety of the flower that was dedicated to Stella and given her nickname (fig. 10).[28]

The Gágs remained close. At gatherings music still played a central role: the Gág brothers-in-law Herbert Treat and Richard Stewart were,

10. FLAVIA GÁG, "BOBBY" HIBISCUS, 1970, WATER-COLOR, 15 1/2 X 11 1/2 IN. PRIVATE COLLECTION.

11. LEFT TO RIGHT: HERBERT TREAT, HOWARD GÁG, AND RICHARD STEWART, 1957.

like Howard, talented musicians (fig. 11). Time and age were beginning to have their inevitable effects, however. Dehli died in 1958. Flavia devoted two years to the care of Howard and Stella during their final illnesses; he passed away in November 1961, and she followed him four months later. "Nursing them both," Flavia wrote to a friend at Christmas 1963, left her with "no time or energy to do any books."[29] Nelda died in New Jersey in 1973 at age seventy-four.

Flavia stayed on in Lake Como, occasionally spending time in New York or New Jersey. She made a final visit to Minnesota in June 1977, appearing at the University of Minnesota to accept the Kerlan Award, given posthumously to Wanda for her achievements in children's literature and in appreciation of a donation of prints, drawings, and letters to the university's Children's Literature Research Collection.[30] By this time Flavia was ill with cancer, but she still retained the Gág will to create, mentioning on a visit to New Ulm during that same trip that she had several manuscripts in progress.[31]

But these projects would not be finished. She died on October 12, 1978, in Crescent City, Florida. Despite her chronic frailty, Flavia, at seventy-one, had lived much longer than had her father, her mother, or Wanda. The only sibling to outlive her was Asta, who died in 1987 at age eighty-eight.

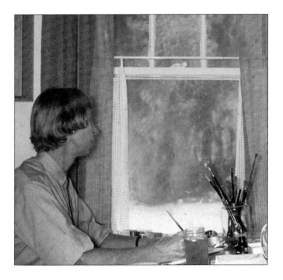

12. FLAVIA AT WORK, FLORIDA, C. 1965.

The Gágs may seem to have lost their connection to Minnesota and German Bohemia

13. FLAVIA SPEAKING TO SCHOOLCHILDREN IN FLORIDA, 1970.

in later years, but the tie was intact. A few years after Wanda's death in 1946, Stella and her husband, William, visited New Ulm. At the Biebl farm—Grandma's Place—where only Aunt Lena was still alive, they found a surprisingly large cache of paintings, about thirty-five in all, by Anton Gag. Stella was allowed to take these back to St. Paul for safekeeping. She offered to share them with her siblings, but perhaps because they had had little connection with their father as a painter, they expressed little interest. (Flavia took the 1903 self-portrait.) Stella displayed a few of the paintings in her home and put the rest away.

When the Harms moved to Florida, Anton's paintings went with them. Flavia, living nearby, experiencing excitement before a landscape or a single flower, painted it with a joy inherited from the painter-father she had scarcely known. Her art was by and large quite different from his. But, like him, she made a career as an artist by working for the markets available to her. Like him, too, she never lost what

Cézanne had called the frisson before nature, producing many landscapes for herself that captured this pleasure.

The lives and works of Anton Gag and his children, especially Wanda and Flavia, are all of a piece. Each had strong feelings before nature and always—even if diverted for a time by the cultural life of cities—returned to the beauty of the countryside. Each struggled with the distressing feeling of not being understood. Each was driven to create, even in the face of poverty and illness. Nature, for Anton, Wanda, and Flavia, was the lodestar. Each worked hard but also had a sense of play that manifested itself in words and music. The family was the center of social and emotional life for the three artists. All these themes can be traced back to the Gágs' German-Bohemian roots in the Old Country, where the romantic spirit flourished in art, song, and a festive sense of community. That spirit, transplanted to Minnesota, then to New York City and rural New Jersey, and, finally, to Florida, lives in their art.

Notes

The following abbreviations are used in these notes:

BCHS (Brown County Historical Society, New Ulm, Minnesota)

CLRC (Children's Literature Research Collections, University of Minnesota, Minneapolis)

MHS (Minnesota Historical Society, St. Paul)

VPL (Department of Special Collections, Van Pelt-Dietrich Library Center, University of Pennsylvania)

FG (Flavia Gág)

WG (Wanda Gág)

NOTES TO INTRODUCTION

1. The term *Bohemian* was originally applied to the Gypsies, who were believed to have come from Bohemia.

2. Renoir (1841–1919) began his career painting porcelain and lampshades in Limoges. Later he painted decorative panels and did other work for friends and patrons in Paris and Normandy. See Barbara Ehrlich White, *Renoir: His Life, Art, and Letters* (New York: Harry N. Abrams, 1984), esp. 92–95.

3. Miroslav Cogan, "Das Isergebirge in den Zeichnungen von Jan Prousek," *Jahrbuch für Sudetendeutsche Museen und Archive*, (Munich, 1991) trans. Karen Hobbs. Prousek, who studied briefly in Vienna and Munich, shared Gag's dedication to his cultural heritage. He worked in solitude and was poorly rewarded until 1899, when he was commissioned to illustrate an encyclopedic work on North Bohemia. In Bavaria in March 1998, Robert Paulson spoke with Leopold Hafner, sculptor of the New Ulm German-Bohemian immigrant monument, about the German-Bohemian artistic tradition. Several generations of Hafner's German-Bohemian family have been artists.

4. WG diary, May 3, 1922 (VPL).

5. Griselda Pollock presents Barr's diagram of the development of modern art as a particularly tangible expression of this common idea. See Griselda Pollock, *Vision and Difference: Femininity, Feminism and Histories of Art* (London: Routledge, 1988), 50–51.

6. Selma Kraft, "Definition of Feminist Art or Feminist Definition of Art?" in Ronald Dotterer and Susan Bowers, ed., *Politics, Gender, and the Arts:* *Women, the Arts, and Society* (Selinsgrove, Penn.: Susquehanna University Press, 1992), 16.

7. Thalia Gouma-Peterson and Patricia Mathews, "The Feminist Critique of Art History," *Art Bulletin* 69 (Sept. 1987): 332–34.

8. See Linda Nochlin, "Why Have There Been No Great Women Artists?" *ArtNews* 69 (Jan. 1971): 23–39, 67–71. This is a seminal article in feminist art-historical scholarship.

NOTES TO CHAPTER 1

1. WG, "Childhood Reminiscences: Paper Dolls" (typescript, CLRC).

2. See Simon Schama, *Landscape and Memory* (New York: Alfred A. Knopf, 1995), esp. Chap. 2, "Der Holzweg: The Track through the Woods," for a thoughtful examination of the relation of the German forest to art, literature, and myth.

3. See Ken Meter and Robert Paulson, *Border People: The Bömisch (German-Bohemians in America)* (Minneapolis: Crossroads Resource Center, 1991). The authors, both descended from German-Bohemian families, were the first to identify this national group. On the political history of Bohemia, see La Vern J. Rippley and Robert J. Paulson, *German-Bohemians: The Quiet Immigrants* (Northfield, Minn.: St. Olaf College Press, 1995), Chap. 1, "German-Bohemians: Their Origins."

4. WG, "Paper Dolls."

5. WG, "Childhood Reminiscences: Wanda and God" (typescript, CLRC).

6. Rippley and Paulson, *German-Bohemians*, 182. For a thorough discussion of German-Bohemian folkways, see Chap. 6, "The Folklore of German-Bohemians."

7. Czech villages, in contrast, tended to be circular. German villages typically lined a *Stringstrasse* (long street). See Meter and Paulson, *Border People*, 21.

8. Rippley and Paulson, *German-Bohemians*, 210–11.

9. Ibid., 172, 165–67.

10. Unless otherwise indicated, the following information on the Gaag family and their circumstances in Bohemia comes from Ancestral Research Report No. 9909303/01, prepared for Robert J. Paulson by T and P Research, Czech Republic, Feb. 4, 2000.

11. In 1848 Heiligenkreutz had 88 houses and 659 inhabitants.

12. Rippley and Paulson, *German-Bohemians*, 16–19.

13. See Meter and Paulson, *Border People*, esp. 20, and Rippley and Paulson, *German-Bohemians*, 129–34.

14. Dehenten, which in 1848 had only 25 houses and 164 inhabitants, was in Hayd, a different demesne. Under the rule of the House of Lowenstein, it comprised 32 villages, most of whose inhabitants were German-speaking.

15. Georg senior and Maria did not accompany their son to Walk; apparently they stayed in Dehenten.

16. Wedding customs are described in Rippley and Paulson, *German-Bohemians*, 177–78.

17. Records recovered by T and P Research show that in 1863 the Gaags were unable to pay their taxes. Records for the nineteenth century are not complete, however. According to T and P, many old records, particularly those in German, were destroyed by the Czech Communist government after World War II. For the economic crisis of serfs in Bohemia, see Rippley and Paulson, *German-Bohemians*, esp. 16–26.

18. Karen Hobbs, foreword to *One Hundred Tales from Sudetenland*, trans. and ed. Karen Hobbs (New Ulm, Minn.: German-Bohemian Heritage Society, 1999). This invaluable volume is a translation of tales collected by Josef Rotter in 1892.

19. The Seiferts, who originated in the village of Gibian (now Jivjany) in Mies, the county north of Bischofteinitz, had come to Cottonwood Township in 1856. See Rippley and Paulson, *German-Bohemians*, 59–60. On Peter Gag and Georg Gag, see Robert J. Paulson, "Yes, They Are Related: The Families of Anton and Peter Gag," *News Notes* (BCHS) (spring–summer 2001), n.p.

20. See Rippley and Paulson, *German-Bohemians*, 1–7. Chain migrants, usually motivated by economics rather than political or religious persecution, tended to come in family groups and live in enclaves. Characteristics—well illustrated by the Gaag family—included "language retention, religious homogeneity, endogamy, family transplants, retention of Old World lifestyles, and a somewhat slower than normal rate of assimilation with American society" (5).

21. FG, family memoir, 2 (typescript, Harm Collection).

22. The Settlement Society in New Ulm had links to a German bank in St. Paul, through which members paid their dues. The bank supplied prepaid tickets that were sent to Germany through a Bremen firm, Luddering and Company. Rippley and Paulson, *German-Bohemians*, 91–92. On more general efforts

by the state of Minnesota to recruit German-speaking immigrants, see William E. Lass, *Minnesota: A History*, 2nd ed. (New York: W. W. Norton, 1998), 140–42.

NOTES TO CHAPTER 2

1. Curiously, Anton Gag's children did not seem to know of this sojourn in St. Paul. Reminiscences by Wanda and Flavia do not mention it; they suggest he arrived in New Ulm about 1873. See Alma Scott, *Wanda Gág: The Story of an Artist* (Minneapolis: University of Minnesota Press, 1949), 5–6. See St. Paul city directories, 1874–75, and U.S. Census, 1875, Albin Township, Brown County.

2. See Virginia Brainard Kunz, *St. Paul: The First 150 Years* (St. Paul: Minnesota Historical Society Press, 1991). On the treaties of 1837 and 1851 that led to the Dakota Conflict of 1862, see William E. Lass, *Minnesota: A History*, 2nd ed. (New York: W. W. Norton, 1998), esp. Chap. 4, "Minnesota's Quest for Empire."

3. Virginia Brainard Kunz, *The Mississippi and St. Paul* (St. Paul: Ramsey County Historical Society, 1987), 17–26.

4. Ken Meter and Robert Paulson, *Border People: The Bömisch (German-Bohemians in America)* (Minneapolis: Crossroads Resource Center, 1991), esp. 3–6.

5. Gary J. Brueggmann, "Beer Capital of the State: St. Paul's Historic Family Breweries," *Ramsey County History* 16, no. 2 (1981): 3–13.

6. U.S. Census, 1875, Ramsey County, St. Paul, 3rd Ward.

7. J. Fletcher Williams, *A History of the City of Saint Paul to 1875* (1876; reprint, St. Paul: Minnesota Historical Society Press, 1983), 420, 453–54.

8. *A History of the Assumption Parish, St. Paul, Minnesota* (St. Paul: Wanderer Printing Company, 1931). See also Larry Millett, *Lost Twin Cities* (St. Paul: Minnesota Historical Society Press, 1992), 61.

9. Prostitution was illegal in St. Paul but, as in many cities of the Victorian era, was socially condoned as a necessary outlet for vigorous manhood. Information on the city's houses of prostitution is found in H. A. Guilford, *Holies of Holies* [sic] *of the White Slave Worshiper* (St. Paul: privately printed, c. 1900). This rather scurrilous booklet contains photographs and firsthand descriptions of the houses and their employees (MHS).

10. Joel E. Best, "Long Kate, Dutch Henriette and Mother Robinson: Three Madams in Post–Civil War St. Paul," *Ramsey County History* 15, no. 1 (1980): 3–10. See also SPF Consulting Group, "The Archaeology of the Washington Street Residential District: The Excavation of a Saint Paul Legend," pamphlet (Nov. 1998), n.p. (Ramsey County Historical Society).

11. "Neighborhood Nuisances," *St. Paul and Minneapolis Pioneer Press*, July 23, 1881.

12. The hotel blaze was one of several major fires that night. It drew thousands of spectators, according to the *St. Paul Pioneer Press*, May 20, 1878. Anton also sketched a fire at the Butter Factory on Eagle Street on May 19.

13. *Minnesota Pioneer*, Mar. 13, 1850. Quoted in Isaac Oliver Peterson, "Art in St. Paul as Recorded in the Contemporary Newspapers" (master's thesis, University of Minnesota, 1942). I am deeply indebted to this thesis for its collation of citations to St. Paul newspapers between 1850 and 1909.

14. For panoramas (also called cycloramas) in St. Paul, see Millet, *Lost Twin Cities*, 182–83.

15. On Munger, see *Gilbert Munger: Landscape Artist, a memoir by friends* (privately printed, 1904) (MHS). See also Rena Neumann Coen, *Painting and Sculpture in Minnesota, 1820–1914* (Minneapolis: University of Minnesota Press, 1976), 67, and William H. Gerdts, *Art across America: Two Centuries of Regional Painting, 1710–1920*, 3 vols. (New York: Abbeville, 1990), 3: 11. Peterson, "Art in St. Paul," cites numerous articles on Munger, esp. 49–50.

16. Munger left St. Paul by 1878, when he established a studio in London. He also lived in New York and Washington, D.C., before his death in 1903. *St. Paul Pioneer Press*, July 22, 1878. Quoted in Peterson, "Art in St. Paul," 98.

17. Coen, *Painting and Sculpture in Minnesota*, 42–43, 135; Gerdts, *Art across America*, 3: 45–46.

18. Born in Sherburne, New York, Bradish was associated for many years with Fredonia, New York. From 1852 he taught at the University of Michigan and was an important early lecturer on art in America. Gerdts, *Art across America*, 1: 205. The review appeared in the *St. Paul Daily Pioneer*, Oct. 20, 1874. Quoted in Peterson, "Art in St. Paul," 76.

19. See Marilyn Masler, "Carl Gutherz and the Northwest Landscape," *Minnesota History* 53, no. 8 (winter 1993): 313–22. See also Peterson, "Art in St. Paul," esp. 64–65; Coen, *Painting and Sculpture in Minnesota*, 66; and Gerdts, *Art across America*, 2: 147–49. Gutherz came to America with his family in 1851. After a brief period in Cincinnati, they moved to Memphis. Gerdts characterizes him as "the most distinguished Memphis artist of the period" (148).

20. Peterson, "Art in St. Paul," 133.

21. Ibid., 55; Coen, *Painting and Sculpture in Minnesota*, 67; Gerdts, *Art across America*, 3: 11.

22. "Mr. Peter Clausen, a most skillful painter, is in the city, and offers his services as a fresco and sign painter, and as a painter of scenery, flags and banners, landscapes and ornamental work of every description." *St. Paul Daily Pioneer*, Aug. 12, 1870.

23. St. Paul city directories from 1874 to 1879, Anton's years in St. Paul, place Koempel's studios at 220, 12, and 21 West Third Street addresses. He resided at 20 Marshall Street; Brewer is listed as a porter at this boardinghouse in 1876. See also Coen, *Painting and Sculpture in Minnesota*, 78–79, and idem, *Minnesota Impressionists* (Afton, Minn.: Afton Historical Society Press, 1996), 24–26.

24. Nicholas R. Brewer, *Trails of a Paintbrush* (Boston: Christopher Publishing House, 1936), 55–60.

25. For the art society proposal, see *St. Paul Daily Pioneer Press*, Mar. 26, 1876. Quoted in Peterson, "Art in St. Paul," 89–90. For the art academy and loan exhibition proposals, see idem, 91–98.

26. *St. Paul Pioneer Press*, Aug. 7, 1887. Quoted in Peterson, "Art in St. Paul," 187; *St. Paul Pioneer Press*, May 1, 1887.

27. Cigars were manufactured in St. Paul by the Fitch and O'Gorman Company, which often employed young men and women for piecework.

28. WG, "Childhood Reminiscences: At Grandma's" (VPL).

29. In *Trails of a Paintbrush*, Brewer entertainingly describes how he learned the technique, and discovered the market for such portraits, from a "faker" who charged him eight dollars to learn how to do portraits in one day but whose secret was actually a "pantograph," a mechanical tracing device (65–66). The St. Paul city directory for 1878–79 lists Brewer as a "crayon artist" with a studio at 21 West Third Street.

30. This portrait is in the BCHS collection. According to Rose Klaus Deml, daughter of Vincenz and Margaretha Klaus, the portrait had always hung in the Gag-Klaus home on the Immelberg in New Ulm.

31. Georg Gag's purchase of Outlot 395, abstract, refers to "Georg Gag, of Cottonwood Township." See also his death record, Nov. 24, 1877, Brown County Court House, New Ulm, and obituary, *New Ulm Post*, Nov. 30, 1877.

32. Only Joseph Gag remained in St. Paul, where in 1881 he married Mary Buzek. A son, Joseph, was born February 26, 1882. The senior Joseph Gag was dead by 1885, according to a probate of Georg Gag's will, November 12, 1885 (Brown County Court House). No death record has been found in Ramsey or Brown counties. The son died of typhoid in 1893.

NOTES TO CHAPTER 3

1. For the founding of New Ulm and the role of the

Turners, see L. A. Fritsche, M.D., *History of Brown County, Minnesota*, 2 vols. (Indianapolis, Ind.: B. F. Bowen, 1916), 1: 123–40, and La Vern J. Rippley and Robert J. Paulson, *German-Bohemians: The Quiet Immigrants* (Northfield, Minn.: St. Olaf College Press, 1995), Chap. 5, "The Forty-eighter Turners vs. the German-Speaking Bohemians." Eduard Petry, *The First Fifty Years: A Memorial of the Golden Jubilee, New Ulm, Minnesota, Turnverein, 1856–1906,* trans. August G. Kent (1906; reprint, Minneapolis: University of Minnesota General College, 1979), provides a history of the town's *Turnverein.*

2. See Alma Scott, *Wanda Gág: The Story of an Artist* (Minneapolis: University of Minnesota Press, 1949), 5–6, and FG, family memoir, 3 (typescript, Harm Collection). These versions of Anton's life recall what Linda Nochlin has called the "Myth of the Great Artist," in which a mentor recognizes the natural genius of an untutored boy. The life of Giotto is the prototype. See Linda Nochlin, "Why Have There Been No Great Women Artists?" *ArtNews* 69 (Jan. 1971): 23–39, 67–71.

3. For a memoir of the Schell family, see Trudy Beranek, *The Descendants of August and Theresia Schell* (privately printed, 1995) (BCHS).

4. Wanda gave the latter version in "Childhood Reminiscences: How Many in the Family?" (VPL).

5. Rippley and Paulson, *German-Bohemians*, Chap. 2, "German-Bohemians Settle in Brown County." See also William E. Lass, *Minnesota: A History*, 2nd ed. (New York: W. W. Norton, 1998), Chap. 6, "Peopling the Land."

6. Rippley and Paulson, *German-Bohemians*, 126–40.

7. Ibid., Chap. 8, "The Music of the German-Bohemians."

8. George Gag, born in 1875 in Cottonwood Township, was the grandson of Peter Gag. George Gag obituary, *New Ulm Daily Journal*, Nov. 29, 1965.

9. *New Ulm Review*, Aug. 11 and 18, 1880. The details of Schell's patronage are not known. He seems to have arranged Anton's schooling and provided financial support. All *New Ulm Review* citations in this study are the products of Allan R. Gebhard's fine research.

10. Christine Stansell makes the point that Chicago was a Mecca in *American Moderns: Bohemian New York and the Creation of a New Century* (New York: Henry Holt, 2000), 50–55.

11. See William H. Gerdts, *Art across America: Two Centuries of Regional Painting*, 1710–1920, 3 vols. (New York: Abbeville, 1990), 2: 290–300.

12. See Donald J. Irving, "History of the School," in *100 Artists, 100 Years: Alumni of the School of the Art Institute of Chicago*, exh. cat. (Chicago: Art Institute of Chicago, 1979), 5–7. See also Gerdts, *Art across America*, 2: 291–92.

13. See Wayne Craven, *American Art: History and Culture* (Madison, Wis.: Brown and Benchmark, 1994), esp. Chap. 7, "Painting after 1750." See also Chap. 23, "Painting: The Naturalistic Tradition and Cosmopolitanism, 1870–1900," and Chap. 24, "Painting: American Impressionism, American Renaissance, and Trompe l'Oeil Realism."

14. Herbjørn Gausta (1854–1924), another immigrant artist contemporary with Gag who would become prominent in Minnesota, also studied for several years in Munich. See Rena Neumann Coen, *Painting and Sculpture in Minnesota, 1820–1914* (Minneapolis: University of Minnesota Press, 1976), 71–74, and Gerdts, *Art across America*, 3: 12.

15. *St. Paul Pioneer Press*, Apr. 3, 1881. The art student is not identified.

16. Robert Koehler, *Minneapolis Journal*, Apr. 29, 1917. Quoted in Peter C. Merrill, "Robert Koehler: German-American Artist in Minneapolis," *Hennepin County History* 47 (summer 1988): 20.

17. Gerdts, *Art across America*, 2: 335–36. See also Frederick I. Olson, "Community and Culture in Frederick Layton's Milwaukee," in *1888: Frederick Layton and His World*, exh. cat. (Milwaukee, Wis.: Milwaukee Art Museum, 1988), 11–29.

18. See Naomi Rosenblum, *A World History of Photography*, 3rd ed. (New York: Abbeville, 1997), Chap. 2, "A Plenitude of Portraits." Anton's first photography studio ad asserts, "We will, on demand, finish the pictures in oil or water colors, also frame them neatly." *New Ulm Post*, May 18, 1883.

19. James Boeck, Curator, Wanda Gág House, New Ulm, conversation with author, Sept. 18, 1995; remarks by Thomas O'Sullivan on the probable nature of the Hill portrait, conversation with author, Nov. 23, 1998. For the portrait of Daniel Webster, see *New Ulm Review*, Nov. 27, 1901.

20. Such works were done by Robert Koehler, who was trained in Munich. See Thomas O'Sullivan, "Robert Koehler and Painting in Minnesota, 1890–1915," in *Art and Life on the Upper Mississippi, 1890–1915*, ed. Michael Conforti (Newark, Del.: University of Delaware Press, 1994), 94.

21. Scott, *Wanda Gág*, 29.

22. O'Sullivan, "Robert Koehler," includes a reproduction of Anton Gag's *Raspberries* (1904), with a catalogue note: "This rustic still life attests to Gág's keen interest in straightforward renderings of his world, a feature that marks his best easel paintings" (117–18).

23. Gerdts, *Art across America*, 2: 294–95.

24. The three main social groups in New Ulm—the German Turners, the German-Bohemians, and the German Lutherans—were distinct enough that intermarriage was frowned upon. See Beranek, *Descendants of August and Theresia Schell*, 9.

25. Julius Berndt obituary, *New Ulm Review*, July 19, 1916; Fritsche, *History of Brown County*, 2: 186–89.

26. Fritsche, *History of Brown County*, 2: 187. Both the Berndt obituary and Fritsche's history assert that the architect's dedication to public service was so great that he did not prosper financially.

27. Gag's Hermann painting was restored in 1997–98 and is now exhibited at the BCHS. Restoration of the Hermann monument is in progress. Information on Hermann the Cherusker is drawn from La Vern J. Rippley, presentation, Northern Great Plains History Conference, Mankato, Minn., Sept. 28, 2000.

28. Alma Scott, WG interview notes, stenographic notebook, Scott papers (MHS). This unpaginated notebook contains information not included in Scott's published biography.

29. *New Ulm Review*, Jan. 26, 1887.

30. For the Dakota Conflict, see Fritsche, *History of Brown County*, 1: Chap. 5, "The Indian Massacre of 1862," and Lass, *Minnesota: A History*, 127–35.

31. Scott, *Wanda Gág*, 22–23.

32. The journal of Carl Gutherz provides extensive details about similar painting trips to reservations in the Midwest. See Marilyn Masler, "Carl Gutherz and the Northwest Landscape," *Minnesota History* 53, no. 8 (winter 1993): 313–22.

33. Scott, *Wanda Gág*, 23. On typical attitudes about the Indians, see Lass, *Minnesota: A History*, Chap. 4, "Minnesota's Quest for Empire," esp. 127.

34. *New Ulm Review*, June 22 and July 27, 1887. For Anton's state after Ida's death, see Scott notebook, op. cit. note 28. The poetry does not seem to have survived. No doubt the Berndt home was more spacious that Theresia Gag's house on the Immelberg. Still, it is worth noting that Anton took refuge with the Berndts rather than with his own family at this time.

35. These nine small landscapes are in the Art and Print Collection, MHS (AV 1992.37.41–37.49).

36. For Gag and Impressionism, see Rena Neumann Coen, *Minnesota Impressionists* (Afton, Minn.: Afton Historical Society Press, 1996), 45–46. Also see William H. Gerdts, *American Impressionism* (New York: Abbeville, 1984). He dates the real influence of Impressionism in the Midwest to the 1893 World's Columbian Exposition in Chicago (243–52).

37. Leslie Parris and Ian Fleming-Williams, *Constable*, exh. cat. (London: Tate Gallery, 1991), 51–191.

38. D. Paul Mohn's *Ludwig Richter* (1896) was among Wanda Gág's books at All Creation; it is now at the Wanda Gág House, New Ulm. James Boeck, the curator, suggests that it was a book she knew during childhood. Conversation with author, Sept. 18, 1995.

39. See Gabriel P. Weisberg, *Beyond Impressionism: The Naturalist Impulse* (New York: Harry N. Abrams, 1992). There is no evidence that Gag projected his photographs on screens, as Weisberg documents the French naturalists had done. But the resemblance between painting and photograph in this instance certainly suggests that Gag used photographs as painting aids.

40. *Goose Girl* is in a private collection. Robert J. Paulson, who has photographed Walk, Pernartitz, and environs, attests to the resemblance between *Goose Girl* and the setting of Gag's boyhood.

41. BCHS. The fragment, which may be copied from another source, is entitled "Notes by Anton Gag: On the Observation of Nature for the Education of a Painter" and written in German. The BCHS file contains two translations into English, one by Herman N. Radloff (1989) and the other by Delmar Brick (1993). The quotations here are adapted from both.

42. Here the passage distinctly echoes the ideas of Johann Wolfgang von Goethe, as expressed, for example, in this conversation with Johann Peter Eckermann: "A landscape-painter should possess various sorts of knowledge. It is not enough for him to understand perspective, architecture, and the anatomy of men and animals; he must also have some insight into botany and mineralogy, that he may know how to express properly the characteristics of trees and plants, and the character of the different sorts of mountains." Johann Peter Eckermann, *Conversations with Goethe*, trans. John Oxenford (London: Dent, 1970), 418. Goethe's ideas about art were touchstones for nineteenth-century German artists writing about themselves and their art. See Catherine C. Fraser, *Problems in a New Medium: Autobiographies by Three Artists* (New York: Peter Lang, 1984), esp. 3. Anton Gag owned the illustrated works of Goethe, Heine, and Schiller as well as many German art magazines. Scott, *Wanda Gág*, 21.

43. Coen, *Painting and Sculpture in Minnesota*, dates the school to 1892: "The school lasted only a few months, but it is important as the first serious effort to make art a profession outside of Minnesota's metropolitan areas" (74–75).

44. "Christian Heller: Artist in New Ulm in Early Days," *Brown County Journal*, Schell advertisement,

Saturday Night Series, n.d. (c. 1930).

45. Ignatz Schwendinger obituary, *Brown County Journal*, Nov. 16. 1904; Alexander Schwendinger obituary, *Brown County Journal*, Jan. 12, 1934; Fritsche, *History of Brown County*, 2: 419–20.

46. *New Ulm Review*, Feb. 2, 1887, Apr. 1, 1891, and June 3, 1891. Completion of the panorama by Gag, Schwendinger, and Heller was announced in the *New Ulm Review* on February 1, 1893.

47. See John L. Marsh, "Drama and Spectacle by the Yard: The Panorama in America," *Journal of Popular Culture* 10 (winter 1976): 581–92, and Larry Millet, *Lost Twin Cities* (St. Paul: Minnesota Historical Society Press, 1992), 182–83. *The Battle of Atlanta* is on view at Grand Park in Atlanta.

48. See Coen, *Painting and Sculpture in Minnesota*, Chap. 3, "Painters of the Panorama," and Marsh, "Drama and Spectacle," 586–87. Stevens's 1878 panorama, which has thirty-six scenes, is in the MHS collection.

49. For Clausen, see Roy A. Boe, "The Development of Art Consciousness in Minneapolis and the Problems of the Indigenous Artist" (master's thesis, University of Minnesota, 1947), 107–26. See also Coen, *Painting and Sculpture*, 67–68, and Gerdts, *Art across America*, 3: 11. When the work was destroyed in a Brooklyn hotel fire, Clausen, who had no insurance, was devastated. Boe, 118–21.

50. "New Ulm's Defenders," *New Ulm Review*, Aug. 19, 1885. Julius Berndt was active in this group of defenders. In 1890 Gag was commissioned to design bas-reliefs for the New Ulm Defenders' Monument. See *New Ulm Review*, Jan. 25, 1890.

51. Marsh, "Drama and Spectacle," 588.

52. For the exhibition at the World's Columbian Exposition, see *New Ulm Review*, Apr. 5, 1893. For the panorama's tour, Don O'Grady, "Sioux Uprising Panorama Recalls Chautauqua, Simple Entertainment," *St. Paul Pioneer Press*, Oct. 23, 1955. According to this undocumented feature story, the panorama went around the country and was seen by thousands. In any case, the panorama was not mentioned in the *New Ulm Review* after 1893. In 1954 the historian James Taylor Dunn found it in a barn in Poughkeepsie, New York, and brought it to St. Paul. Now in the MHS collection, the panorama is considered too fragile to unroll.

NOTES TO CHAPTER 4

1. See Tim Starl, "A New World of Pictures: The Use and Spread of the Daguerreotype Process," in Michael Frizot, ed., *A New History of Photography* (Cologne, Germany: Könemann, 1998), 32–50. Neither the *New Ulm Review*, the English-language newspaper, nor the German-language *New Ulm Post* carried notices for photography studios in the early 1880s.

2. Vellikanje was born in Austria in 1841 and trained there in theology, law, and medicine. He came to America in 1865, living in New York before making his way to Minnesota in 1880. J. B. Vellikanje obituary, *New Ulm Review*, Dec. 23, 1896. Gary Harm, conversations with author, Apr. 26, 1996, and June 26, 2001.

3. The first advertisement for the firm appeared in the German-language newspaper the *New Ulm Post*, May 18, 1883. For portrait photography during this period, see Jean Sagne, "All Kinds of Portraits: The Photographer's Studio," in Frizot, ed., *A New History of Photography*, 102–22, and Barbara McCandless, "The Portrait Studio and the Celebrity: Promoting the Art," in Martha A. Sandweiss, ed., *Photography in Nineteenth-Century America* (Fort Worth: Amon Carter Museum, 1991), 48–75. Marcus Aurelius Root, an early photographer and theorist of the new medium, thought "democratic portraiture" to be an excellent antidote to the social instability associated with massive immigration and resettlement in western territories. See McCandless in Sandweiss, 49. See also Beaumont Newhall, *The History of Photography*, rev. ed. (New York: Museum of Modern Art, 1982), 59–71.

4. Sagne in Frizot, ed., *A New History of Photography*, 119.

5. Born in 1868, Herman Amme later studied for several years in Germany and returned to New Ulm to become a prominent architect. Herman Amme obituary, *Brown County Journal*, Jan. 20, 1917.

6. Sagne in Frizot, ed., *A New History of Photography*, 112, 120.

7. Advertisement for C. J. Greenleaf, *New Ulm Review*, Mar. 25, 1885. Greenleaf's establishment was at 27 East Third Street, St. Paul. This ad ran for a month. For Seiter see E. E. Seiter obituary, *Brown County Journal*, Dec. 10, 1921.

8. WG, "Childhood Reminiscences" (CLRC); Alma Scott, *Wanda Gág: The Story of an Artist* (Minneapolis: University of Minnesota Press, 1949), 8.

9. Naomi Rosenblum, *A History of Women Photographers*, rev. ed. (New York: Abbeville, 2000), 48; 56–59.

10. Nadar, testimony in a lawsuit, from Jean Prinet and Antoinette Dilasser, *Nadar* (Paris: Armand Colin, 1966), 115–16. Quoted in Newhall, *History of Photography*, 66.

11. Complaint of the plaintiff, *Anne Ledrach vs. Anton Gag*, District Court, 9th Judicial District, Brown County, State of Minnesota, Mar. 10, 1891 (BCHS);

"Rich, Rocky and Racy," *New Ulm Review*, Jan. 13, 1892; answer of the defendant, *Anne Ledrach vs. Anton Gag*, May 2, 1891 (BCHS).

12. Fritsche affidavit, June 10, 1891 (BCHS). Although neurasthenia is discredited today, the idea that Anton was genuinely ill is supported by the statement by J. H. Kellogg, M.D., supervisor of the Medical and Surgical Sanitarium in Battle Creek, certifying that "Mr. Anton Gag is under treatment in this institution under my care and is necessarily detained from travelling in consequence of illness." June 12, 1891 (BCHS).

13. WG, "Childhood Reminiscences: Going down the Rellrote [sic] Tracks" (VPL); FG, family memoir, 9–10 (typescript, Harm Collection).

14. *New Ulm Review*, May 18, 1892. Anton listed "photographer" rather than "artist" as his occupation on the wedding license; there was no space allotted for the occupation of the bride. Marriage record of Anton Gag and Lissi Biebl, Brown County, May 23, 1892 (BCHS).

15. It is not surprising that Lissi Gag was not mentioned in the firm's name: open acknowledgement of a husband-wife partnership was not common in nineteenth-century photographic studios. Rosenblum, *History of Women Photographers*, 45.

16. Alma Scott, WG interview notes, stenographic notebook, Scott papers (MHS). This unpaginated notebook contains information not included in Scott's published biography.

17. *New Ulm Review*, Mar. 29 and May 10, 1893.

18. *New Ulm Review*, May 30, 1894.

19. *New Ulm Review*, Nov. 4, 1896.

20. Brown County tax records for Anton Gag, 226 North Washington Street, New Ulm (BCHS).

21. The descriptions of Lissi's photography are in FG, miscellaneous notes, 1965 (BCHS). Anton is quoted in Scott, *Wanda Gág*, 16.

22. WG, "Childhood Reminiscences" (VPL).

23. WG, "Childhood Reminiscences: Wanda and God" (CLRC). See also idem, "A Hotbed of Feminists," *Nation*, June 22, 1927.

24. Scott, *Wanda Gág*, 17–36.

25. Ibid., 22.

26. WG, "Childhood Reminiscences: How Many in the Family?" (VPL).

27. WG, "Going down the Rellrote Tracks."

28. WG, "Childhood Reminiscences" (VPL) contains the following genealogical information, transcribed from the Biebl family Bible.

29. Joseph Biebl, handwritten document (VPL).

30. Scott, *Wanda Gág*, 41.

31. WG, "Going down the Rellrote Tracks."

32. WG, "Paper Dolls at Grandma's" (VPL); typescript, with some additions, at CLRC.

33. WG, "Going down the Rellrote Tracks."

34. WG, "Childhood Reminiscences: Grandma's" (VPL).

35. Andreas, the eldest son, had moved to the Twin Cities. He drowned in 1888 in Carver County, Minnesota, while attempting to save his fiancée's life.

36. WG, "How Many in the Family?" Joseph and Magdalena Biebl had in fact legally adopted Johnnie, as Wanda discovered after the death of her mother in 1917. WG, "Grandma's."

37. Lena's twin, Sebastian, called Vessie, had died suddenly in 1894, apparently from pneumonia.

38. Scott, *Wanda Gág*, 43–44.

39. WG, "Paper Dolls at Grandma's."

40. WG, "Going down to Grandma's" (typescript, CLRC). Anna, or Annie, went to the Twin Cities about 1905. She worked in a factory and died in November 1905, very possibly, Wanda believed, from the complications of an abortion. See "Grandma's."

NOTES TO CHAPTER 5

1. Julie L'Enfant and Robert J. Paulson, "Anton Gag, Bohemian," *Minnesota History* 56, no. 7 (fall 1999): 376–92.

2. See Chapter 2 on Peter Gui Clausen, then the best-known artist living in Minneapolis. He remarked toward the end of his life that he might have made a better living with a French or Italian name. See Clausen interview, *Minneapolis Tribune*, Apr. 19, 1914. Quoted in Roy A. Boe, "The Development of Art Consciousness in Minneapolis and the Problems of the Indigenous Artist" (master's thesis, University of Minnesota, 1947), 125–26.

3. On the economic boom in New Ulm, see La Vern J. Rippley and Robert J. Paulson, *German-Bohemians: The Quiet Immigrants* (Northfield, Minn.: St. Olaf College Press, 1995), 118–24. For the Kuetzing ad, see *New Ulm Review*, Apr. 6 and May 11, 1887.

4. *New Ulm Review*, Feb. 20, 1889.

5. Advertisement for Heller and Krause, *Springfield Adler*, May 23, 1890. Heller and Seiter were enterprising: in 1891 they decorated the hall in New Ulm's new courthouse to advertise their skills. *New Ulm Review*, Apr. 8, 1891.

6. *New Ulm Review*, Jan. 6, 1892. A similar ad also ran in the German-language *New Ulm Post* for several months in 1892. See also *New Ulm Review*, Apr. 8, 1891.

7. *New Ulm Review*, May 29, 1895. The partnership was apparently formed that March. The following notice appeared in the *Review* on March 6, 1895: "Heller, Gag and Seiter have formed a partnership. This is a combination that everyone knows is able to do the very finest painting, frescoing and paperhanging, for they are artists all of them."

8. James Boeck, Curator, Wanda Gág House, New Ulm, conversation with author, Sept. 18, 1995.

9. Leah Pockrandt, "Anton Gag's Artistry Evident in Gag House Restoration Project," *Brown County Journal*, Jan. 26, 1997. The observation about brushstrokes was made by Dan Tarnoveanu, the conservator who carried out restoration of the interior of the house in 1996–97.

10. Reprinted in *New Ulm Review*, May 6, 1902.

11. *New Ulm Review*, Aug. 27, 1902.

12. Alma Scott, WG interview notes, stenographic notebook, Scott papers (MHS). See also idem, *Wanda Gág: The Story of an Artist* (Minneapolis: University of Minnesota Press, 1949), 48–50.

13. The Reverends G. Cawley and Richard J. Engels, "The History of St. Patrick's Church," leaflet (c. 1996), n.p. See also "The History of St. Patrick's Church," in *Our Parish Family* (Winona, Minn.: Diocese of Winona, 1988), n.p.

14. *History of the Assumption Parish, St. Paul, Minnesota; Written on the Occasion of the Diamond Jubilee, October 18, 1931* (St. Paul: Wanderer Printing Company, 1931).

15. Bloomers were the solution, she decided. Scott, *Wanda Gág*, 51.

16. Ibid., 49.

17. *Turnverein* membership roll, 1906. Chris Heller is also listed as a member that year. Information supplied by Richard Runck, manager of Turner Hall.

18. Richard Runck, conversation with author, Aug. 16, 1996; *New Ulm Review*, June 30, 1901. For a brief history of the Turner Hall theater, see Hermann E. Rothfuss, "The Early German Theater in Minnesota," *Minnesota History* 32, no. 3 (Sept. 1951): 164–73. See also *A Brief History of the New Ulm Turnverein*,

pamphlet (New Ulm: E. G. Oswald, n.d.), n.p. (BCHS).

19. *New Ulm Review*, "Grand New Opera House," Feb. 2, 1901, and idem, "The New Ulm Turnverein Celebrates the Opening of Their Beautiful Hall in Fitting Manner," June 30, 1901.

20. Scott, *Wanda Gág*, 50.

21. *New Ulm Review*, Feb. 2, 1901.

22. *New Ulm Review*, Apr. 4 and July 4, 1906.

23. *New Ulm Review*, Sept. 7, 14, and 21, 1887. The anonymous writer, identified only as "The Rustler," identified his source as a gentleman who had visited many of the sites and was "well versed in the history, legendary as well as authentic" of the subject matter.

24. The artists used a combination of paints, including oils. The need for restoration suggests that the work was done *a secco*, on a dry surface, rather than with tempera paint on wet lime plaster, the traditional *buon fresco*, or true fresco technique.

25. Allan R. Gebhard, Mural Investigation: Restoration Review, Apr. 4, 1986 (BCHS); Ed Lee, "Noble Project Seeks to Unveil Turner Paintings," *Brown County Journal*, Jan. 10, 1994.

26. The medallions are visible in 1906 photographs but are now beneath paneling. Richard Runck found decorative borders near the ceiling in a small room adjoining the bar that is now a closet.

27. Scott, *Wanda Gág*, 16. Later both Wanda and Flavia repeated this anecdote in various autobiographical writings.

28. WG, "Childhood Reminiscences" (CLRC).

29. *New Ulm Review*, Sept. 23 and Dec. 30, 1896.

30. WG, "Childhood Reminiscences" (VPL).

31. This letter, dated May 30, 1907, is written in German. Parts are illegible (VPL). Translation by Arnold J. Koelpin, BCHS.

32. Kurt Bell, conversation with Darla and Allan R. Gebhard, Dec. 26, 1992 (BCHS): "Dr. Bell stated that his father, Dr. Ludwig Bell, a dentist, was asked by Anton Gag to examine Gag's throat. Anton Gag stated to Dr. Bell that he was sure he was getting better. He also asked Dr. Bell to take Howard Gag in, if he should die. That evening at supper, Dr. Ludwig Bell related his visit to Anton Gag to Kurt and his mother. He said that Anton's throat was full of tubercular lesions and that he doubted that he could live long. They also discussed Anton's request that the family take in Howard. It was decided that they would not do so. Anton Gag died shortly after this incident."

33. *New Ulm Review*, May 6, 1908.

34. See WG, "Childhood Reminiscences" (VPL), and Scott, *Wanda Gág*, 65. Additional description of Anton's delirium is found in the typescript of Scott's biography of Wanda Gág, 83 (MHS).

35. Anton Gag obituary, *New Ulm Review*, May 27, 1908. Chris Heller departed for Youngstown, Ohio, in June 1908. The *New Ulm Review* reported his death on September 2, 1908. Alma Scott's account of Anton taking Heller to the railroad station for his final journey cannot be accurate (*Wanda Gág*, 64).

NOTES TO CHAPTER 6

1. WG, introduction to *Growing Pains: Diaries and Drawings for the Years* 1907–1917 (1940; reprint, St. Paul: Minnesota Historical Society Press, 1984), xxxi. (Hereafter cited as GP.)

2. WG, autobiographical notes, n.p. (BCHS).

3. Karen Nelson Hoyle, *Wanda Gág* (New York: Twayne, 1994), 4.

4. FG, "Childhood Recollections," n.p. (manuscript notebook, c. 1965, Harm Collection).

5. *GP*, 70. The song Wanda played on the piano when she felt "dreamy" was "The Böhmerwald." See GP, 65, and Alma Scott, *Wanda Gág: The Story of an Artist* (Minneapolis: University of Minnesota Press, 1949), 14–15.

6. "Truth to nature" is an imprecise term. Yet it implies a sincere desire to let art serve nature that fits Anton Gag. See Julie L'Enfant, *William Rossetti's Art Criticism: The Search for Truth in Victorian Art* (Lanham, Pa.: University Press of America, 1999).

7. *GP*, 41–42.

8. Ibid., 17.

9. Ibid., 32–33.

10. Ibid., 6, 51, 57, 107.

11. Ibid., 67. On the exhibition, see Thomas O'Sullivan, "Robert Koehler and Painting in Minnesota, 1890–1915," in *Art and Life on the Upper Mississippi*, 1890–1915, ed. Michael Conforti (Newark, Del.: University of Delaware Press, 1994), 99–100.

12. *New Ulm Review*, Apr. 13, 1910.

13. *GP*, 75–76, 86.

14. Ibid., 84.

15. Ibid., 92–93.

16. Ibid., 97.

17. Ibid., 103.

18. Ibid., 112–13.

19. Ibid., 141.

20. In *GP* Edgar is called "Armand Emraad." Even in later years, when the book elicited hundreds of letters with questions about Armand, Wanda refused to identify him.

21. *GP*, 148, 149–50.

22. On the St. Paul School of Art, see Isaac Oliver Peterson, "Art in St. Paul as Recorded in the Contemporary Newspapers" (master's thesis, University of Minnesota, 1942), 217–27. See also Donald R. Torbert, *A Century of Art and Architecture in Minnesota* (Minneapolis: University of Minnesota Press, 1958), 16–17. On the controversies surrounding women drawing nude models, see Ann Sutherland Harris and Linda Nochlin, *Women Artists*, 1550–1950 (New York: Alfred A. Knopf, 1984), esp. 50–53, and Tamar Garb, "'Men of Genius, Women of Taste': The Gendering of Art Education in Late Nineteenth-Century Paris," in *Overcoming All Obstacles: The Women of the Académie Julian*, ed. Gabriel P. Weisberg and Jane R. Becker, exh. cat. (New York: Dahesh Museum; and New Brunswick, N.J., Rutgers University Press, 1999).

23. St. Paul School of Art catalog, 1912–13, 14, 5 (copy in CLRC).

24. *GP*, 168; see also 193–94.

25. Ibid., 176–77, 180.

26. Ibid., 180.

27. Ibid., 181, 182–83.

28. Ibid., 197–98.

29. Ibid., 206–7.

30. Ibid., 169–72.

31. Ibid., 212–13, 221.

32. Ibid., 249.

33. Ibid., 239.

34. Wanda was distressed at speculation in New Ulm about the reasons for this withdrawal of patronage (*GP*, 273–75).

35. *GP*, 259–62; asterisked note, GP, 284.

36. *GP*, 308. For Alma's remarks, see 274–79.

37. *GP*, 305, 309–10.

38. On Jones, see Jeffrey A. Hess, *Their Splendid Legacy: The First 100 Years of the Minneapolis Society of Fine Arts* (Minneapolis: Minneapolis Society of Fine Arts, 1985), 24, 36–40. On Jones's offer, see GP, 313–20. Wanda felt she should consult with McWhorter, who said, "Accept it."

39. Hess, *Their Splendid Legacy*, 14.

40. Carl Zigrosser, *The Artist in America* (New York: Alfred A. Knopf, 1942), 37. McWhorter had warned Wanda that the school might be too "academic" and superficial (GP, 320). Richard W. Cox argues that the school was less rigid than it might appear in "Adolf Dehn: The Minnesota Connection," *Minnesota History* 45 (spring 1977): 168–69.

41. *GP*, 324, 342.

42. Hess, *Their Splendid Legacy*, 8, 11, 29.

43. Ibid., 33–35.

44. *GP*, 334–35.

45. See Torbert, *A Century of Art*, 30–33. Flannagan was in Wanda's circle, but she never got to know him well. A rare comment on Flannagan in *GP* refers to him as "a taciturn, un-smiling creature who reads Nietsche [*sic*] and Schopenhauer and is all for the modern tendencies in art" (453). Egilsrud later became music critic for the *Minneapolis Tribune* as well as a poet and professor of English at the University of Minnesota. Wanda's correspondence with him is in CLRC. On Dehn, see Cox, "Adolf Dehn," 167–86, and idem, "Adolf Dehn: The Life," in Joycelyn Pang Lumsdaine and Thomas O'Sullivan, *The Prints of Adolf Dehn: A Catalogue Raisonné* (St. Paul: Minnesota Historical Society Press, 1987).

46. *GP*, 362.

47. Ibid., 398.

48. Ibid., 434–35.

49. Ibid., 452.

50. *GP*, 456–57. See also FG, family memoir, 53 (Harm Collection).

51. *GP*, 457.

52. The Gag children could not count on more than occasional help from extended family. Magdalena Biebl (Wanda's maternal grandmother) had died in 1916, her husband, Joseph, a few years earlier. The Gags were estranged from nearby Gag relatives, the Klauses and the Sellners (WG, "Childhood Reminiscences," CLRC). On sending the scholarship competition drawings, see GP, 458.

53. "Untamed," GP, 432. On Wanda's pacifism, see GP, 271. On Dehn's views, see Cox, "Adolf Dehn: The Life," in Lumsdaine and O'Sullivan, *Prints of Adolf Dehn*, 3.

54. By this time the younger children had a court-appointed guardian, Albert Steinhauser; he approved of this decision. Documents on guardianship are in BCHS.

55. Jean Sherwood Rankin, *A Child's Book of Folklore: Mechanics of Written English* (Minneapolis: Augsburg Publishing House, 1917). WG diary, Aug. 11, 1917 (VPL). See also FG, family memoir, 56, 82 (Harm Collection).

NOTES TO CHAPTER 7

1. This preeminence was new, dating from about 1910. See Christine Stansell, *American Moderns: Bohemian New York and the Creation of a New Century* (New York: Henry Holt, 2000), esp. 1–8, and Ann Douglas, *Terrible Honesty: Mongrel Manhattan in the 1920s* (New York: Farrar, Straus and Giroux, 1995), esp. 3–28.

2. Quoted in Alma Scott, *Wanda Gág: The Story of an Artist* (Minneapolis: University of Minnesota Press, 1949), 145.

3. WG diary, April 1918 (VPL).

4. WG letter, n.d. Quoted in Scott, *Wanda Gág*, 146.

5. The Eight were Arthur B. Davies, William Glackens, Robert Henri, Ernest Lawson, George Luks, Maurice Prendergast, Everett Shinn, and John Sloan. The name was given to them after a 1908 exhibition of their work at the Macbeth Gallery in New York City. See Wayne Craven, *American Art: History and Culture* (Madison, Wis.: Brown and Benchmark, 1994), 423–34.

6. Robert Henri, *The Art Spirit* (Philadelphia: J. B. Lippincott, 1923).

7. An excellent brief history of the Art Students League is in Ronald G. Pisano, *The Art Students League: Selections from the Permanent Collection*, exh. cat. (Huntington, N.Y.: Heckscher Museum, 1987), 7–14.

8. Robert Henri, statement in a symposium, "Should American Art Students Go Abroad to Study?" in *Creative* Art 2 (April 1928): 40.

9. WG, diary, Jan. 25, 1918 (VPL).

10. WG diary, Nov. 7, 1917 (VPL).

11. WG diary, Mar. 20, 1921. Quoted in Audur H. Winnan, *Wanda Gág: A Catalogue Raisonné of the Prints* (Washington, D.C.: Smithsonian Institution Press, 1993), 217.

12. See Winnan, *Catalogue Raisonné*, 206. After Wanda's death in 1946, family members stored the diaries in a bank vault, then at the Philadelphia Museum of Art, and finally, in 1971, donated them to the Van Pelt Library, University of Pennsylvania. They were closed to the public except by special permission until March 1993, the centenary of her birth.

13. The feminist movement achieved a great victory in August 1920 with the formal ratification of the Nineteenth Amendment to the Constitution, giving women the right to vote. The following decade was a time of disillusionment, as it became clear that this new power would not quickly change society, or, indeed, most women's lives. See Stansell, *American Moderns*, Chaps. 8 and 9. See also Elaine Showalter, ed., *These Modern Women: Autobiographical Essays from the Twenties* (New York: Feminist Press at the City University of New York, 1989). The major theme of the essays, according to Showalter, is "disillusion and maturity." She refers to the "feminist crash of the 20s" (10).

14. Richard W. Cox, "Adolf Dehn: The Minnesota Connection," *Minnesota History* 45 (spring 1977): 171–73.

15. Judith Goldman, foreword to *One Hundred Prints by 100 Artists of the Art Students League of New York*, 1875–1975 (New York: Art Students League, 1975), 15–17.

16. See Winnan, *Catalogue Raisonné*, 6–7, and cat. nos. 1–5. For mention of her first lithograph, see WG diary, Aug. 1 or 2, 1920 (VPL).

17. Richard W. Cox, "Adolf Dehn: The Life," in Joycelyn Pang Lumsdaine and Thomas O'Sullivan, *The Prints of Adolf Dehn: A Catalogue Raisonné* (St. Paul: Minnesota Historical Society Press, 1987), 3.

18. WG to Adolf Dehn, June 2, 1920 (VPL). Quoted in Winnan, *Catalogue Raisonné*, 214.

19. Scott, *Wanda Gág*, 152–53.

20. The city built a group of model tenements on 78th and 79th streets, between York and Marie Curie avenues. According to *The WPA Guide to New York City* (1939; reprint, New York: Pantheon Books, 1982), these apartments represented "one of the most significant Manhattan housing developments prior to the Amalgamated Dwellings on the Lower East Side" (248–49).

21. Lucile Lundquist Blanch to Alma Scott, c. 1946 (BCHS).

22. See Cox, "Adolf Dehn," in Lumsdaine and O'Sullivan, *Prints of Adolf Dehn*, 3.

23. WG diary, Apr. 11, 1921 (VPL).

24. WG diary, Jan.–Feb. 1921. Quoted in Winnan,

Catalogue Raisonné, 216.

25. Whitney Chadwick, *Women, Art, and Society* (London: Thames and Hudson, 1996), 252–78.

26. WG diary, May 22, 1920, and Nov. 19, 1917 (VPL).

27. WG diary, Sept. 19, 1914, *Growing Pains: Diaries and Drawings for the Years 1907–1917* (1940; reprint, St. Paul: Minnesota Historical Society Press, 1984), 273.

28. Various avant-garde movements intent on breaking down the distinction between fine and applied arts embraced textile and clothing design. See Chadwick, *Women, Art, and Society*, 252–78.

29. Examples of Wanda's drawings for Happiwork projects are in CLRC.

30. See Clinton Adams, "Adolf Dehn: The Lithographs," in Lumsdaine and O'Sullivan, *Prints of Adolf Dehn*, 26–27.

31. The Weyhe Gallery and bookstore were owned by Erhard Weyhe, a German immigrant who sponsored exhibitions of works by the European modernists as well as by young American artists and printmakers. On the gallery, see Winnan, *Catalogue Raisonné*, 17–20.

32. WG diary, May 22, 1920 (VPL).

33. WG to Adolf Dehn, June 2, 1920. Quoted in Winnan, *Catalogue Raisonné*, 214.

34. WG diary, April 2, 1920. Quoted in Winnan, *Catalogue Raisonné*, 213. See also ibid., 9. Sanger's birth-control clinic had opened in 1916. Its constituency was mainly made up of poor working married women. See Stansell, *American Moderns*, 234–41.

35. She identified it only as a "short article on Rodin." WG diary, July 29, 1919. The quotes here are all from that day's entry.

36. WG diary, Sept.–Nov. 1920. Quoted in Winnan, *Catalogue Raisonné*, 215–16.

37. WG to Earle Humphreys, copied into diary, autumn 1922. Quoted in Winnan, *Catalogue Raisonné*, 227.

38. WG diary, May 3, 1922 (VPL). The book to which she refers is Arthur Jerome Eddy, *Cubism and Post-Impressionism* (Chicago: A. C. McClurg and Company, 1914).

39. Ibid.

40. WG diary, May 18, 1922. Quoted in Winnan, *Catalogue Raisonné*, 225.

41. WG diary, June 21, 1922. Quoted in Winnan,

Catalogue Raisonné, 226. Such passages connect Wanda Gág to a "primitivizing" strain in modern art. See Jacquelyn Gourley, "Wanda Gág: American Artist, Modern Primitive" (master's thesis, George Washington University, 2001).

42. WG diary, Oct. 31, 1921. Quoted in Winnan, *Catalogue Raisonné*, 219. Wanda would see Dehn when he returned to New York in 1925, in 1930, and on other later visits. Their relationship remained strained, however, especially after she commented negatively to Carl Zigrosser on Dehn's Parisian lithographs, satires on Paris café life that she considered decadent and imitative. See Cox, "Adolf Dehn: The Minnesota Connection," 176–78.

43. The New York Public Library exhibition also included twenty-one drawings for children. See Winnan, *Catalogue Raisonné*, 13. In July 1922 Wanda had a dream about watching a "weird plant" sprout on a hillside. When a middle-aged man bent it forward she felt "intense transport," indeed "more than it is in our mortal capacity to feel." WG diary, July 21, 1922 (VPL).

44. WG to Adolf Dehn, December 1923. Quoted in Winnan, *Catalogue Raisonné*, 232–33.

45. WG, statement in "Should American Art Students Go Abroad to Study?" *Creative Art* 2 (Apr. 1928): 43. Later Wanda told Alma Scott that her reversal of fortune had been providential: "I was not yet strong enough to resist European influences." Quoted in Scott, *Wanda Gág*, 156.

NOTES TO CHAPTER 8

1. WG diary, Oct. 29, 1929. Quoted in Audur H. Winnan, *Wanda Gág: A Catalogue Raisonné of the Prints* (Washington, D.C.: Smithsonian Institution Press, 1993), 260.

2. WG diary, June 1935. Quoted in Winnan, *Catalogue Raisonné*, 278.

3. WG diary, Oct. 29, 1929. Quoted in Winnan, *Catalogue Raisonné*, 260–61.

4. Alma Scott, *Wanda Gág: The Story of an Artist* (Minneapolis: University of Minnesota Press, 1949), 162.

5. WG to Adolf Dehn, Dec. 1921. Quoted in Winnan, *Catalogue Raisonné*, 221.

6. WG diary, Oct. 18, 1914, *Growing Pains: Diaries and Drawings for the Years 1907–1917* (1940; reprint, St. Paul: Minnesota Historical Society Press, 1984), 287. (Hereafter cited as GP.)

7. See Jacquelyn Gourley, "Wanda Gág: American Artist, Modern Primitive" (master's thesis, George Washington University, 2001), 40–49. According to

Gourley, the Regionalist artist whose work has the most in common with Wanda Gág is Charles Burchfield.

8. See, for example, Mary Mathews Gedo's discussion of Picasso's use of organic forms to represent Marie-Therese Walter in *Picasso: Art as Autobiography* (Chicago: University of Chicago Press, 1980), esp. 139–40 and 144–45.

9. John B. Flannagan, "The Image in the Rock," *Magazine of Art* 35 (Mar. 1942), 90–95.

10. Linda Nochlin, in Ann Sutherland Harris and Linda Nochlin, *Women Artists, 1550–1950* (New York: Alfred A. Knopf, 1984), 58–59, 64–67.

11. See, for example, Thelma Gouma-Peterson and Patricia Mathews, "The Feminist Critique of Art History," *Art Bulletin* 69 (Sept. 1987): 334–37.

12. On Surrealism and its use of automatism and biomorphic forms, see Maurice Nadeau, *The History of Surrealism*, trans. Richard Howard (Cambridge, Mass.: Belknap Press of Harvard University Press, 1989), with an introduction by Roger Shattuck. Wanda Gág herself noted the nightmarish quality of some of her images in a "discourse written long ago" sent to Carl Zigrosser in May 1926. It describes how she drew hills and trees so long one day that she dreamed about them that night in an "ego-fraught nightmare" and woke up thinking how terrible it would be to live in a world created entirely by oneself (or any other artist, for that matter). Quoted in Winnan, *Catalogue Raisonné*, 242.

13. WG to Adolf Dehn, Dec. 1921. Quoted in Winnan, *Catalogue Raisonné*, 221. Wanda's diary entry of April 10, 1928, describes a party in Harlem and her response to dancing with Jimmy Harris. "There was this subtle wild animal beside me, and Rockwell [Kent] and Carl [Zigrosser] meant nothing to me then. That's brutal, but it's true so I insist on writing it. What puzzles me is where I get so much of the jungle."

14. WG diary, Oct. 6, 1914, GP, 282. Stella "is unselfish. . . . She does not wail as I do; she is much braver in that respect. She has a fine, big heart, and a marvelous insight into character (marvelous in that she has seen so little of the world)."

15. WG, "Childhood Reminiscences: At Grandma's" (VPL); WG, Nov. 17, 1914, GP, 302. ("I have written Stella a long and take-it-from-your big-sister-y sort of letter.")

16. Asta Gág to WG, c. June 1923 (VPL); WG, "Childhood Reminiscences: Going down the Rellrote [*sic*] Tracks" (VPL).

17. WG diary, Aug. 8, 1915, GP, 425.

18. The contra-bass is illustrated, showing Howard's

drawing skill. Howard Gág to WG, Jan. 16, 1920 (VPL).

19. FG to WG, Oct. 1, 1925 (CLRC).

20. FG to WG, June 14, 1920 (VPL). On FG's reactions to illness see, for example, FG to WG, Nov. 22, 1924, and Oct. 1, 1925 (CLRC).

21. FG to WG, Jan. 18, 1925 (CLRC).

22. The 1925 *Centralian*, yearbook of Central High School, Minneapolis (copy in MHS).

23. FG, family memoir, 63–64 (Harm Collection). Subsequent citations of her memoir are from this collection.

24. FG, autobiographical sketch for Random House, 1949 (Harm Collection).

25. FG diary, Oct. 5, 1928 (Harm Collection). Subsequent citations of her diary are from this collection.

26. WG to Harold and Doris Larrabee, Aug. 21, 1927. Quoted in FG, family memoir, 73–74.

27. WG wrote to Zigrosser about, for instance, her problems with perspective ("wrangling with the hills"), May 10, 1926. Zigrosser wrote her about the possibility of "an intimate and enduring friendship," Apr. 5, 1926 (Glotzbach Collection, BCHS).

28. Murdock Pemberton, review of Wehye Gallery exhibition, *New Yorker*, Nov. 13, 1926. Quoted in Winnan, *Catalogue Raisonné*, 29.

29. Clinton Adams, "Adolf Dehn: The Lithographs," in Jocelyn Pang Lumsdaine and Thomas O'Sullivan, *The Prints of Adolf Dehn: A Catalogue Raisonné* (St. Paul: Minnesota Historical Society Press, 1987), 26–27. On attitudes of museums toward prints, see also Jeffrey A. Hess, *Their Splendid Legacy: The First 100 Years of the Minneapolis Society of Fine Arts* (Minneapolis: Minneapolis Society of Fine Arts, 1985), 35–36.

30. See Winnan, *Catalogue Raisonné*, 17–20.

31. Christine Stansell, *American Moderns: Bohemian New York and the Creation of a New Century* (New York: Henry Holt, 2000), 90–91.

32. Karen Nelson Hoyle, *Wanda Gág* (New York: Twayne, 1994), 32. Chap. 2, "*Millions of Cats*: The Story behind the Story," is an excellent account of Wanda's first and most successful book.

33. Karen Hobbs, trans. and ed., *One Hundred Tales from Sudetenland* (New Ulm, Minn.: German-Bohemian Heritage Society, 1999), xvi.

34. Anne Carroll Moore, review of *Millions of Cats*, by Wanda Gág, *Book Dial* (fall 1928). Quoted in

Winnan, *Catalogue Raisonné*, 37–38. Moore, who was head children's librarian at the New York Public Library, a board member of the *Horn Book* (a magazine for children), and a reviewer for *New York Herald Tribune Books*, had great influence in the field of children's books. See Hoyle, *Wanda Gág*, 73.

35. FG, family memoir, 78.

36. Ibid., 76–77.

37. On illustrations for *Millions of Cats*, see Hoyle, *Wanda Gág*, 33–37.

38. Quoted in Scott, *Wanda Gág*, 174.

39. Quoted in Winnan, *Catalogue Raisonné*, 257.

40. WG diary, Oct. 29, 1929. Quoted in Winnan, *Catalogue Raisonné*, 257–58.

41. Hoyle, *Wanda Gág*, 30–31.

42. Ibid., 37–41.

43. WG to Lewis Gannett, May 1929. See Hoyle, *Wanda Gág*, 43.

44. FG, family memoir, 79–82.

45. WG diary, Mar. 6 and 16, 1930. Quoted in Winnan, *Catalogue Raisonné*, 264–67.

46. WG diary, Mar. 6 and 16, 1930. Quoted in Winnan, *Catalogue Raisonné*, 266.

47. FG, family memoir, 82.

48. See Elaine Showalter, ed., *These Modern Women: Autobiographical Essays from the Twenties* (New York: Feminist Press at the City University of New York, 1989).

49. WG to Carl Zigrosser, July 15, 1927. Quoted in Winnan, *Catalogue Raisonné*, 248.

50. Stansell, *American Moderns*, makes the interesting point that many artists and writers who came to New York from small towns and local capitals tended to exaggerate the backwardness of their places of origin. See Chap. 2, "Journeys to Bohemia."

51. Richard W. Cox, "Wanda Gág: The Bite of the Picture Book," *Minnesota History* 44 (fall 1975): 252–53.

52. Handwritten note, signed "Egmont," n.d. (CLRC).

53. WG diary, Apr. 10, 1928 (letters copied into diary entry) (VPL). Wanda spent a week with Stieglitz and Georgia O'Keeffe at Lake George in September 1928. See WG diary, autumn 1928. Quoted in Winnan, *Catalogue Raisonné*, 255.

54. Six volumes of diaries by Flavia exist in the Harm Collection. Some are typed to allow for greater thoroughness, "a conscientious record of all important happenings and thoughts" (June 6, 1930). She tried to write with complete frankness, planning, she recorded telling her friend Sedgwick Gold, to label them "'In case of death, burn these *without reading them*'." When he laughingly advised her that one cannot be sure what people will do after one is dead, she replied, "Then I guess all there is left for me to do is to tear out certain pages" (June 21, 1930). In fact, some pages of the diaries are crossed out with heavy black lines; others are torn out, creating gaps of up to twenty pages.

55. FG diary, Sept. 17, 1928, Aug. 24, 1929, and May 29, 1930.

56. FG diary, Sept. 6, 1928.

57. On Tin Pan Alley and the boom in popular music, see, for example, Ann Douglas, *Terrible Honesty: Mongrel Manhattan in the 1920s* (New York: Farrar, Straus and Giroux, 1995), esp. 356–60 and 553–56.

58. FG diary, Sept. 1, 1929.

59. FG diary, Sept. 11, 1929. The book-jacket blurb for *Sue Sew-and-Sew* (1931) described Flavia as "the composer of some 45 popular numbers—one of which was arranged for publication and broadcast from several stations."

60. On Minneapolis, see FG to WG, Oct. 12, 1929 (VPL). On Flavia's state of mind, see esp. FG to WG, Dec. 1929 ("my nerves were so ragged that they practically hung in ribbons") (VPL).

61. FG diary, Feb. 4–5, 1930.

62. WG to "Flops" (FG), Jan. 27, 1930 (VPL). Lucile Lundquist Blanch wrote to Alma Scott c. 1946 about Wanda's "outrage" and "panic" regarding one of her sister's "first experience with a little spooning. She was absolutely tigerish" (BCHS).

63. FG to WG, Feb. 2, 1930 (VPL).

64. For extended descriptions of this collapse, see FG diary, Feb. 12 and May 28, 1930. Except as noted, the following description of Flavia's state comes from these entries.

65. WG to "Flops" (FG), Mar. 2, 1930 (VPL); FG to WG, Mar. 6, 1930 (VPL); and WG to FG, Mar. 11, 1930 (VPL).

66. Earle worked sporadically as a salesman and at other jobs; he was frequently involved in labor organizing. See Winnan, *Catalogue Raisonné*, 45, 55.

67. FG diary, May 28, 1930.

68. FG diary, Aug. 16, 1930.

69. FG diary, June 10, 1930.

70. Scott, *Wanda Gág*, 166.

71. FG diary, July 27, Aug. 17, and Sept. 1930.

72. FG diary, Aug. 13 and Sept. 24, 1930.

Notes to Chapter 9

1. Karen Nelson Hoyle, *Wanda Gág* (New York: Twayne, 1994), 19. Wanda chose not to participate in Works Progress Administration (WPA) projects, another means by which some artists actually made a better living during the Depression than they had previously.

2. WG diary, Mar. 6, 1930. Quoted in Audur H. Winnan, Wanda Gág: *A Catalogue Raisonné of the Prints* (Washington, D.C.: Smithsonian Institution Press, 1993), 263–64; WG diary, Mar. 30, 1930. Quoted in Winnan, 268.

3. Winnan, *Catalogue Raisonné*, lists exhibitions and museum collections (45–47).

4. FG diary, Jan. 22, 1931 (Harm Collection). Subsequent citations of Flavia's diary are from this collection.

5. FG diary, Mar. 8, 1933.

6. FG diary, Jan. 17, 1934.

7. For example, Amy Fox, Flavia's former English teacher at Central High in Minneapolis, wrote that teachers' salaries had been "reduced to the vanishing point." FG diary, Oct. 28, 1932.

8. FG diary, July 28, 1930.

9. WG to FG, copied into FG diary, Oct. 4, 1930.

10. Alma Scott, *Wanda Gág: The Story of an Artist* (Minneapolis: University of Minnesota Press, 1949), 47.

11. See, for example, WG to FG, Oct. 9, 1930 (VPL).

12. FG diary, June 24, 1930; FG to WG, Nov. 1930 (VPL). ("Our second royalty check for 'Sue' came this summer, and we were quite surprised to see that the book is still selling in spite of the depression.")

13. Regarding the end of the 1920s, Ann Douglas writes, "The best writers and artists, it was believed, knew what was good for their art and got out of the commercialized and hard-drinking city." *Terrible Honesty: Mongrel Manhattan in the 1920s* (New York: Farrar, Straus and Giroux, 1995), 24.

14. See WG to Howard Gág, May 24, 1931 (VPL). See also Scott, *Wanda Gág*, 166–68. (Howard is hereafter cited as HG.)

15. FG, family memoir, 72, 86 (Harm Collection). Subsequent citations of Flavia's memoir are from this collection.

16. WG to HG, Feb. 10, 1932 (VPL).

17. HG to WG, Feb. 12, 1932 (VPL).

18. WG to HG, Feb. 15, subsequent short letter also postmarked Feb. 15, and Mar. 26, 1932 (VPL).

19. HG to WG, Mar. 31, 1932 (VPL).

20. FG diary, Mar. 19, 1932.

21. See Winnan, *Catalogue Raisonné*, 48. On the length of their stay, see WG to HG, Feb. 10, 1932 (VPL).

22. FG diary, Mar. 8 and 22, 1932.

23. The foregoing quotations regarding this episode are all from FG diary, Mar. 25, 1932.

24. Howard Cook to Gray Winnan, Jan. 15, 1972. Quoted in Winnan, *Catalogue Raisonné*, 48.

25. FG diary, Apr. 4, 1932.

26. For a thorough discussion of how *The ABC Bunny* was created and received, see Hoyle, *Wanda Gág*, 52–55.

27. WG to Hugh Darby, June 9, 1933 (CLRC). Quoted in Winnan, *Catalogue Raisonné*, 274–75.

28. FG diary, May 30, 1933.

29. FG diary, June 5, 1933. On Wanda's work habits, see Scott, *Wanda Gág*, 218–23.

30. FG diary, March 8, 1932. Although Snooky was male, Flavia's diary refers to him with feminine pronouns. The Gágs had the curious habit of referring to *all* cats as "she." FG diary, Dec. 13, 1933, Jan. 11, 1934, and Feb. 27, 1935. She wrote an account of Snooky's last illness on March 1, 1935.

31. FG diary, Feb. 26, 1933. Flavia took Snoopy's ordeal very hard. On Snoopy's death, see FG diary, Sept. 25, 1933. ("Our household was cheerless from then on, and *my* world at least was plunged in sorrow.") "'I'm perfectly exhausted from sobbing so much all day,'" Flavia recorded that she told Wanda. "'Yes, I feel the same,' Wanda confessed." Flavia wrote about these cats in "Snoopy and Snooky," *Junior Red Cross News* 39, no. 5 (March 1958): 20–23.

32. Apparently Wanda was attracted only to Rivera's mind, the energy of which was belied by his corpulent exterior. WG diary, July 10, 1933. Quoted in Winnan, *Catalogue Raisonné*, 275. The Mexican painter's Radio City murals were destroyed before completion after he refused to remove an image of Lenin.

33. FG diary, Mar. 1, 1935.

34. The following account comes from an extended description in FG diary, Oct. 29, Nov. 5, and Nov. 27, 1933.

35. FG diary, Nov. 5, 1933. See also Douglas, *Terrible Honesty*, on the vogue in the white intelligentsia during the 1920s for "slumming" in Harlem (esp. 74).

36. In 1934 Flavia had a job at *Forecast* magazine but suffered a breakdown after about four months because of what she considered "incredibly brutal" conditions there (FG diary, July 5, 1934).

37. FG diary, Jan. 16, Feb. 9, and Mar. 5, 1934.

38. FG diary, Mar. 19, 1932. Information on the art school episode comes primarily from letters between Flavia and Wanda, March–May 1936 (VPL). The school is identified as the "American Artists School" in FG to WG, Mar. 17, 1937 (VPL). See also WG to FG, May 21, 1936 (Harm Collection), in which Wanda scolds Flavia for her withdrawal from the school because it put *her* in an embarrassing position and also eliminated Flavia's chance to meet people.

39. FG to WG, Mar. 17, 1937 (VPL).

40. WG to FG, Mar. 19, 1937 (Harm Collection).

41. FG to WG, Mar. 26 and Apr. 15, 1937 (VPL). Wanda continued trying to arrange for Flavia to go to art school and make social contacts with other artists. On a class taught by Thomas Lo Medico, a sculptor who worked at the Metropolitan Museum of Art, see WG to FG, Jan. 30, 1941 (Harm Collection), and FG to WG, Feb. 21, 1946 (CLRC).

42. FG to WG, Apr. 15, 1937 (VPL). Gendron was the graduate of a college in Montreal.

43. WG to FG, Apr. 16, 1937 (Harm Collection). "Fancy" meant "tight" or drunk. FG to WG, Apr. 17, 1937 (VPL).

44. FG to WG, June 10 and 13, 1938 (VPL).

45. WG to FG, June 15, 1938 (VPL). This letter has a notation in Wanda's hand, "not sent because she returned that day." George disappeared from Flavia's life after about a year.

46. Dehli's problems manifested themselves in a preoccupation with certain tenets of Christian Science, especially the idea that "There is no Life, no Truth, no Substance, no Intelligence in Matter." FG diary, Aug. 13, 1930. See also May 6, 1935.

47. FG diary, May 12, 1933.

48. FG diary, Nov. 23, 1932.

49. FG diary, Jan. 19, 1934, and Mar. 28, 1935. In 1935 a book by Earle Humphreys was turned down by several publishers. He continued sporadically to try to write but never published his work. He asked Robert Janssen to destroy his manuscripts after his death, and Janssen complied. See Winnan, *Catalogue Raisonné*, 55, and Robert Janssen, audiotaped interview, June 26, 1987 (BCHS).

50. FG diary, Jan. 3, 1934; WG to FG, May 29, 1939 (VPL). Asta lived in Flushing, Long Island; Dehli in New York City; and Nelda in Bergenfield, New Jersey.

51. Winnan, *Catalogue Raisonné*, 53–54, 58. See cat. nos. 103, 104, and 109.

52. WG diary, Sept. 17, 1933. Quoted in Winnan, *Catalogue Raisonné*, 275–76.

53. WG diary, Sept. 12, 1934. Quoted in Winnan, *Catalogue Raisonné*, 277.

54. WG diary, July 26 and Sept. 7, 1938. Quoted in Winnan, *Catalogue Raisonné*, 279–80. Wanda's brush-and-ink study drawing for *Abandoned Quarry I*, a lithograph of 1939, resembles pen-and-ink drawings that van Gogh made in Arles. See Winnan, *Catalogue Raisonné*, cat. no. 115, and Ross Neher, "Van Gogh's Problem with Tradition," *Arts* 65 (January 1987): 43–48.

55. WG diary, May 24, 1931. Quoted in Winnan, *Catalogue Raisonné*, 269–70.

56. WG diary, Aug. 2, 1939. Quoted in Winnan, *Catalogue Raisonné*, 284.

57. WG to FG, June 28, 1937 (photocopy, Harm Collection; original lost). "Paint mixing scene this morning. It was raining so I wore papa's lodenrock. The little kitty was lonely & climbed up *under* the coat—I felt like a humpbacker."

58. WG diary, Aug. 2, 1939. Quoted in Winnan, *Catalogue Raisonné*, 282. This long entry, written when she was too troubled by dizziness to paint, contains an extended description of her experiments in drawing and painting. See also WG to Carl Zigrosser, Sept. 10, 1939. Quoted in Winnan, 284–85.

59. WG diary, Aug. 2, 1939. Quoted in Winnan, *Catalogue Raisonné*, 281–82. On the fifteen or so oil paintings in the Estate of Wanda Gág, see Winnan, 67.

60. See Hoyle, *Wanda Gág*, 81. For an excellent discussion of the genesis, production, and reception of *Growing Pains*, see Hoyle, 81–86.

61. The journal of the short-lived Russian artist Marie Bashkirtseff (1858–1884), published in 1887, is one of the few that were available at that time. See Wendy Slatkin, *The Voices of Women Artists* (Englewood

Cliffs, N.J.: Prentice Hall, 1993). *Growing Pains* brought Wanda great number of letters (many from young girls who identified with its adolescent angst). For example, a woman in Columbia, Missouri, wrote: "I am about your age and went thru the feelings you had in a milder form, and I loved to draw as a child." Mrs. Thomas Atkinson to WG, Feb. 13, 1941 (CLRC). But *Growing Pains* did not have large sales figures. For how the book was received, see Hoyle, *Wanda Gág*, 85.

62. See Hoyle, *Wanda Gág*, 57. Hoyle thoroughly discusses the volumes of fairy tales (57–79).

63. Marie L. Shedlock, *The Art of the Storyteller* (New York: D. Appleton, 1927). See Hoyle, *Wanda Gág*, 59.

64. On Wanda's habit of working in bed, see Hoyle, *Wanda Gág*, 60. Stevenson's "The Land of Counterpane" is included in *A Child's Garden of Verses*. Wanda had worked on illustrations for this book in the late 1920s; they were never published.

65. See WG, "I Like Fairy Tales," *Horn Book* 15 (Mar.–Apr. 1939): 75–80. Wanda "tested" the violent content on children, particularly on Alma Scott's daughter Pat, who, at age four, was unfazed. See Scott, *Wanda Gág*, 179–80.

66. Quotation from WG, "About Fairy Tales" (typescript, CLRC).

67. WG, introduction to *Tales from Grimm* (New York: Coward-McCann, 1936), vii–viii.

68. See Scott, *Wanda Gág*, 37–38. See also FG, family memoir, 89.

69. WG diary, Mar. 14 and 22, 1938. Quoted in Winnan, *Catalogue Raisonné*, 278–79, 281. See also Winnan, 54–55. *Ceiling of the Paramount Theatre* is pl. 3.

70. Hoyle, *Wanda Gág*, 78.

71. WG to HG and FG, May 3, 1936 (Harm Collection). See also Scott, *Wanda Gág*, 177–79, and WG to FG, May 4, 1936 (Harm Collection).

NOTES TO CHAPTER 10

1. WG, "Plans for Work," application for Guggenheim Fellowship (partial typescript, VPL).

2. WG to Howard Gág, Apr. 6, 1941 (CLRC). Quoted in Karen Nelson Hoyle, *Wanda Gág* (New York: Twayne, 1994), 88. (Howard is hereafter cited as HG.)

3. WG diary, Aug. 18, 1941. Quoted in Hoyle, *Wanda Gág*, 89. See also Audur H. Winnan, *Wanda Gág: A Catalogue Raisonné of the Prints* (Washington, D.C.: Smithsonian Institution Press, 1993), 60.

4. *New Ulm Review*, Nov. 14, 1940. Alma Scott

worked at the New Ulm Public Library from 1936 to 1947 and, after that, in the archives department of the University of Minnesota library in Minneapolis.

5. Correspondence between Wanda Gág and Johan Egilsrud on this topic, Mar. 10, 1942 –Dec. 10, 1943 (CLRC). Egilsrud's book, published by the University of Minnesota Press in 1943, also includes a lithograph by Adolf Dehn.

6. A. O. Eberhart to WG, Sept. 25, 1943, characterizes her letter (CLRC); WG to A. J. Russell, Sept. 20, 1943 (MHS).

7. On producing a sequel to *Growing Pains*, see WG to Mr. Bredouw, care of Coward-McCann, Oct. 22, 1941 (CLRC). The foregoing quoted material is from WG diary, Nov. 1, 1941 (VPL). Quoted in Winnan, *Catalogue Raisonné*, 286–87.

8. On "Childhood Reminiscences," see also Hoyle, *Wanda Gág*, 97–98. Five sections of this unfinished project are found in CLRC in typewritten form. Comparison with Wanda's handwritten version shows that these were altered, perhaps by Flavia, to make them more like stories. For instance, they use a third-person narrator, "the Child," rather than the first person. These versions tend to be cloying.

9. WG diary, Oct. 29, 1929. Quoted in Winnan, *Catalogue Raisonné*, 259.

10. Alma Scott, *Wanda Gág: The Story of an Artist* (Minneapolis: University of Minnesota Press, 1949), 216–17.

11. Carl Zigrosser to WG, Feb. 3, 1946 (VPL).

12. WG to FG, Apr. 1, 1941 (VPL). See also FG diary, June 11, 1935, on Wanda's efforts on Flavia's behalf at *Child Life*. On the possibility of a film, see WG to HG, Aug. 15, 1942 (VPL).

13. WG diary, Jan. 4, 1942 (VPL). Quoted in Winnan, *Catalogue Raisonné*, 287–88.

14. WG to FG, May 24, 1943 (VPL); WG to FG, Oct. 14, 1943 (Harm Collection). Wanda went on to note here that the dentist she wanted to see to help her was ill and that, on top if it all, she was feeling dizzy.

15. WG to Johan Egilsrud, Mar. 10, 1942 (CLRC).

16. WG diary, Aug. 5, 1942. Quoted in Winnan, *Catalogue Raisonné*, 288.

17. WG to Growald, Nov. 14, 1945 (CLRC). Quoted in Hoyle, *Wanda Gág*, 92.

18. WG to HG, May 24, 1931 (VPL); WG to HG, Mar. 29, 1942 (VPL).

19. WG to HG, Mar. 26 and 29, 1942 (VPL).

20. HG to WG, Mar. 31, 1942 (VPL). See also Flavia's remark that the three youngest Gágs—Dehli, Howard, and she—had rickets as children. FG, "How a Book Is Made," talk at Palatka College, Palatka, Fla., Apr. 1967 (BCHS).

21. HG to WG, Aug. 18, 1942 (VPL); Winnan, *Catalogue Raisonné*, 61.

22. WG diary, Aug. 27, 1943 (written Nov. 11, 1943). Quoted in Winnan, *Catalogue Raisonné*, 288–89.

23. WG diary, Nov. 1, 1941 (VPL).

24. WG diary, Aug. 27, 1943 (written Nov. 11, 1943). Quoted in Winnan, *Catalogue Raisonné*, 289.

25. FG to WG, June 9, 1944 (VPL).

26. WG to FG, Nov. 8, 1944 (VPL).

27. WG to Mrs. R. P. Brecht, Lansdowne, Pa., Oct. 23, 1944 (CLRC). See also Hoyle, *Wanda Gág*, 98–99.

28. WG to FG, Dec. 2, 1944 (Harm Collection).

29. Scott, *Wanda Gág*, 224.

30. WG to Carl Zigrosser, Jan. 31, 1945 (VPL).

31. WG to Carl Zigrosser, Feb. 18, 1945 (VPL).

32. Scott, *Wanda Gág*, 224; Winnan, *Catalogue Raisonné*, 63. Janssen later stated that he, Earle, and Howard knew the truth, but they were never sure whether Wanda knew or not. Her sisters did not want her to think her condition was serious. Robert Janssen, audiotaped interview, June 26, 1987 (BCHS).

33. Carl Zigrosser to WG, Mar. 2, Apr. 4, April 17, May 15, and June 16, 1945 (VPL).

34. WG to Carl Zigrosser, July 24, 1945 (VPL).

35. WG to Carl Zigrosser, Dec. 1, 1945 (VPL).

36. Carl Zigrosser to WG, Dec. 9, 1945 (VPL).

37. WG to Carl Zigrosser, Jan. 11, 1946 (VPL).

38. WG to Carl Zigrosser, Apr. 6, 1946 (VPL).

39. Ibid.

40. WG to Carl Zigrosser, June 17, 1946. Wanda speculates that she is an allergic type and cites Flavia's related complaints. She resolves to write him again soon, more cheerfully (VPL).

41. WG diary fragments, June 19 (Wednesday) and June 20 (Thursday), 1946 (VPL).

42. FG to Alma Scott, July 1, 1946 (VPL).

NOTES TO CHAPTER 11

1. FG to Alma Scott, Aug. 30, 1946 (VPL). See also "Prints by Wanda Gag," *Minneapolis Institute of Arts Bulletin* 35 (Dec. 1946): 154–59.

2. Alma Scott, *Wanda Gág: The Story of an Artist* (Minneapolis: University of Minnesota Press, 1949), 225.

3. See FG to Carl Zigrosser, Oct. 3, 1946, and Feb. 27, 1947 (VPL) and FG to Alma Scott, Mar. 6 and July 20, 1947 (VPL).

4. FG to Alma Scott, June 21, 1947 (VPL). Flavia wrote Scott that she wouldn't make too many changes in one section because "Earle said he had made so many *big* changes in the same section that it would be better if I just let it go as it is. Of course I've made marginal notes. In general I thought it read quite well but I felt that the writing was becoming definitely adult in spots." See also FG to Alma Scott, Nov. 9, 1949 (VPL): "I haven't seen Earle since his return from Minnesota, but I heard from Bob [Janssen] how disheartening it was to you to have your manuscript slashed here and there. Well, it's all finished now, and I can about imagine how relieved you are to have the thing off your chest at long, long last. It's been a tremendously long pull."

5. FG to Alma Scott, Aug. 30, 1946 (VPL).

6. WG to Carl Zigrosser, Jan. 31, 1945 (VPL).

7. George Glotzbach notes of conversation with Gertrude Gillespie, Oct. 14, 1992 (Glotzbach Collection, BCHS).

8. Howard and Ida relinquished Wanda's apartment because the neighborhood had drastically changed for the worse. Flavia did not even consider taking it herself because of the continual noise. FG to Alma Scott, Sept. 22, 1953 (VPL).

9. FG, autobiographical sketch for Harper's Publishing Company, c. 1947 (BCHS).

10. Flavia did look for jobs in the year before Wanda's death, illustrating sample Christmas cards for the Norcross company (although she found its products "sugary-sweet") and fearing that she "may land in the library yet." FG to WG, Mar. 28, 1946 (CLRC).

11. Lyn Lacy, "The Life and Times of Flavia Gág," typescript for June 1997 slide presentation (Harm Collection). See also Ellen Lewis Buell, review of *Emma Belle and Her Kinfolks*, by Eva Knox Evans, *New York Times Book Review*, June 16, 1940.

12. FG, autobiographical sketch for *Child Life*, c. 1945 (Harm Collection).

13. FG to WG, Jan. 26, 1946 (CLRC). Also see FG to WG, Jan. 9 and 12, 1946, on the same subject.

14. FG, "How a Book Is Made," talk at Palatka College, Palatka, Fla., Apr. 1967.

15. FG to Alma Scott, Nov. 1 and 5, 1952 (VPL).

16. FG to Alma Scott, Apr. 20, 1950 (VPL).

17. FG to Alma Scott, May 21, 1950 (VPL).

18. A. B. McG., review of *Fourth Floor Menagerie*, by Flavia Gág, *Saturday Review*, Aug. 20, 1955, 28.

19. FG, Christmas card to Alma Scott, 1956 (VPL).

20. Flavia wrote Alma Scott that *A Wish for Mimi* "is based on our early life in New Ulm, by the way." FG to Alma Scott, June 19, 1958 (VPL).

21. R. E. Livsey, review of *A Wish for Mimi*, by Flavia Gág, *Saturday Review*, Oct. 25, 1958, 34.

22. FG to Alma Scott, Dec. 29, 1948, and June 12, 1949 (VPL).

23. "Flavia Gag Loves New Ulm, but Needs a New York City," *New Ulm Lifestyle*, June 21, 1977. This account does not identify Flavia's fiancé by name.

24. FG to WG, Jan. 4, 1946 (CLRC).

25. "This book is for the fact-collectors as well as the young naturalists. . . . Entertaining to browse through, the book may also stimulate further investigation of the natural world" E. L. B., review of *Nature Was First!*, by Walter C. Fabell, *New York Times Book Review*, Apr. 13, 1952.

26. "Author Flavia Gág Will Speak at College," *Palatka Daily News*, Apr. 18, 1967. See also *Daytona Beach Morning Journal*, May 17, 1967. This article, which concerns her visit to a third-grade class in Crescent City, includes the information that "Miss Gag also writes rock and roll music and the boogie beat for adults."

27. See FG to Stella and Bill Harm and Alma Scott (who was visiting in Florida), Feb. 1 and 10, 1960, describing paintings done in St. Augustine, Florida (VPL).

28. Gary Harm, conversation with author, June 26, 2001.

29. FG, Christmas card to Irvin Kerlan, M.D., 1963 (CLRC).

30. Flavia also donated many of her own books and original manuscripts to the Kerlan Collection. Karen Nelson Hoyle, *Wanda Gág* (New York: Twayne, 1994), 117.

31. "Flavia Gag Loves New Ulm."

Selected Bibliography

ARCHIVAL SOURCES

Brown County Historical Society (BCHS)
 George Gag file
 Glotzbach Collection

Children's Literature Research Collections, University of Minnesota, Minneapolis (CLRC)
 Wanda Gág Collection
 Flavia Gág Collection

Department of Special Collections, Van Pelt-Dietrich Library Center, University of Pennsylvania (VPL)
 Wanda Gág diaries, correspondence, and "Childhood Reminiscences"
 Flavia Gág correspondence

Harm Collection
 Flavia Gág diaries, family memoir, and childhood recollections
 Gág family correspondence

Minnesota Historical Society (MHS)
 Wanda Gág correspondence
 Alma Scott Schmidt Papers
 Stenographic notebook, Wanda Gág interview notes

SECONDARY SOURCES

Boe, Roy A. "The Development of Art Consciousness in Minneapolis and the Problems of the Indigenous Artist." Master's thesis, University of Minnesota, 1947.

Brueggmann, Gary J. "Beer Capital of the State: St. Paul's Historic Family Breweries." *Ramsey County History* 16 (1981): 3–13.

Chadwick, Whitney. *Women, Art, and Society*. 2nd ed. London: Thames and Hudson, 1996.

Coen, Rena Neumann. *Painting and Sculpture in Minnesota, 1820–1914*. Minneapolis: University of Minnesota Press, 1976.

_____. *Minnesota Impressionists*. Afton, Minn.: Afton Historical Society Press, 1996.

Cox, Richard W. "Wanda Gág: The Bite of the Picture Book." *Minnesota History* 44 (fall 1975): 239–54.

_____. "Adolf Dehn: The Minnesota Connection." *Minnesota History* 45 (spring 1977): 167–86.

_____ and Julie L'Enfant. "Wanda Gág's Free Spirit: A Reconsideration of the Prints." In *Second Impressions: Modern Prints and Printmakers Reconsidered*. Ed. Clinton Adams. Albuquerque, N.M.: Tamarind Institute and University of New Mexico Press (Feb. 1996): 59–64.

_____ and Julie L'Enfant. "Old World Symphony: Thoughts of Minnesota in the Late Work of Wanda Gág." *Minnesota History* 55 (spring 1996): 3–15.

Craven, Wayne. *American Art: History and Culture*. Madison, Wis.: Brown and Benchmark, 1994.

Douglas, Ann. *Terrible Honesty: Mongrel Manhattan in the 1920s*. New York: Farrar, Straus and Giroux, 1995.

Fritsche, L. A., M. D. *History of Brown County, Minnesota*. 2 vols. Indianapolis, Ind.: B. F. Bowen, 1916.

Frizot, Michael, ed. *A New History of Photography*. English edition. Cologne, Germany: Könemann, 1998.

Gág, Wanda. *Growing Pains: Diaries and Drawings for the Years 1907–1917*. 1940. Reprint, St. Paul: Minnesota Historical Society Press, 1984.

Gerdts, William H. *American Impressionism*. New York, Abbeville, 1984.

_____. *Art across America: Two Centuries of Regional Painting, 1710–1920*. 3 vols. New York: Abbeville Press, 1990.

Gourley, Jacquelyn. "Wanda Gág: American Artist, Modern Primitive." Master's thesis, George Washington University, 2001.

Harris, Ann Sutherland, and Linda Nochlin. *Women Artists, 1550–1950*. New York: Alfred A. Knopf, 1984.

Hess, Jeffrey A. *Their Splendid Legacy: The First 100 Years of the Minneapolis Society of Fine Arts*. Minneapolis: Minneapolis Society of Fine Arts, 1985.

Hobbs, Karen, trans. and ed. *One Hundred Tales from Sudetenland*. Original German text by Josef Rotter. New Ulm, Minn.: German-Bohemian Heritage Society, 1999.

Hoyle, Karen Nelson. *Wanda Gág*. New York: Twayne, 1994.

Kunz, Virginia Brainard. *The Mississippi and St. Paul*. St. Paul: Ramsey County Historical Society, 1987.

_____. *St. Paul: The First 150 Years*. St. Paul: Minnesota Historical Society Press, 1991.

Lass, William E. *Minnesota: A History*. 2nd ed. New York: W. W. Norton, 1998.

Lumsdaine, Joycelyn Pang, and Thomas O'Sullivan. *The Prints of Adolf Dehn: A Catalogue Raisonné*. With essays by Richard W. Cox and Clinton Adams. St. Paul: Minnesota Historical Society Press, 1987.

Marsh, John L. "Drama and Spectacle by the Yard: The Panorama in America." *Journal of Popular Culture* 10 (winter 1976): 581–92.

Merrill, Peter C. "Robert Koehler: German-American Artist in Minneapolis." *Hennepin County History* 47 (summer 1988): 20–27.

Meter, Ken, and Robert Paulson. *Border People: The Börnisch (German-Bohemians in America)*. Minneapolis: Crossroads Resource Center, 1991.

Millet, Larry. *Lost Twin Cities*. St. Paul: Minnesota Historical Society Press, 1992.

Newhall, Beaumont. *History of Photography from 1839 to the Present*. Rev. ed. New York: Museum of Modern Art, 1982.

Nochlin, Linda. "Why Have There Been No Great Women Artists?" *ArtNews* 69 (Jan. 1971): 23–39, 67–71.

O'Sullivan, Thomas. "Robert Koehler and Painting in Minnesota, 1890–1915." *In Art and Life on the Upper Mississippi, 1890–1915*. Ed. Michael Conforti. Newark, Del.: University of Delaware Press, 1994.

Peterson, Isaac Oliver. "Art in St. Paul as Recorded in the Contemporary Newspapers." Master's thesis, University of Minnesota, 1942.

Rippley, La Vern J., and Robert J. Paulson. *German-Bohemians: The Quiet Immigrants*. Northfield, Minn.: St. Olaf College Press, 1995.

Rosenblum, Naomi. *A World History of Photography*. 3rd ed. New York: Abbeville, 1997.

_____. *A History of Women Photographers*. Rev. ed. New York: Abbeville Press, 2000.

Sandweiss, Martha A., ed. *Photography in Nineteenth-Century America*. Fort Worth: Amon Carter Museum, 1991.

Scott, Alma. *Wanda Gág: The Story of an Artist*. Minneapolis: University of Minnesota Press, 1949.

Sheehy, Colleen. *The Unseen Wanda Gág*. Exh. brochure. Minneapolis: Frederick R. Weisman Art Museum, University of Minnesota, 1997.

Showalter, Elaine, ed. *These Modern Women: Autobiographical Essays from the Twenties*. New York: Feminist Press at the City University of New York, 1989.

Stansell, Christine. *American Moderns: Bohemian New York and the Creation of a New Century*. New York: Henry Holt, 2000.

T and P Research. Ancestral Research Report No. 9909303/01 prepared for Robert J. Paulson. Czech Republic, Feb. 4, 2000.

Torbert, Donald R. *A Century of Art and Architecture in Minnesota*. In *A History of the Arts in Minnesota*. Ed. William Van O'Connor. Minneapolis: University of Minnesota Press, 1958.

Weisberg, Gabriel P. *Beyond Impressionism: The Naturalist Impulse*. New York: Harry N. Abrams, 1992.

_____ and Jane R. Becker, eds. *Overcoming All Obstacles: The Women of the Académie Julian*. Exh. cat. New York: Dahesh Museum; and New Brunswick, N.J.: Rutgers University Press, 1999.

Williams, J. Fletcher. *A History of the City of Saint Paul to 1875*. 1876. Reprint, St. Paul: Minnesota Historical Society Press, 1983.

Winnan, Audur H. *Wanda Gág: A Catalogue Raisonné of the Prints*. Washington, D.C.: Smithsonian Institution Press, 1993.

Zigrosser, Carl. *The Artist in America*. New York: Alfred A. Knopf, 1942.

Index

Illustration Credits

Art Institute of Chicago: p. 49 top right.

Brown County Historical Society, New Ulm, Minnesota: pp. 32, bottom right; 34, top left and bottom; 35, top; 38, bottom left and right; 39, top left and bottom right; 40; 41; 42; 43; 47; 48; 50; 51, top right; 55, top right; 56, top left and bottom right; 57, top; 60, top and bottom; 62, top and bottom; 63; 64, top left and right, bottom right; 65, top right and bottom left; 66; 67, top left and bottom right; 68, top left and bottom right; 69, top and bottom; 71, bottom; 75, bottom right; 78, top right and bottom; 80, top right; 83; 84, top and bottom; 85, top left and bottom; 87, top right; 89; 90; 92, bottom right; 128; 134, top and bottom; 151; 166; 168; 172, top and bottom left and right.

Children's Literature Research Collections, University of Minnesota, Minneapolis: pp. 18; 19; 24; 36; 59, bottom right; 61; 74; 76, bottom; 77, top left; 94; 97, top and bottom right; 99; 100; 103; 104; 105; 106, top left and bottom; 109, top and bottom; 110; 116, top right; 118; 119; 120; 121; 122, top left and bottom right; 125; 131; 133, top; 135, top; 140, top right; 141; 144; 148; 150; 155; 170.

Allan R. Gebhard: 71, top right; 80, bottom right.

Julie L'Enfant: pp. 52, top right; 86.

Memphis Brooks Museum of Art, Memphis, Tennessee: p. 37.

Minneapolis Institute of Arts: pp. 115; 116, bottom; 117; 124; 129; 135, bottom; 146; 152; 160.

Minnesota Historical Society, St. Paul: frontispiece and pp. 20; 32, top; 33; 35, bottom right; 38, top; 51, bottom; 52, bottom; 59, top; 91; 95.

Robert J. Paulson: pp. 23, top and bottom; 25, top; 82.

Penguin-Putnam, Inc.: pp. 126; 145.

Philadelphia Museum of Art: pp. 112; 143.